ARTIST'S
GUIDE TO
COMPOSITION

ARTIST'S GUIDE TO COMPOSITION

BY RALPH FABRI

WATSON-GUPTILL PUBLICATIONS, New York

This book is dedicated to all artists
who would like to create better pictorial works.

First published 1970 in New York by Watson-Guptill Publications,
a division of Billboard Publications, Inc.,
One Astor Plaza, New York, N.Y. 10036

Manufactured in the U.S.A.

ISBN 0-8230-0300-0

Library of Congress Catalog Card Number: 77-117074

First Printing, 1970
Second Printing, 1972
Third Printing, 1974

Edited by Margit Malmstrom
Designed by James Craig
Set in eleven point Caledonia by Atlantic Linotype Co.
Printed and bound by Halliday Lithograph Corporation, Inc.
Color Printed by Art Print Company

Contents

Acknowledgments

I am most grateful to Donald Holden, Editor, for his sound advice; to Margit Malmstrom for her excellent editing; to James Craig, for the distinguished design of this book. I also wish to express my thanks to the many private collections, and museums, in the United States and abroad, for their permission to reproduce masterpieces in their possession, in monochrome and in full color.

Preface

First, let's define the meaning of the word *composition* in the fine arts. The term is easy to misunderstand as it has eighteen definitions in a complete dictionary of the English language, from, "the art of combining parts or elements to form a whole" through, "an aggregate material formed from two or more substances" and, "a short essay written as a school exercise" to, "the mathematical process of making a composite function of two given functions." We use the word extensively in reference to music. A work of music is called a composition, and the writer or creator of such a composition is called a composer. Also, newspapers and other publications have a composition room, where type is set up for printing.

In the fine arts, composition means the organization or grouping of the different parts of a work of art into a unified whole. Such a composition can be good, bad, or mediocre, like anything else. A composition is good when experienced people feel that nothing in a particular work of art could be changed, moved, or eliminated without damaging the esthetically satisfying appearance of the work. In a bad or mediocre composition, we feel that the work would be better if this or that part were pushed one way or another, made larger or smaller, or totally omitted.

In this book we'll be dealing, specifically, with pictorial composition. The word *pictorial* pertains to the art of painting and of drawing pictures. We also speak of pictorial effect or appeal, meaning the impact, good or bad, a picture as a work of art makes on us. Composition has nothing to do with subject matter or style. A portrait, a solitary figure, a few pieces of fruit, vegetables, the waves of the sea, flowers in a vase, Biblical, mythological, historical, or everyday events; all themes, done realistically, in an impressionist, cubist, abstract, or any other manner—and even nonobjective paintings (paintings without any attempt at recognizable elements)—have to have a composition. In the final analysis, it's the composition that makes or unmakes a work of art, regardless of how good the technique of the artist may be.

You may have a fine subject, and sufficient skill to paint it; yet, the work is rejected by a jury of selection because errors in the composition reduce or destroy the esthetic value of your picture. The aim of this book is to explain the fundamental principles of composition; to show that these principles aren't capricious, arbitrary, or nonsensical, but that they have provable, understandable reasons; to show you how to avoid the most common mistakes, and thus to help you create much better works of art than you'd be likely to produce without this knowledge.

I hasten to add that I don't believe in formulas in art. The so-called academic ideas promulgated in the eighteenth and nineteenth centuries, that all you have to do is to follow certain recipes and you'll turn out great art, are fallacious. And most of the widely celebrated large paintings based on academic formulas failed to survive the test of time; although beautifully done, they leave us cold. They look more like exercises in formulas and techniques than impulsive, emotional, and gripping pictorial creations.

The immense variety we find in important artists of the present as well as of the past eloquently proves that there are many kinds of great art, many kinds of great compositions, and that individuality, in addition to real talent and skill, is of paramount importance in any field of art. I must also add, however, that certain fundamental principles are recognized and practiced by all great artists; and that, on the other hand, there are certain features characteristic of the works of students and amateurs you'll never find in any great painting. This book will describe and explain the invariably positive as well as the invariably negative traits of composition, leaving you plenty of room for developing your own, personal approach.

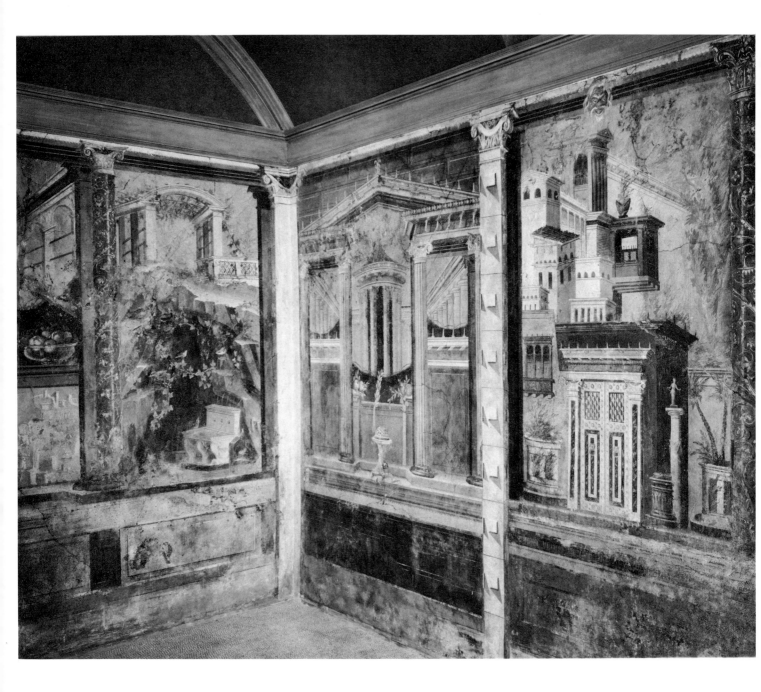

Cubiculum (bedroom). Detail from a Villa near Boscoreale, Italy (40–30 B.C.). Roman wall paintings showed realistic, but often imaginary rustic scenes, views of city houses with balconies, arcades, and fancy entrances. The sections are separated by realistically painted columns or pillars. Lights and shadows are very effective. Much of the work is trompe-l'oeil *architecture*. The Metropolitan Museum of Art, New York. Reinstallation, 1963, Rogers Fund, 1903.

1
Historical Background

The popular notion that art came into being due to man's innate desire for beauty and sense of the decorative—or that art was self-expression in prehistoric times—is completely naive. The term *self-expression,* as we understand it, was unknown before the era of Dr. Sigmund Freud (1856–1939). As for a desire for beauty and decoration, man doesn't do a thing without a reason. The reason may be foolish or absurd, but a reason it is.

Why did prehistoric man paint?

We see prehistoric paintings, mostly in caves, in many parts of the world, from Spain and France to South Africa and Siberia. There were several reasons for drawing and painting in ancient times, but none of them was esthetic. This we know through the extensive studies conducted among primitive tribes by anthropologists such as Dr. Margaret Mead. One of the most important discoveries that came out of these studies was that primitive man has the habit of drawing a characteristic part of the object he is discussing with someone; he draws this feature with his finger in the air. If it isn't clear to his companion, he'll draw the same traits, perhaps the horns or antlers of an animal, in the ground with a stick or his finger. Such a drawing is only one step from depicting an object more or less permanently on a solid surface.

Information via drawing

If a drawing helped to describe things for which correct terms were not available as yet, another reason for drawing or painting was to give lasting information. Animals were of supreme importance: they were food and clothing; their bones were made into tools. Young men had to be taught to recognize animals and to overpower them. Pictures of animals were unquestionably used for target practice by prehistoric man. Sometimes the heart of the animal is clearly shown, and you can see that the rock has been chipped off where it has been hit with weapons.

Magic was the main reason

A child believes that whatever he holds in his hands is his, especially when he's made it himself. A fetish is a symbolic object with the help of which primitive man tried to control his surroundings. Many prehistoric paintings show the silhouettes of human hands, obviously placed there while the artist was painting an animal around the hands, as if working around a stencil. Painting began largely for magic reasons, and art has retained its magic power all through the ages. The mere ability of an artist to depict real or imaginary things is a sort of magic, even though a magic different from the original concept.

Painting or picture?

Prehistoric man painted animals and humans all over the cave walls, often utilizing bulges in the rocks to simulate the bulky bodies of huge beasts. When space was no longer available, he painted animals over the old ones. Here and there, especially in South Africa, we find groups, or herds, of animals. Mostly, though, each item is a separate unit, painted in all directions and sizes. Such items are literally paintings, of course, in the technical sense of the word, but they aren't *pictures*. A picture is self-contained, whether it represents a single object or a scene from mythology or history.

Man is a slave of his habits

We start something for a reason, then stick to it long after the original reason is forgotten. As man moved from caves to dwellings erected by himself, and as he organized communal living, magic grew into religion, and magic pictures became religious imagery of a more and more sophisticated nature. Intrinsically, there's a close connection between the paintings in the Altamira cave in Spain, executed tens of thousands of years ago, and Michelangelo's paintings on the ceiling of the Sistine Chapel in Rome (early sixteenth century).

Religion ruled Egyptian painting

The art of ancient Egypt was totally religious. The Egyptians believed that life goes on forever in the hereafter, exactly as on earth, provided that the body of the deceased is preserved, and/or as long as any likeness of the dead person, painted or sculpted, remains intact. They also believed that whatever was painted on the walls of tombs, or kept in the tombs in any other form (such as miniature versions of all the necessities of life), would be real in the other world, forever. As a result, they depicted not only the deceased, but their slaves, scribes, pets, as well as all their earthly activities: farming, construction, fishing, fowling, parlor games, parties with musicians and dancing girls, pleasure boats and, naturally, all food stuffs.

Purpose was nonesthetic

All Egyptian figures and objects were painted in horizontal sections, one above the other. Each group stands on (that is to say, it stands on top of) a flat, horizontal stripe, except occasionally, when the stripe is slightly curved, indicating a farmland. These horizontal stripes, separating one level of depictions from another, may run across the entire wall; or they may be shorter. The stripes, and thus the figures and objects above them, aren't necessarily of the same over-all size. Some are taller than others. The deceased may be as tall as two rows of slaves, for example. Each item is painted individually on the plaster walls, outlined in dark paint or incised lines. Each section is covered with conventional colors, without any indication of light and shadow. All items are conventionalized, so-called "memory," pictures.

Overlapping figures

In groups at a party as well as in groups of soldiers or harvesters, all the figures in Egyptian art are about the same, one slightly overlapping the other in every gesture (as if done with a stencil, pushed a few inches left or right several times). The same thing happens when the artist shows a row of pots: the first one is fully seen, the others are in a neat row, one exactly like the other, each hidden a little by the one in front of it.

Design and rhythm

Although the purpose of Egyptian art was not in the least esthetic, the over-all effect in the finest tombs is often quite attractive. The design has, by the nature of the work, a certain symmetry which is obvious on the short walls containing a symbolic painted or carved door for the spirit (*Ka*). On such walls, all figures on the left look right, and figures on the right look left; the two sides are very similar in design. On the longer walls, there's a rhythm similar to that of a parade of soldiers marching in single file: slaves always step the same way, figures always stand or sit in the same stance. Animals, often very beautifully done, are also identical in shape and motion. The sameness of the conventional colors adds to the feeling of rhythm.

Cretan painting

Cretan (also called Aegean or Minoan) civilization preceded the Greek civilization by some two thou-

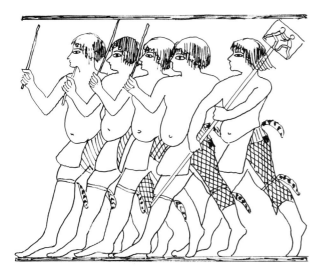

Sketch of Nubian Mercenaries, *from an Egyptian tomb. One of the men is a standard-bearer; figures, standing on a horizontal stripe, overlap each other with no indication of any background.*

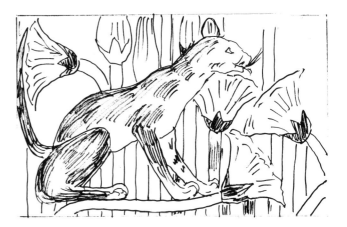

Sketch of Cat among Papyrus Plants, *from an Egyptian tomb. The scene is part of a wall covered with realistic pictures, but with no regard for over-all composition.*

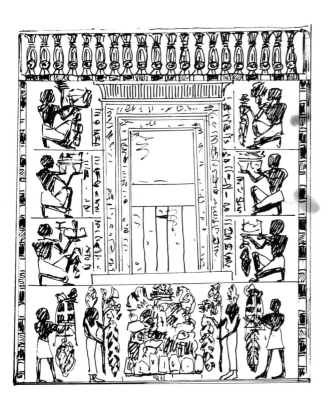

Egyptian tomb paintings around a door for the Ka, *the immortal spirit. Figures on the left and the right are similar in size, posture, and layout, all looking toward the Ka door. A balustrade painted across the top acts as a frame, and the symmetrical pattern shown in this sketch is very pleasing to the eye.*

Sketch of Cretan wall painting, A Prince in a Garden. *In this naive side view, the stuccoed figure has its own lights and shadows.*

sand years, but we knew nothing about it until the 1870s, when Heinrich Schliemann (1822–1890), in his effort to prove that the Homeric epics, *The Iliad* and *The Odyssey*, were based on historical events, discovered ancient Troy in what is now northern Turkey. Schliemann then continued his impulsive and amateurish excavations on the island of Crete. Sir Arthur Evans, one of the founders of scientific archeology, began excavations on Crete in 1900, and discovered the Palace of Knossos (the mythological labyrinth built by the Cretan king for the Minotaur, a monster with a bull's head and a human body), still containing scores of rooms. The excavations include countless pieces of plaster chips, many of which have been put together like jigsaw puzzles into frescoes of amazing beauty.

Composition in Cretan painting

There are several almost complete Cretan murals, executed in very bright colors. The figures are as conventional as in Egyptian art, without lights and shadows, but many figures are done in low plaster relief, so that the light hitting the picture creates shadows and highlights. Often, but not always, there's a pictorial background.

One of the most famous frescoes represents flying fish executed in an impressionist manner, with complete freedom. Another noted scene, from about 1500 B.C., shows narrow-waisted men fighting with, or doing acrobatics around, a somewhat elongated bull. Most of the frescoes form understandable and visually satisfactory units. Many of them have wide, decorative borders of geometric patterns, and most appear to be strictly secular decorations.

The Greek mind

The Cretan civilization ended when the barbarian Greeks overran the decadent empire by 1100 B.C. For about three hundred years, the Greeks (probably related to the Cretans) lived off the fat of the land. By around 800 B.C., only the ancient Cretan myths were left, combined with the Greeks' own mythology, and the Greeks began to develop their own culture. Being a seafaring nation, they found inspiration in Egypt as well as all over the Aegean islands and the mainland. The greatest thing they added to what they had gathered was

their own particular mind: a mind dedicated to absolute logic and the development of final formulas in every field on the basis of measuring, weighing, and mathematical calculation.

Belief in perfect beauty

Greek religion was anthropomorphic; that is, they believed that their gods and goddesses were exactly like human beings, except that they were immortal, omnipotent in their respective fields, and perfectly beautiful. In order to depict such deities, mostly in sculpture, the Greeks devised what they considered perfect beauty in the human face and figure. They also developed what they considered perfection in all things they made or built.

Greek painting

Ancient paintings were mostly done on walls, and few of them survive. We have only fragments of Greek murals, and descriptions of paintings by contemporary writers. The most celebrated murals, however, were reproduced (on a very much smaller scale) on Attic (Athenian) pottery, and the best pottery painters were so famous that they signed their vases. The subjects ranged from everyday life, occupational activities, artisanship, scenes in schools, satyrs running after nymphs, to historical events. There was very little color in these vase paintings. The earlier pottery paintings were black figures in silhouette on the brick-red background of baked clay, with fine lines for details.

A later period brought forth brick-red figures against a black background. Still later, a couple of other colors were added. Thus, the art of the Attic vase painter is comparable to graphic arts. Picasso and other modern masters have found endless inspiration in these Greek outline drawings on ceramics. The Greeks liked precision and abhorred anything indefinite. A background, such as a landscape, or any scenery, runs out of the picture, right and left; hence, it's indefinite. Instead, background or locale is suggested by symbols. On vases, figures and objects are usually depicted running around on (on top of) a horizontal stripe. On the early, large burial urns, there are rows of pictures, one above the other, as in Egyptian tombs, each set placed on a stripe running around

the urn. There is a knowledge of foreshortening (perspective in figures or small objects), but no indication of light and shadow.

Composition in Greek painting

Linear perspective is employed in Greek murals; as far as we can tell, figures, objects, and symbols (such as rocks or trees) are scattered all over the surface, but each figure is in a different posture; one figure in front of another, often in vehement action. The main figure may be prominently placed in the center, on a higher level.

In vase painting, the shape of the vase is cleverly utilized. Where handles divide the vase into two halves, there are usually two different but related pictures. Each of them is a complete unit and self-explanatory in subject matter. In some cases, figures are literally running around the vase, and the effect is equally good from any angle.

Probably the most successful paintings are on shallow mixing bowls and cups, where the center section is almost flat. In these scenes, the figures and objects are carefully arranged to offer a visual balance, with standing, crouching, and reclining figures of the same size covering each other in a large variety of fashions.

It's interesting that the Greek idea of the artist signing his work was forgotten during the early centuries of Christianity. Even during the Renaissance and the Baroque, many painters failed to sign their works. In recent times, of course, a signature has become customary, although not all artists sign all of their paintings.

Roman painting

The Romans had a true catholicity of taste and spirit. They took over cults, tastes, art forms they liked, and dismissed what they didn't like. The Romans admired all forms of Greek art, but by 146 B.C., when they conquered Greece, Greek art had already been considerably transformed, largely by Alexander the Great (356–323 B.C.), into what we call Hellenistic art: a combination of Greek, Roman, Persian, and other elements.

Pompeii and Herculaneum

Wealthy Romans had villas in several summer resorts, the largest of which were Pompeii and Her-
culaneum at the foot of Mt. Vesuvius, on the Bay of Naples. It was thought that Vesuvius was extinct, as it had not been active in about five hundred years. In A.D. 79, however, the volcano erupted. By a strange quirk of nature, the eruption consisted of cinders and volcanic stones instead of the usual lava. Pompeii was buried under hot ashes; over Herculaneum, the ashes were mixed with a drenching rain, so that a kind of blazing hot plaster buried the town to a depth of as much as sixty-five feet.

Hundreds of murals

Modern, scientific excavations started only at the turn of the twentieth century, and hundreds of well-preserved, though scorched or damaged, murals have been uncovered. Most of the paintings must be considered second- or third-rate works, according to contemporary Roman standards—good enough for a summer resort, but inferior to murals in the great townhouses of Rome. Yet, the murals give a perfect idea of the taste, knowledge, and customs of a long-past era.

Subjects in Roman painting

Roman private houses as a rule had only one large room, called *atrium*; the rest of the rooms consisted of cubicles. Most rooms had no windows, in order to keep the heat of the sun out during the warm months. The smaller rooms had pictures, often showing scenery one might see through a window, intended to make them appear bigger. The *atrium* was decorated with figure compositions from mythology, history, or everyday life. Floral designs and still lifes were also very popular. We see many *trompe-l'oeil* (eye-cheating) architectural subjects, such as fantastic palaces with vivacious sculpture or arcades and balconies painted so realistically that they seem to expand the space (an idea also developed during the Baroque, long before these Pompeiian murals were discovered). Erotic subjects, rendered in an absolutely realistic or in an exaggerated manner, were found in many places. Let's not think our age is the first permissive one!

Genre paintings, the kind of story-telling pictures introduced after the Protestant Reformation in the Netherlands and elsewhere, were very well liked in ancient Rome. The subjects included *putti*, cherubic little boys (with or without wings),

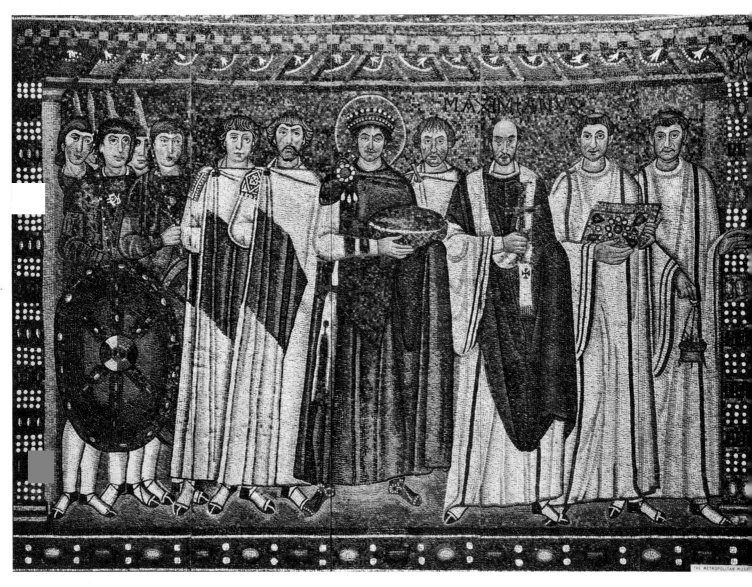

The Emperor Justinian and Members of his Court. The original of this Byzantine mosaic picture is in the Church of San Vitale, Ravenna, Italy (A.D. 536–547), 8'8" x 12' in size. All figures, flanking the emperor in the center, stare out of the picture. If there are more figures on one side, they are more compressed than the figures on the other side in order to retain symmetry, a Greco-Roman tradition in art. The background is just color. The Metropolitan Museum of Art, New York.

which were also employed in Roman sculpture and which retained their popularity throughout the Renaissance and the Baroque.

Another surprise is to find that the Romans had a period when impressionist pictures were the vogue. One of the best is a cockfight, executed in the sort of quick strokes we associate with our own modern art. Many of the subjects were done in mosaics, a technique especially favored in the North African colonies of the Roman Empire.

Composition in Roman painting

All Roman painting is based on symmetry: there's a main figure in the center, and other figures on the left and on the right, neatly balanced in number and in size; or the subject has two equally important figures, painted just right and left of the center, facing and perhaps touching each other. Other items in the picture are also equally distributed to the left and to the right. Each picture is a complete unit, separated from others on a large wall by various kinds of borders—sometimes these are decorative designs (especially in mosaics), sometimes columns or pillars painted with perfect realism. All pictures have lights and shadows and complete, realistic backgrounds. Many of them have figures in the foreground, and in the middle ground. The best of Roman painting may be judged by presentday standards of realistic art.

Painting in the Christian Era

By the time of the Emperor Nero (A.D. 37–68), there were Christian groups in many parts of the Roman Empire. The effect of new religious beliefs on art was on subject only, not on style. Accustomed to their Roman environment, Christian artists depicted the holy personages of Christianity exactly like Roman personages. The difference between Jupiter, head of the Roman Olympus, and St. Peter, for example, was merely that Jupiter held lightning bolts in his hand, while St. Peter held a big key. The apostles looked like Roman Senators; but crosses, often cleverly interwoven with other border designs, made their true identities clear.

Early Christian painting in the East

Constantine the Great (A.D. 288?–337), who moved the capital of his vast empire to Byzantium

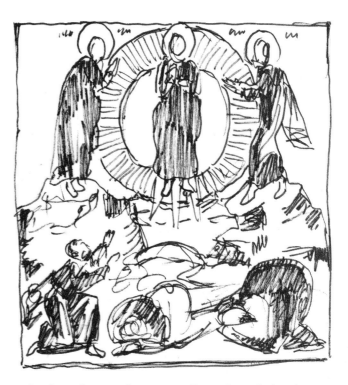

Sketch of The Transfiguration, *a Byzantine painting, in which symmetrically arranged figures are shown with a primitive suggestion of scenery.*

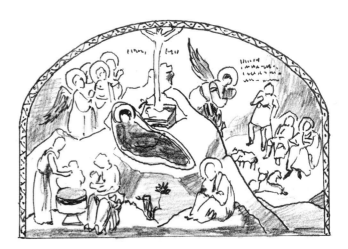

Sketch of Byzantine mural in Istanbul, with an early approach to story telling: the Holy Virgin, the baby Jesus being washed, angels, shepherds, and scenery are interwoven without any sense of proportion or perspective.

and called it Constantinople (now Istanbul), legally sanctioned Christian worship, and Christian art first flourished in that largely Greek part of the world. However, pictorial arts were the only ones permitted, as the Ten Commandments forbade graven images, but didn't mention paintings. Whether the work was executed in paint or in mosaics, the sole aim of the Byzantine Christian artist was to make visible the supranatural, and he succeeded in this, despite a lack of knowledge of draftsmanship, proportion, and perspective.

Icons

Icons, holy pictures, became an integral part of the Eastern Christian Church. Painted on wood panels, in sizes ranging from those small enough to carry in a pocket to larger ones filling the screen called the *iconostas* or *iconostasis*, which separates the worshippers from the altar, icons represented saints, martyrs, and the events in their lives, including scenic backgrounds. (Icons had a great influence on several modern artists, notably on Russian-born Marc Chagall (1887–), whose works can only be fully appreciated when we realize the effect of Russian icons on the artist.)

Composition in Byzantine painting

The ancient Greco-Roman symmetry is retained in all Early Christian work: main figure in the center, others left and right, in perfect balance; when figures stand in a row, literally staring at the viewer, the most important personage is in the exact center. Each picture is an inseparable unit, usually surrounded by a very ornate border. Under Greek influence, large paintings or mosaics often have a simple color for background, with symbols, such as trees, flowers, lambs or stars; and a name is often clearly marked next to each personage.

Romanesque painting

Romanesque is the name applied to Early Christian art in the West. That part of the Roman world was so strongly addicted to sculpture that the Christianized Romans accepted it. Painting was employed in illuminating manuscripts, and decorating the walls of churches. Perfect symmetry was the basis of composition.

Gothic painting

It took more than a thousand years for Christianity to fully entrench itself in Europe. By the eleventh century A.D., people began to breathe more easily, and artists experimented with new styles. A whole new movement was born in France and swept across Europe (except the Italian peninsula, where ancient Roman concepts of art were too deeply interwoven into the fabric of the culture). The name for this movement, from about 1150 to 1550, was introduced only toward the very end of the era by Michelangelo, who called it Gothic. This was a derogatory appellation, as the Goths were supposed to have been barbarians, without any art. We now use the name with admiration.

In the cathedrals and churches of the Gothic period, there was little wall space between the pointed arches, the many windows, separated by piers (bundles of narrow, vertical columns), so that murals were out of the question. Altarpieces were introduced; standing on sturdy legs near the altar, these altarpieces usually had two wings which could be opened and closed like doors. Scenes from the Scriptures were painted on the altarpiece itself, on the inside and the outside of the wings, in such a manner that the visible pictures were cohesive whether the wings were open or closed. The various panels of the altarpieces were separated by ornate, Gothic frames.

Stained-glass windows

The drabness of the stone interior of the Gothic church was successfully broken by the introduction of stained-glass windows. Daylight streaming through such windows was not only radiant, but threw bouquet-like patterns of colors onto the floor or the wall. At night, the oil lamps or candles in the church made the stained-glass windows glow when seen from the outside.

Tapestry

Tapestry had been made since very ancient times, but it was in great demand during the Gothic period, especially in private and public buildings. A large piece of tapestry would cover a whole stone wall, and look attractive, besides which it kept the cold out in the winter and reduced the heat in the summer.

Composition in Gothic pictorial work

Altarpieces, stained-glass windows, and tapestry were all pictorial creations, designed by artists according to the taste and style of the period. Gothic artists still adhered to the symmetrical arrangement of previous periods. The panels of the altarpieces were so arranged that the main picture was in the center. Left and right sections were always symmetrical: a figure on the far left looks right, while a figure of similar size and shape on the far right looks left.

Color composition in stained glass

One point of great significance is the fact that stained-glass windows, regardless of their subject matter, were seen in color, rather than in detail, from a distance. Thus, it soon became evident that colors, as well as figures and backgrounds, have to be composed. Symmetry in color combinations, therefore, became just as significant as symmetry in design.

Early Renaissance painting

The Renaissance (*rebirth* in French) began in Italy early in the fourteenth century and extended through the fifteenth and sixteenth centuries. The artist Duccio di Buoninsegna (1255–1315) was one of the harbingers of this new era. Duccio adhered to absolute symmetry, with hardly any indication of depth. In his famous *Majestà* (1308–1311), in the Museum of the Cathedral of Siena, the Holy Virgin with the Child Jesus sits in the exact center, on a naively designed throne. Angels and saints on the left look right; the identical figures (in reverse) on the right look left. There are, however, a couple of faces tilted in the opposite direction, also symmetrically. In spite of the flatness and uniformity of faces, the painting has an emotional quality never found in classic Roman painting. This early Renaissance style is usually called Italo-Byzantine art.

A more advanced master of the new period is Giotto (1276–1336), born near Florence. One of his most moving frescoes is *Pietà* (1305) in the Arena Chapel, Padua. The two halves of the painting have the same visual weight; the bulky garments on the right make up for the larger number of figures on the left. The head of Jesus, held by

His Mother, is on the far left, but all faces, left and right, are turned toward Him. A rocky ledge in the background, slanting down from the right, also leads the eye to the most important heads. Small angels flying in a variety of directions and exquisitely observed trees on the right announce the coming of the High Renaissance with all its stunning realism.

Leonardo's *Last Supper*

One of the best-known creations of the Renaissance is the *Last Supper*, painted by Leonardo da Vinci between 1495 and 1498, on the wall of the refectory (the dining hall) of Santa Maria delle Grazie in Milan. No matter how great a genius Leonardo was, his art can only be understood in the Renaissance context. Adhering to Renaissance symmetry, he placed Jesus in the center, six apostles on the left, and six on the right, all on the far side and the two ends of the table, like a scene in an old-fashioned stage play. What makes this work a milestone in art is the fact that Leonardo manages to depict the true consternation on the faces of the apostles as the Master declares, "One of you will betray me tonight."

Formerly, all faces were stereotyped, more or less alike, in painting. Leonardo used living models (the second apostle from the right is a self-portrait of the artist), so that each face is different, individual. And not every apostle is looking at Jesus; Leonardo found other ways of leading the viewer's eye to the central figure—some apostles point and look at Him, others just point, while looking at each other and talking.

Composition in Renaissance painting

As indicated in the preceding examples, Renaissance art stuck to symmetry, but searched for different arrangements within this general scheme. Occasionally, the main figures were right and left of the center, as in some ancient Roman pictures. Left and right sections had a visual, rather than an actual numerical, symmetry. In scenic as well as architectural backgrounds, the greatest artists found a way of lessening the monotony of symmetry by depicting forms of almost equal masses and colors, but of sufficiently different forms, in the left and right halves of the picture.

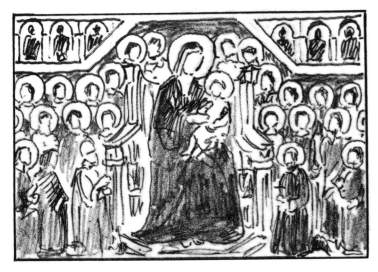

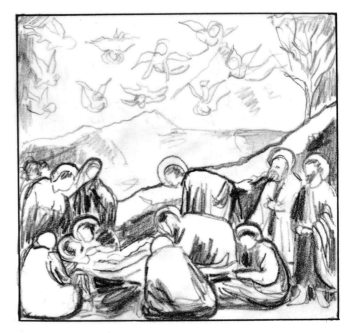

Sketch of the center section of Majestà *(1308–11) by Duccio di Buoninsegna (1255–1319), one of the first great painters of Italy. This work, in the Museum of Siena Cathedral, is a fine example of the Italo-Byzantine style. The Holy Virgin with the Child is in the exact center. Angels and saints on the right are practically traced, in reverse, on the left. Most faces look toward the Virgin, but there are a couple of exceptions, due to the more naturalistic approach of Italian artists who were influenced by the many classic Roman works found everywhere on the peninsula.*

Sketch of Pietà *(1305), a fresco in the Arena Chapel, Padua, by Giotto (1276–1336). The head of Jesus, held by His Mother, is at the far left, even though the composition is symmetrical. The visual weight of the right half is equal to that of the left half, because the bulky garments on the right make up for the larger number of figures on the left. All faces turn toward Jesus, and are practically alike (except for the beards). The rocky ledge in the background leads the eye to the head of Jesus. There's a certain rhythm in the bent figures and the folds of the garments. Small angels flying in all directions, in remarkably well foreshortened forms, and the beautifully observed trees, give a hint of the absolute realism to come with the High Renaissance. Later on, more sophisticated artists wouldn't place a sitting figure exactly in the corner, as Giotto did on the left-hand side.*

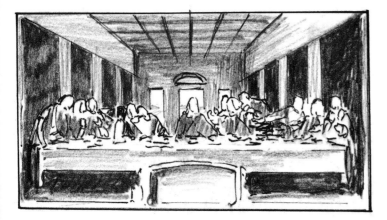

Sketch of the Last Supper (Santa Maria delle Grazie, Milan) by Leonardo da Vinci (1452–1519), is as symmetrical as the Duccio Majestà, *but far more sophisticated. Realistic figures, all in different postures, are shown in three dimensional space. The eye of the onlooker is guided to Jesus, in the exact center, by the slanting beams on the ceiling as well as by the eyes and/or hands of the apostles.*

Baroque painting

The Protestant Reformation in the first half of the sixteenth century, and the Counter-Reformation mounted by the Church of Rome, caused upheaval and bloodshed all over Europe. The general turmoil didn't bypass the artists. They reacted by creating works of vehement action. Everything seemed to be blown by a windstorm; the actions of Biblical, historical, and everyday people were equally tumultuous. The symmetry of the Renaissance was gradually dismissed and replaced by an asymmetrical, off-centered composition. The new type of art was so different from the calm Renaissance that it was called *Baroque,* from the Portuguese word *barroco,* or the Spanish *barrueco,* a word applied to odd-shaped pearls.

Rococo painting

By the middle of the eighteenth century, the style was so extravagant that ceilings appeared to have been ripped open to show the heavens. Architectural elements were partly painted, partly real. Every work of artists and craftsmen was full of ornamentation. This phase of the period is called Rococo, derived from the French *rocaille* (rok-äy′), meaning small stones or shells employed in decorating boxes, frames, and so forth. The Baroque and Rococo lasted through the eighteenth century.

Asymmetry in all subjects

Composition in all subjects, which now began to include landscape, seascape, still life, interiors, and *genre* (scenes from everyday life), was off-centered, diagonally zigzagging or spiraling. Even a single portrait is slightly off-centered. Nor does the size of the painting affect this composition. Many small easel paintings were done after the end of the sixteenth century for the small houses of middle-class people in addition to the colossal murals done for churches and public buildings and huge canvases for royalty and a growing number of private collectors.

Classic Revival painting

The French Revolution, which broke out in 1789, brought with it the ideas and symbols of the ancient Republic of Rome. Curiously, though, it never brought back the symmetry of Greco-Roman

painting. Jacques-Louis David (1748–1825), probably the most important master of the Classicist, or Classic Revival period, consistently used baroque composition, although his subjects were often taken from classic history. In his painting, *The Death of Socrates* at the Metropolitan Museum of Art (see color plate), you see a perfect example of baroque asymmetry. The basic difference between this and a real baroque painting is that it's static, like a *tableau vivant* (a staged scene immobilized for a moment), without the turbulent vitality of the best works of baroque artists.

Academic art

In the eighteenth and early nineteenth centuries, the belief spread among European artists, critics, and public alike, that great paintings can be created only by following formulas established by the famous artists of the past. Artists began to look for classic Greek proportions, and copied details faithfully. Everything had to be flawlessly precise. Story-telling pictures, so-called "conversation pieces," were most fashionable. The result was that the quality of draftsmanship and craftsmanship was often quite high, but the paintings were stiff and dull.

Impressionist painting

Impressionist artists began to rebel against academic formulas. They went outdoors and painted what they saw, instead of depicting imaginary palaces and scenery. They paid more attention to color, motion, and atmospheric conditions than to small details. These artists, called Impressionists because they painted quickly and, according to prevailing standards, superficially, still retained the asymmetrical composition of the Baroque and Classic Revival periods. If you reduce impressionist paintings to lines and main masses, you'll find that composition in them is the same as in paintings by Rubens, Rembrandt, and hundreds of other Baroque artists.

Composition in Oriental painting

Oriental art wasn't really known in Europe until after the "opening" of Japan on behalf of the Western powers by Commodore Mathew Calbraith Perry (1794–1858). In the 1850s, Japanese scrolls,

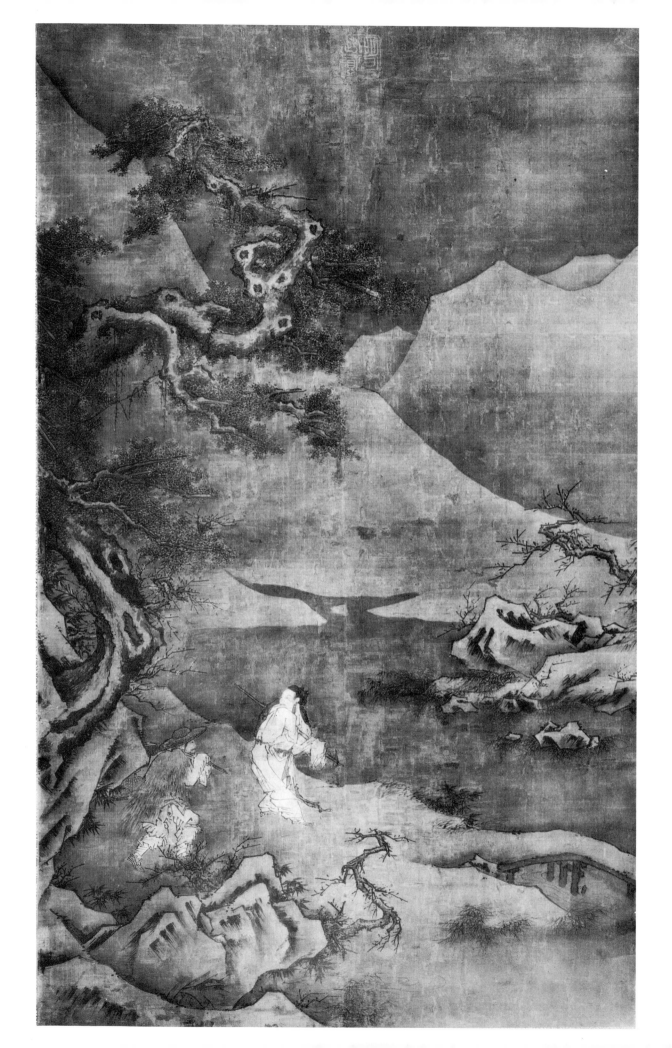

woodcuts, and other kinds of art were introduced to Europe, and they exerted a tremendous influence on Western art. Strangely enough, Japanese painting proved to be just as asymmetrical as European painting, but appears to have reached that form of composition centuries earlier. Japanese art, however, had something very new to offer: a certain simplicity of over-all design, and the ability to suggest, rather than actually depict, backgrounds. It also proved that a painting can be quite realistic, without being photographic. (This was of extreme significance for European artists who were faced with competition by the widely introduced new machine, the camera.)

Composition in recent painting

Despite the frequent changes in art styles during the twentieth century, the fundamental features of composition have retained their importance. If you scrutinize the linear construction of paintings by Picasso, Braque, Matisse, Modigliani, Juan Gris, Joan Miró, Rouault, Seurat, Duchamp, Vlaminck, Derain, Hartung, Kandinsky, Rivera, and countless other artists, you'll find that most of them are asymmetrical. There's no law about this, of course, and many paintings by these and other artists are symmetrical. Some have a kind of over-all pattern, especially in so-called "automatic art," and in geometric abstraction. The principles of composition explained in this book are based on the works of the finest artists of all periods. Composition is as vital an instrument for painters as the piano, the violin, or any other musical instrument is for musicians. You have to know how to handle your instrument. Naturally, skill in handling an instrument, in this case composition, is merely a foundation upon which to erect artistic achievement.

(Left) **The Travelers.** *Chinese painting on silk, Sung dynasty (960–1279), formerly attributed to Chao Kan (c. 900). Oriental perspective is naive, as if everything were seen from a certain height. Distant objects are placed one above, rather than one behind, the other. The rhythm of nature is always enhanced. Similar forms are repeated in diverse sizes.* The Metropolitan Museum of Art, New York. Purchase, Fletcher Fund, 1923.

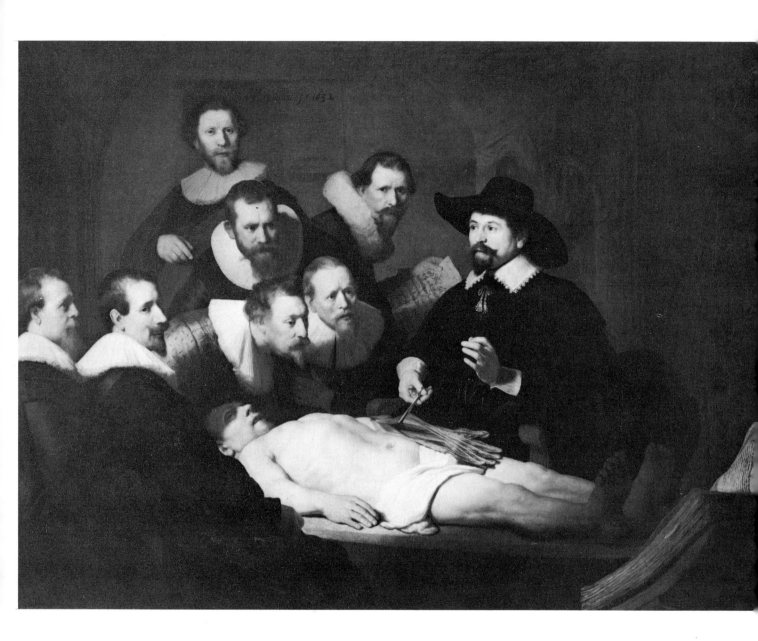

Dr. Tulp's Anatomy Lesson (more correctly: ***Dr. Tulp and his Fellow Surgeons of the College of Surgery***) by *Rembrandt Harmensz, or Harmenszoon, van Rijn, or Ryn (1606–1669). Although Rembrandt was a Baroque master, just like Rubens, his temperament preferred calm, mysterious scenes. This group portrait, his first financial success, already contains the strong contrasts between darks and often unexplained lights so characteristic of his later works. The composition is asymmetrical; artists of the Baroque avoided all symmetry. Dr. Tulp could be fitted into a pyramid. Five of the other surgeons could also fill a pyramid.* Collection Mauritshuis, The Hague.

2
Balance in Composition

When we hear the word *balance* in everyday life, we think of measurements and financial records, or of balancing acts in a circus; perhaps also of art juries consisting of traditional and modern members in equal numbers. We also speak of a well-balanced person, meaning a man or a woman who is attractive, intelligent, charming, etc.

Balance in nature

All living creatures are balanced; left and right sides are alike in mammals, birds, fish, and insects. We take this for granted. How could any creature function in any other way? Trees, flowers, fruit, and vegetables are also balanced, so that one could cut them into two fairly equal halves. A tree or bush can be forced to grow asymmetrically by some accidental obstacle, such as a wall, or by deliberate human efforts. Even then, the distorted forms are usually symmetrical. Rocks and rock formations have to be balanced. Erosion of millions of years has created fantasmagoric forms in the Grand Canyon, and other places, but each unit has eroded in a more or less symmetrical fashion.

Lack of balance

All of us find out, in early childhood, what a loss or lack of balance means. A tree bends down—if it

doesn't break—and supports itself on its branches, and new branches try to create a new balance. A human being totters or falls. Rocks roll down when a formation is eroded more on one side than on the other. You cannot carry a heavy load on one arm or in one hand for very long. And would you place all your furniture and furnishings in one half of a room, leaving the rest empty, on a permanent basis (not just temporarily, because the other side is being painted)? The dodo bird became extinct because it wasn't well balanced by nature.

Balance in pictures

The word *balance* has about twenty-five definitions in a big dictionary. The one referring to the fine arts says that balance is the composition or placement of elements of design, figures, forms, color, in such a manner as to produce an esthetically pleasing or harmoniously integrated whole. This sounds like a good definition, but what is esthetically pleasing? What's a harmoniously integrated whole? A work of art can be great, and deeply moving, without being pleasing to the eye. "Esthetic" is as difficult to define as "beautiful." As for the term "harmoniously integrated," I'd prefer to say: a work of art in which everything is in its proper place, size, shape, color (if any), and value.

One thing must be clear: balance in a picture is

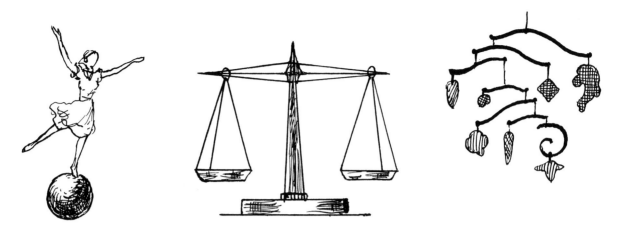

There are many kinds of balance: an acrobatic dancer on a large ball, a scale, a mobile.

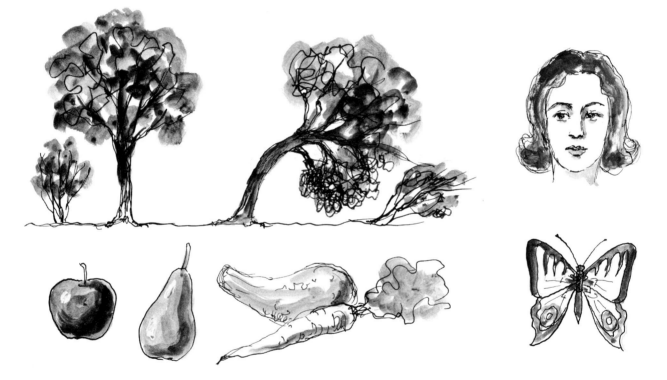

There's balance in all forms of nature: bush, tree, apple, pear, squash, carrot, butterfly, the human face. Nothing seems to be able to exist without symmetry.

The skeleton of the dodo bird shows the peculiar proportions and lack of balance of this bird. No wonder it couldn't survive.

not necessarily the sameness, perhaps in reverse, of the right and left halves, the equal distribution of objects and figures on both sides. (As we saw in the preceding chapter, composition may be divided into two basic forms: symmetrical and asymmetrical.) However, these two major systems can be further subdivided into zigzagging and spiraling types of balance. Great paintings are possible with many different kinds of composition, but, as I've mentioned, artists of each period prefer the composition of their own time.

Advantage of symmetry

A symmetrical arrangement seems to be the most elementary kind of composition, as nature is so symmetrical in its separate forms. Even when you doodle (and who doesn't?), you start with a little spot, then go this way and that way, all around, expanding your doodle in all directions. Practically all doodles come out in symmetrical forms, unless you're interrupted and leave your splendid doodle unfinished. Public buildings are usually symmetrical, with the main, ornate entrance in the center. Indoors, furniture, hangings, and paintings are often arranged in a completely symmetrical manner.

Such symmetry is a safe bet; it gives you no headache. Place something in the center, fill the two sides with an equal number and type of articles or objects, and you have a literally well-balanced room, picture, or garden.

Disadvantages of symmetry

Placing the main figure in a painting in the center normally means that the figure looks at you in a formal pose. You have the problem of arranging other figures according to some protocol, left and right, as at a state dinner. A certain formality pervades the picture. Renaissance masters made clever variations. For example, a prancing horse on one side balanced two or three men on the other by sheer volume. A figure with a voluminous or wind-blown garment counterbalanced two simply-dressed figures. In Early Christian art, all figures stood in a row, staring out of the picture, like suspects in a police line-up.

Leonardo da Vinci's *Last Supper* is a far cry from the common symmetrical arrangement. Yet, with all its sophistication, marvelous detail, and dramatic power, this famous work is still a stiff stage-setting compared with the more intricately composed versions of the same popular subject by artists of the Baroque.

Advantage of asymmetry

The major advantage of asymmetry is that there are innumerable ways of devising asymmetrical compositions. A symmetrical arrangement is off-balanced if there's the slightest discrepancy. If one of two symmetrically hung pictures on a wall is an inch lower than the other, the mistake is obvious at once. If paintings are hung irregularly, you accept the difference without any hesitation. This doesn't mean that anything goes in asymmetry; the elements of the composition are still balanced. El Greco's early works were all in the Renaissance style, yet they're dramatically different from identical subjects painted by Raphael (Raffaello Sanzio, 1483–1520), and Titian (Tiziano Vecellio, 1477–1576). Diego Rodriguez de Silva y Velázquez (1599–1660) also often composed his major works in Renaissance symmetry, as in his *The Surrender of Breda* (the Prado).

Freedom is a challenge

The greatest factor in asymmetry is that it stimulates the competent artist to create something new. In an asymmetrical arrangement, the artist has to find a way of leading the viewer's eye to the most important figure or object of his painting. Jesus is in the exact center in Leonardo's *Last Supper*; He is unmistakably the supreme figure. It's more difficult to find Jesus when he sits at the opposite end of a long table, on the side, and is smaller than all the guests, in a setting of constant motion in *The Wedding at Cana* (Santa Maria della Salute, Venice) by Tintoretto (Jacobi Robusti, 1518–1594). Yet, the viewer is bound to see Him almost at once, thanks to the ingeniously arranged slanting lines of table and ceiling beams, which guide his eye to the physically insignificant figure.

More motion and action

An off-centered arrangement requires diagonal lines, which may be straight or curved, steplike or meandering. Such a line goes away from your eye toward the background; you follow this line all

(1) A doodle begins with a little spot, and grows left and right, up and down, into some sort of symmetrical nonsense. (2) A painting can be arranged with complete symmetry. (3) It may be vertically asymmetrical. (4) It may be diagonally asymmetrical.

Sketch of Feast in the House of the Pharisee Simon (Louvre), by Paolo Veronese (1528–1588). This painting is a striking example of Renaissance composition. It's as symmetrical as possible without actually tracing one side on the other; yet the artist makes the scene vivid and lifelike with lights and shadows, and differences in hues. There's no central figure. Jesus is slightly off-center, on the right. His foot is being washed. The background is typically anachronistic—there couldn't have been a house like this magnificent Roman palace in Jerusalem then.

over the picture, from foreground to middle ground and background, and back again. In a symmetrical composition, you are more likely to stay with the center; the background, and the middle ground, if any, are also symmetrical, and often look like unimportant space-fillers.

Asymmetry needn't be tumultuous

The symmetry of the Renaissance can show motion, and the asymmetry since the Baroque may show calm, even though asymmetry is more conducive to strong action. Two of the very greatest exponents of the Baroque, the Flemish master, Peter Paul (Petrus Paulus) Rubens (1577–1640), and the Netherlands artist Rembrandt Harmenszoon van Rijn, or Ryn (1606–1669), prove better than anyone else how different the results of the same basic system may be.

Composition isn't everything. It's the foundation on which the artist builds his picture. Rubens liked over-fed women and muscular men in endless motion; everyone contributing his share of the action with all the vehemence he or she can muster. Rembrandt painted gentle, tender, spiritual faces, illuminated by mysterious lights and veiled by equally mysterious shadows.

Disadvantages of asymmetry

Asymmetrical composition gives the artist so many possibilities that some of them are bound to be bad, or not so good. Too much zigzagging, too much gesticulation, a spreading of objects in all directions, may be confusing and boring. A party needn't be dull just because its participants aren't all drinking and dancing in the wildest fashion. We see the extravagant development of the Baroque asymmetry in the Rococo, where the conglomeration of forms and actions is often blinding or dazing rather than pleasing or interesting.

Pictorial balance

Ultimately, pictorial balance is much more than the balance in nature or the scale in a grocery store. The artist cannot go by the actual physical weight of the objects he uses in his picture. There are pictorial weights which have little, if anything, to do with measurable weights. As a matter of fact, pictorial balance has to be seen, not measured.

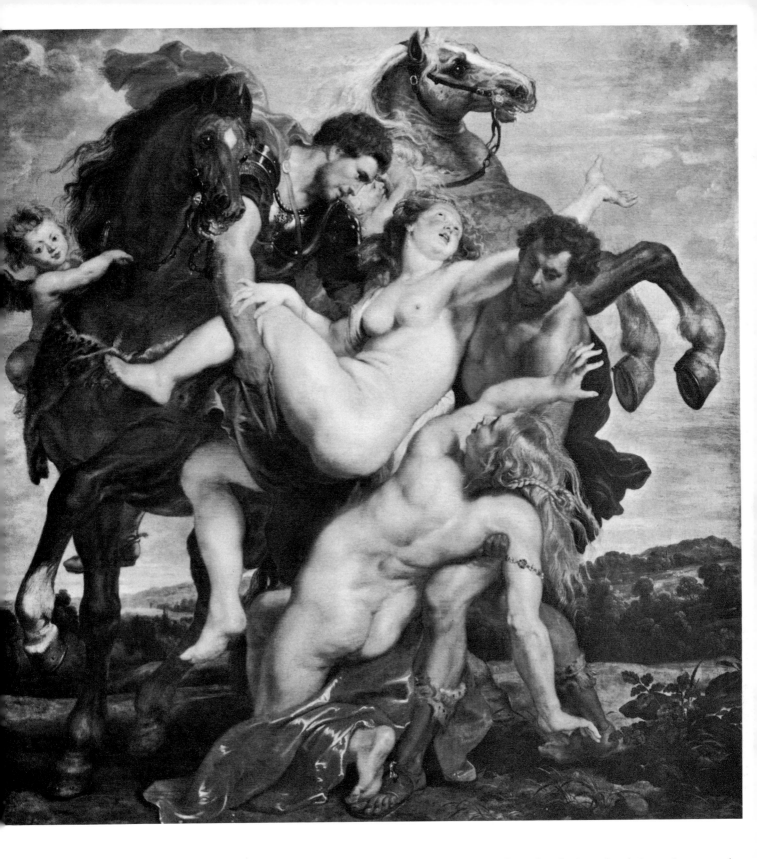

The Rape of the Daughters of Leukippos by *Peter Paul (Petrus Paulus) Rubens (1577–1640), oil on canvas 87" x 82⅜", represents the legendary Castor and Pollux, one on horseback, the other on the ground, trying to lift the plump girls onto the spirited horses. You might take a tracing paper, and draw two diagonals across the picture: the geometric center is the center of a circle which forms* the buttock of the girl being lifted. Everything's in motion, except the background. Rubens liked vehement action. Colors, lights and shadows, are so well arranged that they carry the onlooker's eye around and around. One might wish, though, that the artist had omitted the winged putto (small boy, or cherub) on the left. There's barely enough space for him. Collection Alte Pinakothek, Munich.

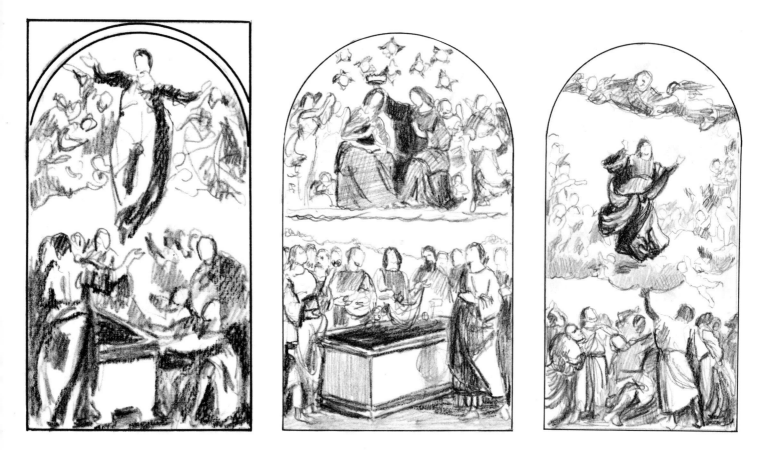

(Left) Sketch of Assumption of the Virgin (The Art Institute of Chicago) by El Greco (1541–1614). Executed in 1577 before the artist became so highly individualized, this painting already shows his simplification of forms, his dramatic shadows and bright streaks of light. The Virgin arises from her coffin and rises to heaven with a simple, but majestic, gesture. The minimized drapery enhances the feeling of flying upward. (Center) Sketch of Crowning of the Virgin (Vatican Museum) by Raffael (1483–1520) also shows the coffin, but on a larger scale. It is surrounded by sweet-looking people, basically resembling the artist himself. A horizontal cloud separates the humans from the Virgin being crowned by Jesus, while angels play musical instruments and small baby faces are scattered over the sky like stars. The subject is almost the same as El Greco's, but the personality of the artist is clearly noticeable in the calm, perfectly symmetrical composition. (Right) Sketch of Assumption of the Virgin (Accademia, Venice) by Titian (1477–1576) shows the Virgin overloaded with drapery, above a combination of clouds and winged putti (small boys or cherubs), going to heaven where angels and the Lord are awaiting her. There's no coffin, but people on the ground watch her ascent with amazement. Titian was the greatest colorist of the Renaissance, and this painting relies largely on the radiance of its hues. The ancient Roman love for drapery was retained by Italian artists through many centuries, and both Raffael and Titian have a great deal of it in these paintings. El Greco, on the other hand, pays more attention to motion and to contrasts between light and shadow than he does to the realistic rendering of drapery.

Sketch of Wedding at Cana *(Santa Maria della Salute, Venice) by Jacopo Robusti, called Il Tintoretto (1518–1594). In this Baroque painting, Jesus, performing the miracle of turning water into wine, is nowhere near the center of the scene. He is at the far end of a table on the left, a small figure seen in perspective. Everything is asymmetrical—people are moving or standing, the hall itself is seen from an angle. But the slanting lines on walls and ceiling, and in the table, infallibly conduct the viewer's eye toward Jesus.*

Baroque asymmetry is many-faceted. (Above) In the diagram of Hunters in the Snow *(Kunsthistorisches, Vienna) by Pieter Bruegel (or Breughel) the Elder (1525?–1569), the off-centered diagonal lines and forms fit into each other like pieces of a Chinese puzzle. (Below) In this sketch of* Destruction of Sennacherib's Army *(Pinakothek, Munich) by Peter Paul Rubens (1577–1640), you can see his dramatic and turbulent rendering of the subject.*

Lake Geneva at Chexbres by Ferdinand Hodler (1853–1918), Swiss master of rhythm in painting. Done in 1905, this picture is an outstanding example of his landscapes. The large and small clouds on top, similar in shape to the lake, and the small clouds lower down with their reflections in the lake, have a poetic rhythm. The contrast between the horizontal far shore, streaks in the water, and the upright strokes denoting vegetation on the near shore, which curves into the lake on the right, creates a sense of peace and serenity, a sense enhanced by the feeling that the clouds are suspended in the sky. Collection The Public Art Gallery (Öffentliche Kunstammlung), Basel.

3

How to See in Pictures

The first thing an artist ought to learn is to see in pictures. This may sound like a joke. Doesn't everyone, layman as well as artist, see pictures? What else can he see? Whoever has eyes must see the same things. One can imagine a colorblind artist who knows how to draw, but fails to understand color. But a normal artist obviously sees what he's painting. Unfortunately, this assumption is wrong.

Views in life, views in pictures

In reality, every object is three dimensional. This book isn't concerned with rules of perspective an artist has to know if he wants to render realistic forms on a flat support to create a sense of space. We're probing the fact, seldom realized by laymen, and hardly ever by art students, that as we look at anything, we're inside, so to speak, looking around, rather than being outside, looking at a view. We turn our faces and eyes in all directions, so that we know what we see from a variety of viewpoints.

Outdoors, we notice rocks, houses, trees, hills, clouds, roads, figures, vehicles; indoors, we see furniture, books, windows, rugs, flowers, dishes, et cetera. We probably could make out a satisfactory list of objects we'd seen. We also see faces and figures of relatives, friends, close acquaintances. We recognize them; we "remember the face, even

if we don't remember the name." But what about painting such scenes, objects, or people? Where do we start? How much of what we see can we fit into a single picture? How much do we want?

Pictures are flat

The support on which we execute a picture is flat, and limited by its edges, or by the frame. An exception is the complete, panoramic, circular picture popular a few generations ago, and still an attraction in some cities. Such circular panoramas usually depict historical events (*The Battle of Atlanta,* for example); three dimensional rocks, shacks, figures, carriages, and whatnot are added to the foreground, so that the result is a diorama, rather than a picture, and it's made by a team of painters, sculptors, and craftsmen. Admission is charged, as though it were any pavilion or booth in an amusement park.

In reality, you see a different picture every time you move your eye; in a picture, you can show only a single view; no matter which way you move, you see the same picture. That single view ought to be as complete, as interesting, as you feel the whole actual scene is. A photographer can take many pictures of the same subject from different angles. An artist cannot afford this procedure. He has to see and paint the right subject.

Binocular vision

We have two eyes, and see two pictures from slightly different angles. Make this simple test: hold your index finger (or any small object) straight up, about fifteen inches from your face; look at it with the left and the right eye alternately, in rapid succession, closing the other eye each time. When you look with your left eye, the finger seems to jump right; when you look with your right eye, it jumps left, visually. The same visual sensation occurs when you look at the house across the street, at a tree, a rock, a lamppost, and so forth.

Your left eye sees more of the left side of a small object; your right eye sees more of the right side. On large objects, you cannot easily notice the difference. When you look with both eyes, your mind unites the two pictures into one. It's this binocular vision that makes us see three dimensionally. A person who's lost the sight of one eye sees everything flat.

We see in circles

Our eyes are round, and we see round pictures; actually, we see two slightly overlapping round pictures—so that the view is wider than it is high. This explains the general preference for horizontal pictures. Opera glasses have lenses as far apart as the human eyes; we see two separate pictures when looking through such glasses, but, again, our minds combine them into one.

In movies, a view seen through binoculars is always clearly indicated by encompassing it with the silhouette of the binoculars. The binocular (two-lensed) camera takes two separate pictures of the same object simultaneously, also from points as far from each other as the human eyes. When we look at such pictures in a stereopticon projector (as common in homes a couple of generations ago as TV is today), we behold one single three dimensional picture.

Peripheral vision

Our eyes, and the lens of a camera or telescope, transmit enough rays from beyond the actual circle of vision to fill a rectangular picture. This is what we call peripheral vision. What actually happens is that our eyes keep moving, ever so slightly, and

thus we see beyond the circle. Forms seen from what we call "the corners of our eyes" curve inward, but we don't notice such distortions unless we look at a photograph, where lines on the left and right of horizontal pictures, and on the top and bottom when the picture is taken vertically, curve inward, even though better lenses are polished in such a manner as to compensate for certain optical distortions.

Rectangular pictures

We're so accustomed to rectangular, especially oblong, pictures that we no longer see the true image. Since very ancient times, we've seen the outside world through rectangular windows or doors; we smile at circularly matted and framed photographs, and paintings, as prototypes of the bourgeois taste of the Victorian era. We accept vertically shaped pictures, including the very tall Oriental scroll paintings, because many views are high. Also, we don't realize that we see high mountains, skyscrapers, and other tall objects only by moving our heads and eyes up or down, except when they're very far away, and that distance diminishes them visually.

How big is your circle of vision?

The circle of vision depends upon your distance from whatever you're looking at. A still life fits into your circle of vision from a short distance; so does a portrait head or bust. An entire human being, however, can only be seen at once if you're at least twelve or fifteen feet away from him. Otherwise, you have to look at the upper part, then at the middle, finally at the lower part. This may sound like a very odd comparison, but look at a keyhole. All you see is a keyhole, until you get closer to it, when you probably see a light come through the hole. Place your eye on the keyhole, and you'll see a great deal. Perhaps even things you're not supposed to see. So don't peep through keyholes, please; just get the idea of the circle of vision.

Shaped canvas

Artists at present are producing paintings in all kinds of odd shapes, depending upon the artist's esthetic concept, or whim, or on the particular place where the painting is to hang. Such paintings

are generally called "shaped canvases" even though most of them are executed on wallboard, wood or Masonite panels, rather than on canvas (except when the canvas is glued onto a hard panel). The reason is obvious: it's impossible to have odd-shaped stretchers for canvas, and framing is costly as well as difficult; a hard support can be attached to the wall without any frame.

Panoramic view

One of the most thrilling visual experiences of my life occurred in Istanbul, when I stepped onto the private little terrace of my room in a famous hotel. I beheld a vast panorama of a huge metropolis, with its myriad windows, minarets, and domes sparkling in the sunlight. The city contrasted with the amazingly dark blue Bosporus. Similar sensations await you in Switzerland, Cape Town, Denver, San Francisco, Baghdad, and many other places where it's possible to get a view of a large section of the city or the countryside from your hotel room.

How can you paint this?

Obviously, you cannot put everything down on a support, regardless of the size of the support. The question is how to select the most pictorial view, and how to make your picture suggestive of the vast subject.

Composition begins with the choosing of the subject—use your knowledge, judgment, and taste as well as your eyes. An artist friend of mine, living on the East River in New York City, had a marvelous view of the Brooklyn Navy Yard and all the activities on the river during World War II. The view was fantastic. He tried to put everything in the same picture: docks, derricks, destroyers, cruisers, barges, tugboats, smokestacks, trucks; also, a submarine approaching, with its crew lined up on deck. The painting looked like a junk yard, rather than a navy yard. You couldn't tell what it was. Forms and colors were sprawled all over the canvas.

Consider the flat view

My constant advice to art students is to use a view-finder. Nobody takes a photograph without looking through the view-finder which is part of every camera. A picture doesn't really take itself: it's the person behind the camera who selects the view. Why doesn't the artist consider his subject as carefully as a good photographer does? Or even more so, because snapshots can be taken in seconds, and cost very little to develop and to print, whereas hand-painted pictures require much work, and money, too.

Make a view-finder

Whether you're a beginner or an experienced artist, a view-finder will often be a help to you. Cut a piece of 4″ x 6″ cardboard or matboard, and cut a rectangular window in its center in the most general proportions of pictures. These are a 3:4 ratio; that is, 9″ x 12″, 18″ x 24″, 30″ x 40″, and so on. An opening of 1½″ x 2″ is in the 3:4 ratio. You can view any subject through this small window by holding it closer to, or farther from, your eyes, with one eye closed. Scan the subject back and forth, up and down, in order to discover if any part of it is attractive or interesting enough to paint.

Use it indoors and outdoors

The view-finder is useful in any subject, including a small still life on your kitchen table. You might discover, for example, that your still life leaves large empty spaces here and there on the support, or that some of the items are too close, or too far apart. An interior of a room or a building could pose tremendous difficulties, unless you select the right section through the view-finder. The small window will also help you decide whether to use the support in a horizontal or in an upright position.

You needn't stick to a single view

You aren't a camera which can take only pictures within the range of the lens; you may make changes. In a still life, you can actually shift or remove objects. In a landscape, the changes have to be visual, of course. You cannot actually cut out and remove a tree, or plant a big new tree, but you can push it from one section to the other in your layout. We call this maneuver telescoping, and artists like Cézanne, and countless others, have used the method to make their paintings more interesting. A certain amount of experience

Rhythm is perceivable in every manifestation of nature, but rhythm in art is never a mechanical repetition of forms, sizes, colors, and motions.

(Left) A monotonous repetition of sea and sky. (Right) A pleasing, uneven repetition in waves and clouds.

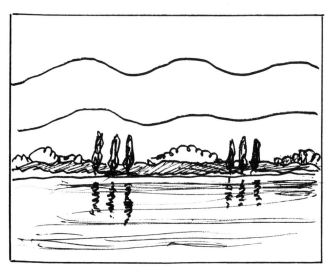 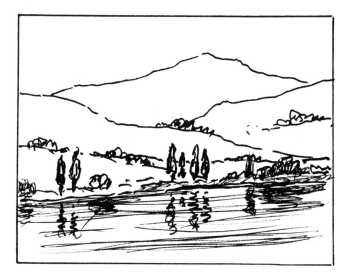

(Left) Mountains, hills, trees repeated again and again, in the same forms. (Right) The same objects are repeated with slight variations.

(Left) We admire precision, but these dancers are like wind-up toys. (Right) In reality, and in art, there's an endless variation of forms.

and judgment is needed, however, as shifting an object cannot always be done without changing some lights and shadows as well.

Flat picture versus flat design

When I speak of seeing reality in flat pictures, I don't mean flat design. That term refers to a field of commercial art, in which designs are prepared for printing upon wallpaper or textiles. The best of these designs are stylized, rather than realistic and three dimensional in concept. Various nationalities have their own traditional and typical designs; individual designers have styles of their own, which run parallel to the latest fashions. But such designs aren't pictures one normally frames.

Flat design is an over-all pattern. The artist draws one section, and this is repeated mechanically all over the rest of the material. A fine arts painting is flat physically (even when executed on a curved wall or vault). Within this flat surface, the picture has to be a complete, self-explanatory unit, at least artistically. The subject may be beyond the knowledge of the average onlooker, as is the case with some historical, mythological, Biblical themes, and paintings connected with the religious beliefs of other parts of the world.

Rhythm in painting

Rhythm is easily understood in poetry and music, where words, notes, and chords are repeated time after time. Rhythm is also understandable in most types of labor. If you watch workers on a job, you'll discover a certain rhythm in their motions. In painting, rhythm is a patterned repetition of a motif, formal element, or color at regular or irregular intervals, in the same, or some similar form. Rhythm is everywhere in nature: hills and mountains in a range have very similar wavy lines; trees in one group are likely to be similar; seagulls sweep up and down in long, rhythmic spirals.

Rhythm of a more subtle kind can be most effective in pictures, especially in outdoor subjects. Observe and depict such rhythmic views or details without making them look like traced repetitions. People marching, flags waving, crowds cheering can be a very fine theme, but you have to select a certain view (or devise such a view if you don't actually see one) which is sufficiently complete, yet varied. Not every marcher should step exactly

the same way; not every flag should wave in the same form, and so forth. Trees, houses, clouds, waves, and rocks may be repeated in various shades, sizes, and forms.

Ferdinand Hodler (1853–1918), the famous Swiss artist, was a master of rhythm in his landscapes as well as in his murals. His *Lake Geneva at Chexbres* in The Public Art Gallery, Basel, is a typical example. Its large and small clouds on the top, small clouds and their reflections in the water lower down, offer a lovely and poetic rhythm. In his mural at the University of Jena, *Uprising of the Students of Jena* (in the Napoleonic War), soldiers march together in the snow. Four abreast, they're seen from slightly different angles, with just a small difference in the directions of the rifles, and you feel that there's an endless army marching on before your eyes.

One of Hodler's most remarkable murals is *Retreat from Marignano*, in the Swiss National Museum, Zurich. What nation would want to depict and exhibit a retreat of its soldiers, even though the event occurred in 1515? The Swiss did it, and more power to them. There were many sketches and heated arguments and fights about this mural before the final version was executed in 1900. We see the last of the retreating Swiss mercenaries, straggling, but still holding their flags erect, their lances high, after twenty-eight hours of fighting against the French army under Francis I and his allies.

Memory pictures

Most people think in terms of memory pictures even today. Egyptian, Assyrian, Babylonian art was almost totally memory work. Artists of those

In this sketch of a section of The Uprising of the Students of Jena *by Ferdinand Hodler (1853–1918), famed Swiss master of rhythm, each group of four soldiers is seen from a slightly different angle—rear, side, and front.*

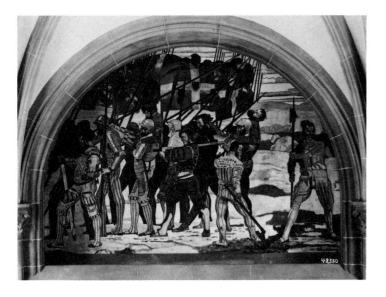

ancient realms depicted figures, objects, and scenery the way they best remembered them, from the most typical angles, conventionalizing every item. The long low-relief friezes in Angkor Wat, Cambodia, are among the most remarkable of these memory images. Every figure, every weapon is conventionalized, yet there's enough natural rhythm in the marching throngs, interspersed with elephants and howdahs, ceremonial umbrellas, and other tall objects, to make the frieze fascinating and truly a work of art.

A different memory picture characterizes Chinese and Japanese art. Those Oriental artists never worked from models (until recent times). They studied everything with great dedication, then drew and painted each figure, object or scene from memory, concentrating on the essential in each item. They always sensed the rhythm of nature.

All these pictures (a low-relief is a pictorial work, too) have one common denominator: they represent three dimensional reality on a flat, or almost flat surface. In each case, the artist had to be able to see the theme as a picture before reducing it to the flat support, and he had to select the most interesting and most comprehensive aspects of the view in order to achieve a work of art.

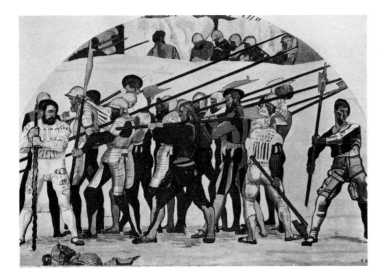

(Above) **Retreat from Marignano** *by Ferdinand Hodler. A most unusual subject; other nations glorify their victories, the Swiss are willing to show a serious defeat. The event occurred on September 14 and 15, 1515, when, after twenty-eight hours of fighting with lances against muskets, the Swiss mercenaries had to retreat. They are wearing a variety of costumes and walking out of step, yet their flags are flying, their lances are held erect. The one man with his halberd upraised on the far right fills the empty space at the rear of the column. Swiss National Museum, Zurich. (Center) Here's the first version (1896) of the work shown above. Hodler's concept was greeted with vehement controversies. The half-figures beyond the hill, in the background, don't seem to belong to the picture. A long-handled battle ax appears to be hitting the foot of the man on the far right. The mercenaries look more like an isolated group than the rear guard of an army, and almost uniformly slanting lances are monotonous. (Below) In this second version (1897–98), the figures in the background are now mere silhouettes of heads. The men in the foreground are scattered. The two almost horizontal and the three vertical weapons look forlorn. The dead or wounded in the middle ground are pictorially confusing. The first and second versions are both in the Kunsthaus, Zurich.*

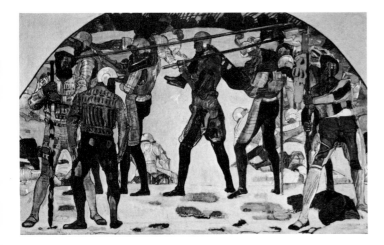

Part of frieze in Angkor Wat, Cambodia (twelfth century). This composition may have naive proportions, but it shows rhythm in the endless variety of people, oxen, carts, elephants with howdahs, ceremonial umbrellas, decorative trees, and weapons held in different positions. It was originally painted in realistic colors.

Oriental artists, literally nature-worshippers, depicted the rhythmic beauties of nature. (Left) Music under the Trees, sketch of painting by Chu Te-jun (c. 1350), Yüan dynasty. (Right) Returning Late from a Spring Outing, sketch of a painting by Tai Chin (c. 1430), Ming Dynasty. Both artists paint similar curves, mountaintops, and vegetation, but alternate the directions and sizes of each form.

Number 27 by Jackson Pollock (1912–1956), oil on canvas 49″ x 106″. Pollock, considered the founder of the New York school of art, claimed to work automatically, by dripping or squirting paint onto the canvas. These swirls and drips have no meaning beyond being a form of self-expression, but a professional artist doesn't really apply paint at random. His taste and skill can be recognized in the final effect, as even the drips are controlled in color, shape, and tonal value. Collection The Whitney Museum of American Art, New York.

4
Composition in Line, Tone, and Color

We constantly use lines in depicting any subject. The most artistically ignorant layman recognizes a picture done entirely in line. Theoretically, lines are invisible in nature, and are a convenient invention of man. Truly pictorial artists have been painting in color, without lines, for a long time. In such paintings, we still think we see lines: the separation between one form or color and another is the same imaginary line we find in reality. Thus, artists work with lines, whether they literally draw them in pencil, charcoal, or ink, or merely establish them with brush and paint.

Line in composition

Lines may be straight, curved, spiral, geometric, odd-shaped, criss-crossed, or overlapping. Linear composition, as the basis of the whole painting, can be reduced to a few types: over-all, symmetrical, asymmetrical, circular or spiral, and pyramidal. I'd like to make it clear that the term *over-all*, in this context, isn't a repeat wallpaper or textile design, but the kind of composition in which every section of the subject is of equal significance.

Over-all composition

Over-all line composition can be seen very clearly on the end walls of ancient Egyptian tombs. Fig-ures and objects are depicted on horizontal stripes, left and right of the painted or carved imaginary door of the *Ka*, the immortal spirit. All figures look toward the center; one side is almost exactly like the other, in reverse. Although the work wasn't planned to be a cohesive picture, it looks like one.

Similar over-all designs were painted on the archaic Greek funerary urns, also on horizontal stripes; and Early Christian paintings followed this pattern. What makes these simple paintings works of art is the variation in figures, articles, symbols; and the obvious attempt of the artist to make his work as good as he knew how.

Egyptian artists were literally compelled to adhere to traditional forms. Greek, and later Christian artists, however, had the freedom and desire to observe and to render things according to their talent and skill, rather than in obedience to religious rules. Thus, Greek vase paintings contain many masterpieces. Certain Cretan murals have an over-all design (such as flying fish), but in a marvelous diversity of realistic positions and forms.

In twentieth-century art, some cubist paintings have an over-all pattern of darks and lights. Many of the geometric abstractions, done with precision, resemble repeat patterns. The New York school of art, introduced by Jackson Pollock (1912–1956), believed in a so-called automatic, self-expressive dripping, squirting, pouring, or throwing of paint

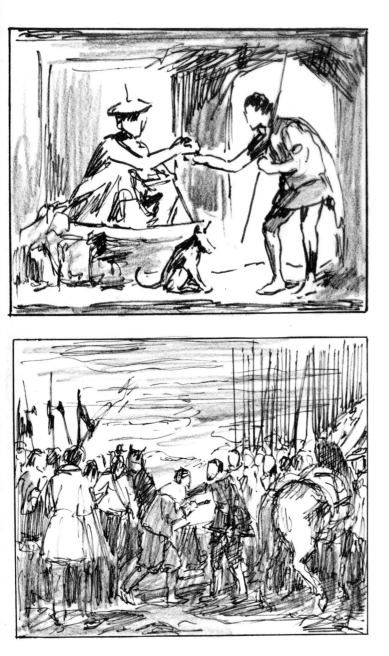

on the support. The result certainly looks like an over-all pattern, but its components aren't mechanically repeated at regular intervals.

Symmetrical composition

Symmetry in all forms of art was characteristic of classic Greece and Rome, and continued through the Renaissance. It's the basis of practically all pictorial work in the Western world during some two thousand years. The main figure or object is in the center, probably larger than the others. The left and right sides are in perfect linear balance. In early times, they were exactly alike, only reversed, without any feeling of space. Later on, much ingenuity went into the creations by outstanding artists who tried to overcome the rigidity of this central composition.

Already in ancient Rome, we find pictures in which the center is empty and two equally important figures are just left and right of center; the two sides are balanced with figures, or objects. An interesting Roman example is *Magic Scene*, in the Museum of Naples. A more impressive example is *The Surrender of Breda* by Velásquez (1599–1660), in the Prado, Madrid. Velásquez was partly Renaissance, partly Baroque in his paintings. This particular painting is in the symmetrical Renaissance style, and shows the Dutch general surrendering the key of the city of Breda to the Spanish general. The two main figures are left and right of center, where the act of passing the key, rather than an actual object, is the center of interest. Not surprisingly, the Spanish court painter represented the Spanish general as taller, and the more gracious of the two.

Velásquez broke the monotony of symmetry by painting a rear three-quarter view of a horse on the right, instead of a number of armed men. Another brilliant idea was the showing of vertical lances on the right, among the victors, while the weapons of the vanquished are held in various directions. The difference between the vertical lines on the right, and the mixed directions on the left is thus of emotional as well as artistic significance.

Asymmetrical composition

Off-centered composition was introduced gradually in the second half of the sixteenth century, and is

(Above) Magic Scene, *from an ancient Roman painting (Naples Museum). Two figures of equal weight stand to the right and to the left of center, each with a similarly well-balanced background. (Below) In the sketch of* The Surrender of Breda *(the Prado) by Diego Rodriguez de Silva y Velásquez, or Velázquez (1599–1660), the symmetrical basis of much of this Spanish artist's work is evident. Here, the Dutch general hands the key of the city to the victorious Spanish general. The lances of the Spanish are vertical, those of the vanquished Dutch stand any which way. A horse on the right balances the group of men on the left.*

At the Opera by Mary Cassatt (1884–1926), the American expatriate who was deeply influenced by the impressionists, and by Japanese woodcuts. The woman in the foreground fits into a pyramid. She stands out from the tiers and audience seen beyond her, but is an integral part of the picture. She would be meaningless without the background, and vice-versa. *The composition is asymmetrical, like most paintings since the Baroque period.* Museum of Fine Arts, Boston. Charles Hayden Fund.

Gertrude Stein (1874–1946), the American author remembered for her "a rose is a rose is a rose," painted in 1906 by Pablo Picasso (1881–), oil on canvas 39¼" x 32". Far from academic realism, the portrait is nonetheless based on sincere observation. It has the same asymmetrical composition we have been following for several centuries. The curved lines and forms, the darks and lights, including the carefully designed scarf, which carry the bright hues of the face to the hands, could be developed into a regular, photographic portrait merely by adding details. The Metropolitan Museum of Art, New York. Bequest of Gertrude Stein, 1947.

Sketch of Idol and Fruit Tray *by Max Pechstein (1881–1955), American expressionist. Every part is of equal importance. Lines and forms of figure, tray, pieces of fruit, tablecloth, and curtain cross (or intermesh with) each other. There's a diversity of shapes, with the shadows enhancing the objects.*

Sketch of Hornby Castle *by Joseph Mallord William Turner (1775–1851). The unevenly wavy lines of the hills and nearby land, the rows of trees, the off-centered position of the castle, and the alternating masses of lights and shadows combine to form a most satisfying view.*

already evident in some of the panels Michelangelo painted on the ceiling of the Sistine Chapel. As I've explained before, asymmetry offers a vast number of possibilities. This system is valid in all subjects and all styles. Twentieth-century artists, such as Max Pechstein and Bernard Buffet, employ it in their still lifes, just as Netherlands artists did in the seventeenth century. You'll see it in landscapes and other subjects by artists of the most diverse temperaments and periods, from sixteenth-century Pieter Bruegel the Elder, through Joseph Mallord William Turner in the early nineteenth century, Georges Seurat in the late nineteenth century, and Picasso of our own era.

Even single portraits and figures are composed in this off-centered fashion, as in *At the Opera* (Museum of Fine Arts, Boston) by Mary Cassatt (1884–1926), the portrait of *Mme. Camille d'Avouille* by James Abbott McNeill Whistler (1834–1903), Picasso's portrait of *Gertrude Stein* (The Metropolitan Museum of Art). Cityscapes by Canaletto (1697–1768), as well as by Maurice Utrillo (1853–1955), have the same basic idea.

Circular or spiral composition

Certain paintings may appear to be confused, as they have no central figure and no outstanding group or object in any part of the composition, yet they are recognizable, and perhaps most intriguing subjects. What happens in the best of such paintings is that the eye of the viewer is carried around and around, and all over the picture, and, eventually, discovers that there's composition in the work. One of the finest of these paintings is *The Wedding Dance* (Detroit Institute of Arts) by the Flemish master, Pieter Bruegel, or Breughel, the Elder (1525?–1569). The organization of the lines and forms in this work is the same as the system in the kind of dancing it represents. The peasants dance with abandon, but not without rhythm and pattern. They swirl in a snake dance, winding around several trees, in a continuous line (P. 46).

Pyramidal composition

Pyramidal composition is found in Renaissance and Baroque, as well as in present-day art. The pyramid is a geometric form with triangular sides, and it was the supreme achievement of Egyptian architecture. Probably few people realize that the

pyramid is so impressive because it's a complete entity. You can place a cone or a pyramid on top of a cube or a prism. A globe will roll away if you push it, or let it go; it has no solid base, no top, no sides. Even a cone, which resembles the pyramid, is vague, as it has no sides. The pyramid is so solid that you never have a feeling that it might topple over. And you cannot add anything to it.

Pyramidal composition has something of this solidity, this feeling of completeness. Of course, in a picture, it's really just a triangle in shape, but in a three dimensional painting you can see a pyramid. Many paintings have such pyramidal groups. Look at such widely different works as *Christ Healing the Sick* (often called *The Hundred Guilder Print*) by Rembrandt. Consider Goya's painting, *The Shooting of the Rebels* (*Los Tres de Mayo*, or *May Third*, in the Prado; or *Venus and Adonis*, by Veronese, in the Prado; and another by the same title by Rubens, in the Berlin Museum. Also, a single portrait of *Madame de Pompadour* by Maurice Quentin de La Tour, in the Louvre. Each of these paintings, like hundreds of others, has its main figure or groups in pyramidal forms.

Tones or values in composition

One can hardly overemphasize the fact that value in painting refers to the tonal position of any color between white, the lightest, and black, the darkest color the human eye can perceive. Every color, except white and black, has many shades. The lighter a color, the higher its value. We compare every shade of every hue with a shade of gray between white and black. What is of primary importance to the artist is not merely that a color is blue, red, or green, but what shade of blue, red, or green it is, as related to the gray shades.

Wash drawings in the Renaissance and Baroque

Artists of the Renaissance and the Baroque had to make sketches of the murals and easel paintings commissioned by their patrons. The artists found that pen-and-ink drawings, executed with quill pens dipped into sepia, the brownish excretion of cuttlefish, weren't sufficiently clear unless they were shaded with washes made by diluting the sepia and applying it with brushes.

These wash drawings, rendering the tones of the planned paintings in shades of brown, gave

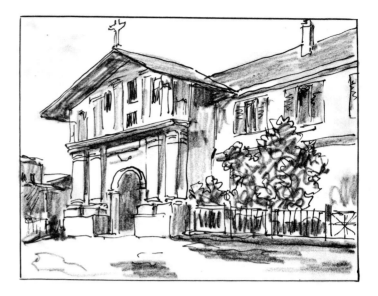

Sketch of Church in Francisco, California *by Maurice Utrillo (1883–1955). This painting was probably done from a photograph or a picture postcard (his usual method) and is a good example of how to place a fairly large building on the support. No line goes into a corner of the canvas; sizes, masses are varied; verticals and slanting lines are interrupted by round forms and trees.*

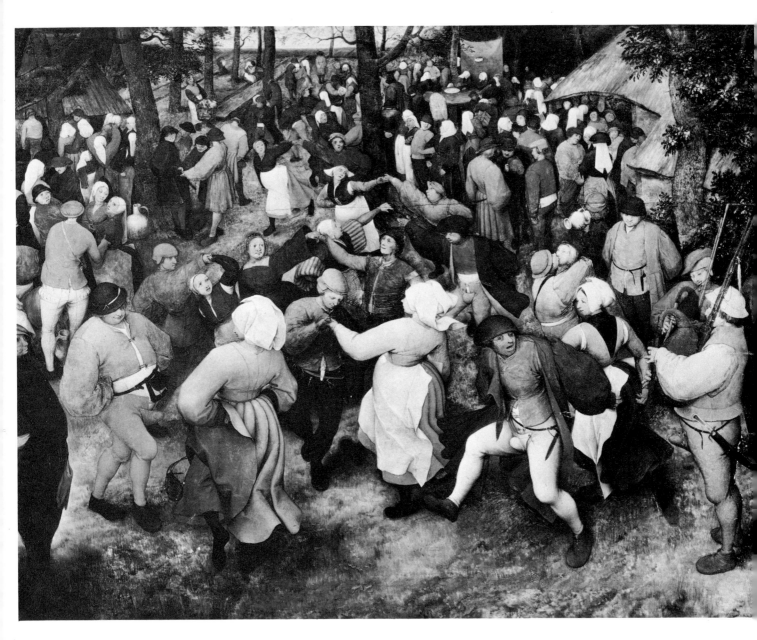

(Above) **The Wedding Dance** by Pieter Bruegel (or Breughel) the Elder (1525?–1569), Flemish artist. At first glance, the picture looks like a snapshot. A little scrutiny, however, reveals the typical baroque asymmetry. The peasants dance with abandon, yet in a cohesive, meandering, chainlike fashion, around and between several trees. This is the kind of over-all composition in which there's no outstanding central attraction (see the diagram of the action of this picture to the left). Collection The Detroit Institute of Arts.

Pyramidal composition was practiced by Renaissance and Baroque artists, as well as by modern painters. (Left) In Christ Healing the Sick by Rembrandt, we see this pyramidal composition in addition to the usual baroque slanting, or curving, asymmetrical lines. As a matter of fact, several of the groups of people can be fitted into several pyramidal shapes. (Right) The same pyramidal composition prevails in The Shooting of the Rebels (the Prado), called Los Tres de Mayo in Spanish, by Francisco José de Goya y Lucientes (1746–1828).

(Left) The figures in the sketch of the Renaissance painting Venus and Adonis by Veronese (the Prado) also fit into a pyramid. (Right) And so do the figures in a painting of the same title by Rubens (Berlin). The two pictures have the same ingredients, so to speak, except for the swans Rubens added to his scene. Yet the difference between Renaissance symmetry and Baroque asymmetry is obvious.

A fine portrait of Madame de Pompadour *by Maurice Quentin de La Tour (1704–1788) shows the same pyramidal form that was illustrated in the preceding pictures.*

a good idea of the finished work. But the tones also helped the artist see his own work better than in an outline drawing. He realized that where lighter washes looked right, he'd have to use lighter shades of colors; and whatever looked good when dark in the sketch had to be dark in the finished painting as well. In a symmetrical approach, the tonal values had to be balanced left and right; in an off-centered composition, the tonal values had to enhance the asymmetrical forms.

Color in composition

The artist has to find out what color and what shade will be the best for a particular spot in his painting. We think that brown is darker than blue, purple is darker than green, and so forth. But it isn't as simple as this. A certain shade of brown may be as light as a yellow; a certain shade of green may be darker than pink. A serious problem in color, the change in hues due to atmospheric conditions and distance, wasn't really solved until the impressionists began to study color effects. It took centuries for Western artists to discover that objects in the far distance are bluish in color.

Colors have lives of their own

Leonardo da Vinci, a universal genius, seems to have been the first to consider what colors might be able to do, but he arrived at no conclusion. Josef Albers, and many other present-day artists, have found that colors alone in purely geometric shapes can become fascinating pictures. As you gaze at some of these paintings, certain sections appear to move, to come forward, or to recede.

A whole school of Op (optical) art has sprung up on the basis of visual illusions which can be constructed, painted, mechanically operated, merely by putting certain hues next to each other, in a vast number of combinations. Whether a precision work of Op art is comparable in esthetic value to a painting by Rembrandt, Cézanne, or Whistler is a question a sensible man will hardly try to answer at present. Suffice it to say that artists have to consider color from every angle.

Lights and darks

The values of colors include lights and darks, of course, but lights and darks can be manipulated

as a special segment of painting. One of the most striking examples is Michelangelo Amerighi Caravaggio (1569–1608), who used very dark shadows to underscore illuminated spots. He was the leader of what we call the Mannerist style, which resulted from an over-accentuation and academization of High Renaissance ideals. Mannerism, in any field, is a lack of sincerity, a superficiality, and we think of Mannerist artists as superficial. But the greatest colorists, such as Giorgione (Giorgio di Castelfranco, 1478?–1511), Titian (1477–1576), and Tintoretto (1518–1594), took full advantage of lights and shadows. Rembrandt began to use strong shadows and mysterious lights at an early age, and he had many followers in the Netherlands. Georges Rouault, one of the best-known modern artists, employed very strong darks against brilliant hues in his expressionist paintings of great emotional power.

Homage to the Square: Silent Hall by Josef Albers (1961), oil on composition board 40" x 40". *Albers has proven that colors can create the illusion of space and/or motion, when properly arranged. His severely geometric patterns often give a sense of depth, as in this case, when one might imagine oneself to be in a dark, empty, silent hall. Composition in geometric works is often, but not always, symmetrical.* The Museum of Modern Art, New York. Dr. and Mrs. Frank Stanton Fund.

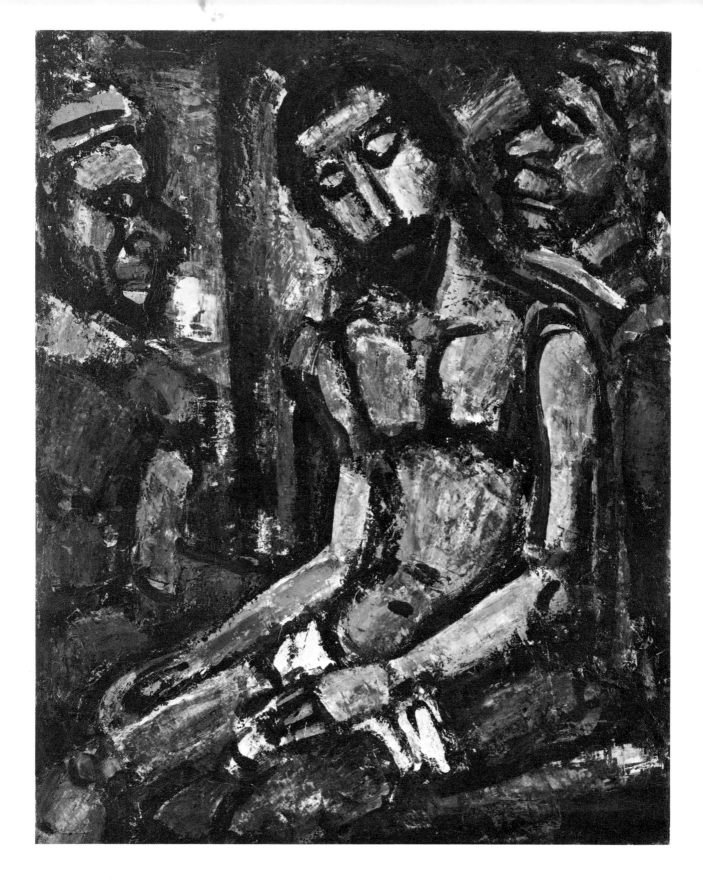

Christ Mocked by Soldiers by Georges Rouault (1871–1958), oil on canvas 36¼″ x 28½″, painted in 1932. Originally a maker of stained-glass windows, Rouault was accustomed to strong contrasts between dark outlines and glowing colors. The darks give his paintings a very powerful linear composition. Christ, the main figure, fits into the shape of the canvas. The soldiers, one in each corner, avoid symmetry, as they're on slightly different levels and the heads are tilted in different directions. Collection The Museum of Modern Art, New York.

5
Psychology in Composition

Most of us may be unaware of the effect of psychological factors, because we take things for granted. We like certain foods and colors, while others make us sick. In many, if not all, instances, our likes and dislikes are based on childhood memories or training. Others are due to later, probably accidental, pleasant or unpleasant experiences. We have perfectly simple explanations for many psychological matters, but explanations seldom cure the effects.

Psychology of size

It's impossible to judge the size of a figure or object unless you can compare it with an object of a size you know for sure. A very tiny person looks just like a giant, if he is well proportioned, unless you place him next to a person of normal size. A person with a comparatively large head looks short; a person with a comparatively small head looks tall, regardless of the person's real height.

What comparative sizes do can best be seen in certain motion pictures. *Alice in Wonderland*, for example, shows Alice as very tall and very small. The actress doesn't change in size, but the furniture and furnishings around her change. She looks huge next to a small chair, and vice versa.

You'd hardly believe that royal palms can grow to a height of 120 feet. Seeing such palms from a distance, all by themselves, you'd think they are 30 or 40 feet tall. Seeing them against houses, however, you realize how tall they really are.

You can deliberately utilize psychological factors in your art. You can make an object appear tall by painting it as tall as your entire support and depicting some small objects next to it, even if your support is only a sheet of notepaper. Leave a lot of space above an object, and it will appear to be small, even if it's of mural size.

A head covering the whole support looks tremendously large, even monstrous; a head with much empty space above it and on its sides appears to be small. These facts are of extreme importance in portraiture. You might make a petite girl look tall by placing the head too high, a basketball player look small by placing the head too low.

Psychology of loneliness

A human being, an animal, a tree, or a flower can appear to be lonesome, abandoned, if placed in the left half of the support, facing or bending toward the left edge; or if placed in the right-hand half, facing or turning to the right. If you wish to suggest loneliness, this is the right composition. Art students are seldom aware of such psychological facts, and they almost invariably place the head or object in the very center of the support.

(Left) A chair is a chair. (Right) A very small girl, or a a very big chair.

You cannot tell the height of the palms on the left, but you can tell that the palms on the right are very tall by looking at the house behind them.

Psychology of flying or sinking

An object placed very high appears to be flying. Naturally, a bird, an airplane, a kite, or an angel ought to look like that, but don't place ordinary human beings, or cars, books, or fruit too high on your support. An object painted too low appears to be sinking or drowning. You might paint a swimmer, a diver, or a sinking boat this way, but objects which have nothing to do with drowning will seem to be rolling or falling out of the picture.

Walking in and out

Any figure very close to the right or left edge of the support, facing inward, appears to be just coming or sliding into the picture. A figure with about half or one-third of his back seen close to the right or left of the support gives the impression of just walking out of the picture. Such depictions may be quite valid when you're painting marching soldiers or any parade, in which some people are literally walking out of, others just coming into, your circle of vision, which is the support of your painting. In this case, too, think of the purpose. Don't paint a person accidentally coming in, or going out.

The feeling of walking in or walking out isn't restricted to humans and animals. Many articles have front and rear sections (such as spouts and handles), and practically any article cut in half may give the impression of not really belonging in the picture.

Cornering an object

If you start your painting impetuously, and a great many people do just that, you may find that there isn't enough room for an object. So you push the object into a corner; when framed, the object will seem stuck there by accident. This is especially ludicrous in a figure, when the back of a head, a hand, or a foot fits right into a corner. The inescapable response of the onlookers is that this cannot be a deliberate idea. Even if you want to depict a cornered animal in a chase, you'd have to work within a pictorial context, and not actually paint the animal in the corner of the picture frame.

Cutting things off

Professional artists as well as students make the mistake of not preparing a layout, but relying on their eyes and skill. As a result, a figure may have its fingers, elbow, some of its toes, the top or back of its head cut off, as there's no room on that side, even though there's plenty to spare on the opposite side. Beginners often think that this doesn't matter, as long as the painting is well done otherwise. But this is incorrect thinking. A work of art has to be equally good from every viewpoint.

I recall a very sad episode, which happened quite a few years ago. A well-known and extremely well-liked artist painted a lifesize nude sitting on a chair in the center of a very large canvas. She was crossing her legs, the left leg almost horizontally across her right knee, going to the left edge of the canvas, but not quite making it. A little over an inch of her toes was cut off by the edge of the support, while the right side of the canvas was absolutely empty, just a dark brownish green color. Had the artist made a good layout, he could have easily moved the nude a few inches to the right. The whole left foot would have been included, and the right side of the picture would not have looked like a huge emptiness.

The nude glowed with lovely, silvery flesh tones. It was a real beauty. An art committee was considering it for a very important purchase award, which would have been the full amount of the price the artist wanted for the painting; the work would have been given to one of America's leading art museums. The committee regretfully, but flatly, refused to purchase the painting because of those slightly cut-off toes.

What about objects?

What's true for figures is true for all objects. Don't cut a tree, an apple, a book, or anything else in half accidentally because you've left no room for it. The table or floor on which the objects are displayed may well go out of the picture, left and right, just as mountains and sky continue far beyond the support, but the objects which constitute your theme should all be included in full, except when the artist has a special reason for dismissing some sections. In these cases, the composition must clearly indicate that the cutting off is deliberate, not haphazard. This is easy to prove by having the right spacing. If there's plenty of empty space on the opposite side of the cutoff, everyone will consider it an error of judgment, rather than a conscious decision on the part of the artist.

For example, you may paint the top of a container with a big bouquet of flowers, provided that you leave just a normal space above the flowers. If you have a huge space above the bouquet, the viewer will take it for granted that you made a mistake. It would be an equal mistake to paint the entire tall container, and cut off the tops of a few flowers in the floral arrangement.

Psychology of color composition

Colors affect most people, as we associate certain colors with ideas from our earliest childhood. Black or other dark colors are depressing, sad, even funereal; very bright hues are cheerful, but often confusing or irritating. Monochrome (that is, various shades of the same color, usually brown or gray tones) is often drab. Very pale hues create the feeling that the picture has been exposed to sunlight and lost its real colors. Such general psychological reactions should be carefully weighed by the artist.

Use the proper colors

If you depict a funeral (and I've seen that done very beautifully), work in subdued colors, even if the funeral takes place on a sunny day. For a carnival, work in brilliant colors. A night scene is bound to be dark, but needn't be jet black. The sky can be a pleasing dark blue, with a blue-green bottom section; buildings may be slightly illuminated; windows may reflect bright colors, or be lit up from the inside. There can be bright spots even on a lonely road. A stormy scene requires dark hues in sky and land, but not necessarily without a spot of light lurking behind the clouds in one spot, or a comparatively bright little place on earth.

But whatever you paint, use the right colors for your subject. I remember a woman who attended a funeral in early February wearing her new Easter hat, full of bright flowers—the latest fashion at the time. She showed it to everybody, too. In a work of art, such a discrepancy may look like a very bad joke or, even worse, an ill-conceived piece of sarcasm indulged in by the artist.

Fundamental principles in composition

Strange as it may sound, the principles are negative, rather than positive. I'd be the last person to tell you that you have to follow certain specific rules and formulas in order to achieve a great painting. But I can and will tell you what not to do, on the basis of all the psychological factors I've explained. The "don'ts" refer to what we never find in the works of great, or at least outstanding, artists. These are the "don'ts", the compositional errors too many artists and art students make; the errors you should avoid.

Psychological illusions are illustrated in the following examples.

Subject is too short.

Subject looks too tall.

Subject is too high.

Subject is too low.

Subject seems to be flying off.

Subject seems to be sinking.

Subject is just coming in.

Subject is just leaving.

Subject seems to be cornered.

Too close to edge.

Subject is closed in tight.

Identical halves.

Subject is sliding downhill.

Subject is climbing uphill.

Subject is too big.

Subject is too small.

Mechanical symmetry.

Too much subject on one side.

Subject much too crowded.

Feeling of loneliness.

Monotonous repetition.

Over-all pattern.

In these examples, we see how poor placement of mass results in lopsided composition.

Subject too much on one side.

Subject too much on top.

Subject too much on bottom.

Subject is all in one half of support.

In these three examples, little bits of the main subject have been accidentally cut off because of poor composition.

Twenty-four "don'ts"

1. Don't make your main subject too small, unless you want it to look small for some special reason, such as in depicting a dwarf.

2. Don't make your main subject too large, unless you wish to depict a giant.

3. Don't place the main subject too high on the support, leaving a lot of empty space below.

4. Don't place your main subject too low, leaving much empty space above.

5. Don't place the subject so that its top is cut off by the top edge of the support, as this creates the illusion that it's flying out of the picture.

6. Don't place the subject so low that it looks as if it were sinking, drowning, or falling.

7. Don't place the subject halfway inside one edge so that it appears to come into the picture, except when this effect is just what you want.

8. Don't place the subject halfway inside one edge in such a fashion that it appears to be walking out of the picture, unless this is the effect you want.

9. Don't place your subject on a slope, facing inward, so that it seems to be sliding downhill.

10. Don't place the subject on a slanting line so that it appears to be going uphill, with the front (or nose) towards the upper end. In this, as in the preceding instance, you might want to show someone slaloming downhill or climbing up a mountainside, in which case the effect is, of course, correct.

11. Don't place the subject in a corner. Such a composition invariably looks absurd.

12. Don't let your subject touch all four corners, or even two or three corners of the support. Such a composition creates a sense of the subject's being completely hemmed in.

13. Don't make your subject half and half, vertically or horizontally, having just about the same amount of objects in one half as in the other. Such a composition reminds people of playing cards, which look the same upside-down as rightside-up.

14. Don't place narrow forms parallel to the edge —any edge—of the support; such a compositional error makes the frame look wider on the side where the parallel form is.

15. Don't make the picture look like an over-all design by carrying the subject practically to the edges all around.

16. Don't make the subject too small, with a lot of empty space all around.

17. Don't distribute your forms in an exactly symmetrical manner, even if you do use symmetry. There must be some variety.

18. Don't place too much subject matter in one half, with just a small amount of forms in the other half.

19. Don't try to overwhelm the viewer by covering the whole support with massive forms.

20. Don't place a main item standing all by itself. This suggests loneliness, abandonment, be the subject a man, a woman, a child, a tree, or a rock. Such composition is all right only if you want to show loneliness as your main theme.

21. Don't repeat the same forms mechanically, whether they're rocks, trees, clouds, or human figures.

22. Don't cover the whole support with similar forms, unless you're doing a wallpaper design.

23. Don't push your subject too far to any side of the support, leaving unnecessary space on the opposite side.

24. Don't cut off little corners of figures or objects just because you've left no room for them; the result will look like what it is, an accident.

Does this sound like a lot?

You might ask if there are really that many rules. Is it possible to remember all these? The rules are based on psychological factors which haven't changed in the course of thousands of years, and aren't likely to change in the future. They all refer to one fundamental principle: don't make mistakes which are invariably mistakes to the experienced, discriminating viewer.

Recently, during the winter Olympics, I watched the figure skating competition on TV. One couple appeared on the way to at least one of the medals, when the man fell, and, a minute later, the woman fell. No matter how beautifully they had skated before and after the fall, they were out. They're still wonderful figure skaters, but not champions.

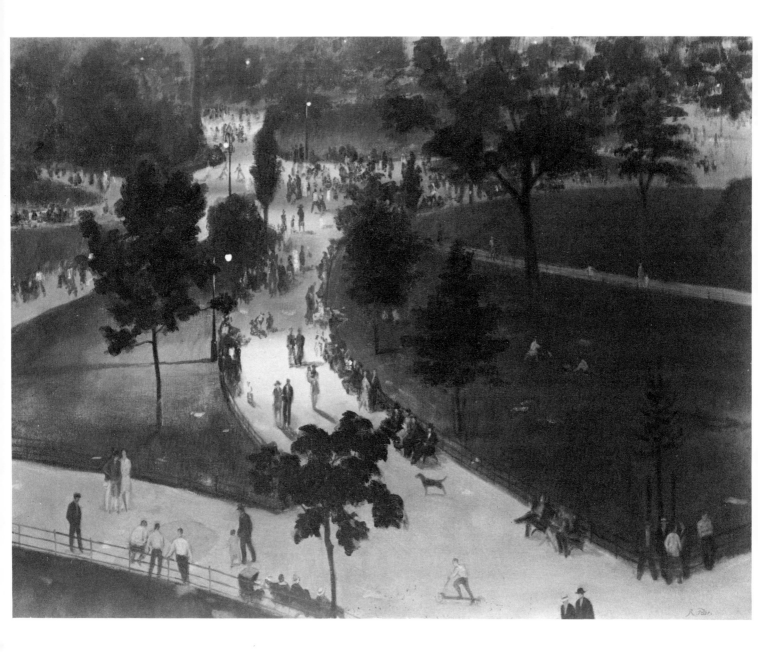

(Above) **Washington Square at Dusk,** oil on canvas 25" x 33", was painted by the author in a realistic style from his studio window. The picture was framed and hung. One afternoon, a friend, looking at it from a reclining position, exclaimed, "There's a Chinaman in your picture!" Figures walking or standing in the patch of light cast by the electric lamp created the illusion of eyes, nose, mouth, in a face with high cheekbones. (To the left, we see the painting after the artist eliminated some figures and changed others in order to rid the picture of the disturbing optical illusion described above.)

6
Optical Illusions in Composition

The world is full of optical illusions, some pleasant, some unpleasant, some disturbing or confusing. In the pictorial arts, you might ruin an otherwise good work through inadvertent optical illusions. You might also create beauty with such illusions. One thing is sure, and don't let anyone kid you about this: art has to be deliberate. If it's an accident, it isn't art. A fortuitous optical illusion won't turn you into an artist, just as winning top prize in a lottery is no sign of financial wizardry. It's just plain luck.

I recall a number of amateurs who happened to turn out one single optically clever or unusual painting, got into some major exhibition, and even won awards, but never again managed to paint a picture that could be accepted by a jury of selection.

Things growing from wrong places

Photographs often show odd scenes, as if a small house were sitting on top of a big building, or a tree were growing out of a rock, or standing on the back of a woman sweeping a golf course. One of the most amusing optical illusions was in a photograph showing a freighter passing the Eisenhower Lock in Massena, N.Y. The large vessel appeared to ride on top of an embankment, because it was taken from an angle which didn't reveal any part of the water. Such a photograph may well be a deliberate trick on the part of the photographer, but can hardly be acceptable in a serious work of art.

National Geographic magazine carried a picture of a sailboat near Rio de Janeiro. The boat seems to be wedged in between two big rocks, and the sea appears to be higher on the right than on the left. In a photograph of the Summer Palace in Peking, a small Chinese house on the shore seems to be the top structure of a pleasure boat on the lake. A camera cannot change such accidental combinations, but a painter can, and should.

The face in the park

Many years ago, I painted a corner of Washington Square, New York City, from my studio window. It was dusk, when the street lights were just going on, but one could still see everything as if under a gray-blue veil. I did a very realistic job, framed and hung the picture, and everyone liked it. One afternoon, a friend of mine, reclining on a sofa, looked at the painting and suddenly exclaimed: "There's a Chinaman in your picture!" The figures in my painting were all very small, without any facial details, so that none of them could look Chinese or anything else. "Oh, I'm not speaking of the little figures," said my friend. "I see a big

These sketches from photographs show examples of optical illusions.

(Left) Cargo vessel passing through the Eisenhower Lock, Massena, N.Y., appears to be sitting on an overpass. (Right) The pleasure boat rowed by a man in Venetian gondoliere fashion seems to have an ornate pavilion on its top. Actually, the pavilion is on the shore of the lake of the Summer Palace in Peking.

(Left) The large tree on the right appears to be standing on a diving platform. The illusion is due to the reflections in the water. (Right) A sailboat off Rio de Janeiro looks as if she'd been caught between two big rocks. And the water is on a higher level, visually, on the right than on the left.

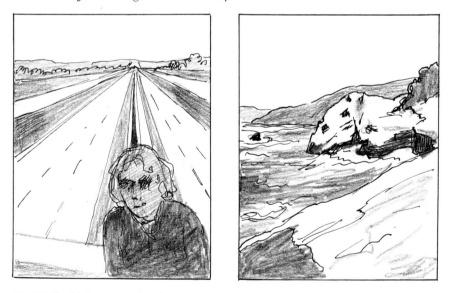

(Left) The highway is, visually, growing out of a woman's head and shoulders. (Right) In a color advertisement of Oregon State as a vacation resort, rock formations resemble the head or skull of a prehistoric beast.

Chinese face in the center, horizontally." She got up and pointed out the shape. The grassy sections, the winding road, the light of the lamp reflected in it, created a large head shape, with high cheekbones. The small figures happened to be so situated that some resembled the eyes, others the nose and mouth.

Once I had seen the face, I couldn't help seeing it whenever I glanced at my picture. Eventually, I changed the figures and eliminated the fantastic head. More recently, I looked at a beautiful painting by Thomas Cole (1801–1848), one of the leaders of the Hudson River school. The painting, *Wolf in the Glen* (Wadsworth Atheneum), has a marvelous composition which goes around and around, guiding your eyes from spot to spot. Every detail is executed with the skill characteristic of Cole. The scene is rustic, natural, but idealized like all paintings of the Hudson River school. Yet, if you look at it suddenly, you see a huge, turbaned head rising from the rocks. Eye, eyebrow, nose, mouth, all's there. The face isn't as clear in the actual colors as in black and white, but there it is, whether you like it or not.

Things jump out of the picture

Certain portions of a painting seem to be jumping out of the picture, without any pictorial reason for such an effect. This problem is usually caused by the wrong color, or the wrong value. A toning-down of brilliant hues in the distance is normally enough to eliminate this jumping-out effect. It's also possible that the bright colors are alright, but the shadows next to them are too dark. If, however, you want an item to jump out of the picture, all you have to do is to brighten it, or to make the shadows next to it deeper.

Holes in the picture

A small part of your picture painted too dark, at least in comparison with whatever is around it, causes the spot to look like a hole or a gash. This may be a desirable effect—if you're painting the entrance to a cave. If the effect is accidental, make the dark section somewhat lighter, or its surroundings slightly darker, and soften the edges of the dark spot.

Occasionally, nature has a configuration which looks odd even in a photograph. In a color adver-

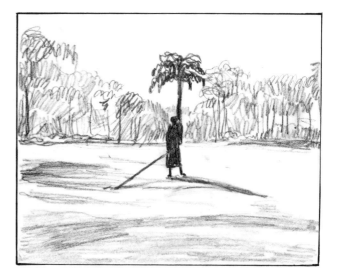

In this optical illusion, a palm tree grows out of the shoulder of a woman sweeping a golf course.

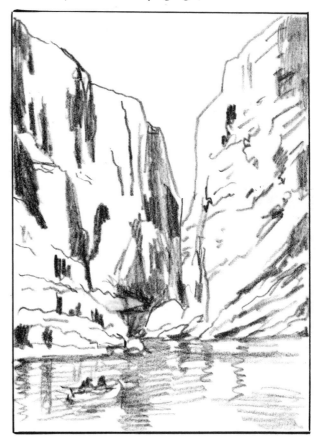

Nature and photographer collaborated in producing this perfect picture in the October 1969 issue of Travel *magazine. You couldn't imagine anything more beautifully composed: the huge rock formations are similar, but different in line; the ground underneath the steep mountains is rhythmically the same, but uneven; the reflections carry the colors into the lower part of the picture; the boat happens to be in the right spot. In another minute, it would have been either in the center or out of the picture.*

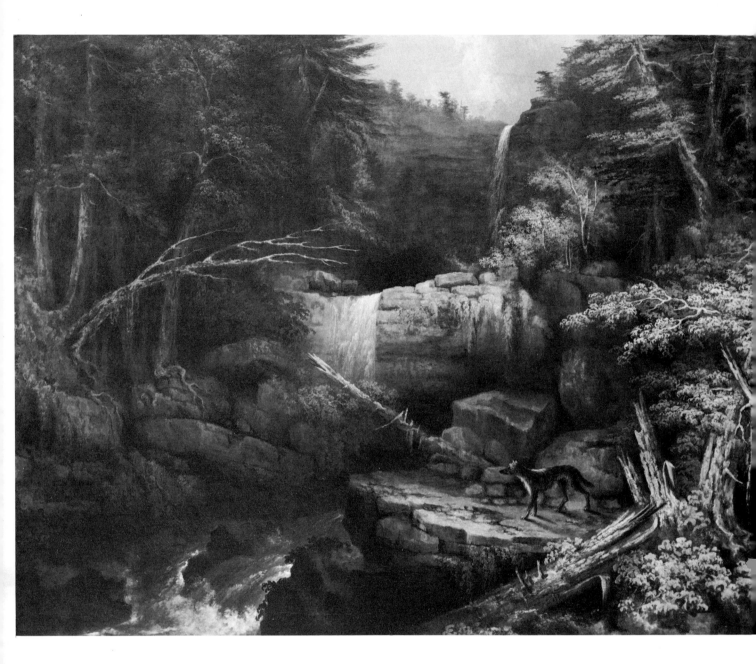

(Above) **Wolf in the Glen** by Thomas Cole, N.A. (1801–1848), one of the leaders of the Hudson River school. Artists of this group depicted rustic scenes in absolute, yet glorified, realism. This painting is an outstanding example of an over-all composition in which the eye goes from one section to the other as it would in reality. Nothing is accidental, despite the photographic details. But if you look at the picture suddenly, you can hardly help discerning a huge, turbaned head near the upper right-hand corner. (See a tracing of this face to the left. Eyes, pugnose, mouth, chin, forehead, and turban are all there!) Collection The Wadsworth Atheneum, Hartford, Connecticut.

tisement of Oregon State, a land formation jutting into the Pacific Ocean looks like the head of a prehistoric beast. The chances are that this appearance is much less noticeable in a different light; that is, when the sun is in another part of the sky.

Optical illusions in figures

Foreshortening plays tricks on your eyes. An arm or a wrist may seem to be growing out of the model's stomach; an upper arm may appear to be a stump.

A talented and experienced, but completely realistic art student of mine was painting a two-figure composition. One girl was sitting on a bench, her feet on the platform; the other girl was sitting on her own heels, on the same platform, leaning on her right arm. This bare arm appeared to be a third leg of the girl on the bench. The painting was true to the actual image the student saw, but, as I pointed out to him, the result looked incomprehensible. All he had to do was to move a few inches to the side, and he would have seen a space between the two legs of one girl, and the arm of the other.

What the shape of the support can do

Most supports are oblong; that is, longer or wider in one direction than in the other. Square supports are available, to be sure, and so are oval and circular ones, although the roundish shapes are considered old-fashioned, Victorian. (They're also expensive to mat and to frame.)

The normal oblong support may be used vertically or horizontally, and here's where inexperienced artists and students make their initial mistakes: there's a tall object in what they're trying to paint, such as a bottle in a still life, or a tree in the scenery, so, presto, they place the support on the easel vertically.

Look at the total effect, not one single item. Very often, the view is wider than high, even though there's a tall object in it, so that a horizontal shape would give you a better chance for a good composition. Try the support in both directions before deciding which way you're going to use it. Even a very high mountain peak may look taller on a horizontal support, which allows you to show a large enough section of the mountain range to indicate the height of the peak. On a

In this sketch, the whitewashed house and part of the road are so bright that they resemble pieces of white paper stuck onto the picture. The values are all wrong. A little toning down would help.

Here, the trees and a part of the road are so dark that they look like holes or gashes in the picture. Darks, as well as whites, can be toned down.

Optical illusions in figures are illustrated in the following examples.

(1) The model seems to have no lower right leg. (2) A student's head appears between model's arm and torso. (3) This model's right thigh looks like part of the drapery. (4) And from another angle, the same woman has no right leg—her right foot becomes part of the drapery on the stool.

(Above) This girl has, visually, a stump instead of a right arm. (Below) The naked arm of one girl sitting on a platform happens to be right next to the naked legs of another girl, as if she had three legs.

The left leg of this woman looks much more slender than her right leg.

vertical support, you can paint the mountain much taller, of course, but there will be nothing with which to compare its height.

Useful optical illusion

Chic women are especially aware of certain optical illusions in reference to the way they dress. For instance, a short, plump woman should never wear a garment with horizontal stripes, as it only makes her look fatter. A tall woman looks less forbidding in height wearing a horizontally striped dress. Similarly, large floral designs on a dress make a short woman appear to be even shorter and heavier, while the same kind of pattern looks just right on a tall, slender woman.

A most interesting application of optical tricks was recently used by Eastern Airlines, advertising "Wing & Water & the Caribbean." In the advertisement, the front half of a graceful, modern ship merged with the rear half of a jet. The white hull of the ship with its blue stripes flowed into the white body of the plane with its blue stripes, forming a strange but beautiful single conveyance.

Optical illusions can be utilized, as in this clever advertisement by Eastern Airlines: "The Wings of Man: Wing & Water & the Caribbean Sun." The forward half of a graceful pleasure ship is combined with the rear half of a jet plane, the white color, and the blue stripes of both merging into one fantastic conveyance.

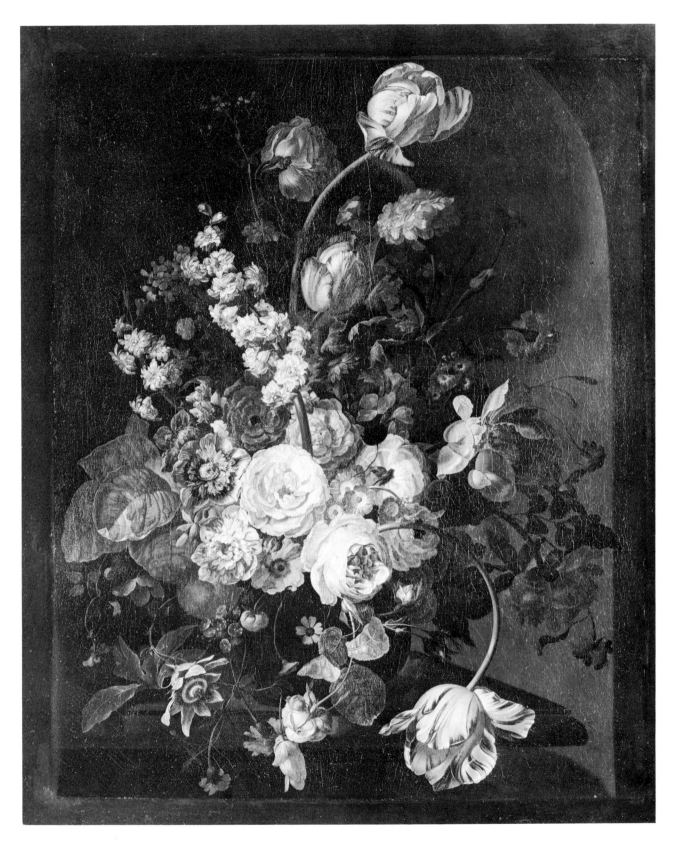

Flowers by Rachel Ruysch (1664–1750), oil on canvas 35⅝" x 29¾". *Holland had several women artists before other countries gave the distaff side an opportunity to join the ever-growing ranks of artists. This flower arrangement is very pleasing, off-centered, leaving plenty of space all around instead of trying to cover the whole canvas. A niche such as this is often found in these still lifes. Lights and shadows are well utilized, drawing the eye into and around the composition.* The Metropolitan Museum of Art, New York. Purchase, 1871.

7
Composition in Still Life

The term still life is rather odd. It's the same as the German *still leben*. The French call it *nature morte*; it's *natura morta* in Italian, and *naturaleza muerta* in Spanish. They all mean *dead nature*. True enough, the subject contains only items which are still, that is, soundless, motionless, but are they all dead? You might paint dead fish or fowl, hares or deer (such items were most popular in the eighteenth and nineteenth centuries), but what about fruit, potted plants or flowers and vegetables? Are they dead? On the other hand, books, silverware, and glassware are neither nature nor dead.

None of these Western languages has a term which would express the vast scope of the subject. The realm of still life includes practically everything and anything you can find in your home, attic, closets, or basement, provided that you can lift it and arrange it into a pictorial composition. But the term *still life* is generally understood by laymen as well as artists, and we have no reason for changing it—especially as nobody has come up with a better name.

Advantages of still life

Still life is available anywhere, anytime. Edible ingredients can be consumed when the painting is finished. (This was an important consideration in a period when artists were supposed to be eccentric and starving Bohemians); other objects can be returned to their normal places. A still life can be set up on a small table; it can be arranged and rearranged to your heart's content. You have a wide selection of forms, sizes, materials, and colors; and you can depict them life size. You can study them better, from a closer viewpoint, than scenery or figures. Not everyone likes still lifes— but nobody likes everything, and there's nothing everyone likes.

How to select still life subjects

Taste is a very personal matter, although we can usually tell if something is in good taste or not, according to prevailing standards. In my experience, the vast majority of art students, old or young, male or female, think that a still life has to include as large a number of items as they can possibly assemble, and that the objects have to be literally piled one on top of the other. Then they try to paint it all on a 16″ x 20″ support, on which an orange will be about as big as a walnut. This, of course, is nonsensical. You wouldn't pile everything together in your home, so why do it in a painting? *Simplicity* is the key word.

It isn't the number that counts

Fifteen items won't make a better still life than five or six, merely because the number is higher. Make an attractive or interesting arrangement consisting of items which go together without being ridiculous, unless you're trying to create a surrealist picture with Freudian elements.

It isn't a bad idea to follow the preaching of Paul Cézanne (1839–1906), even if I don't advise you to imitate his style. Cézanne believed in serious composition. He spent hours, and days, arranging his now famous apples, oranges, and other still life subjects so that they would look natural, yet interesting.

Cézanne was especially keen on a diversity of forms: round fruit, oval tray, horizontal table, slanting shelf, crumpled tablecloth with diagonal lines, and so on. He also considered colors: there would be a green apple among the red ones, cool colors against warm ones. Nothing in his still lifes was accidental, yet his work was far from photographic; his brushstrokes were bold, even shockingly novel. He repainted his backgrounds five or six times, until he thought he had the right color and value to bring out his objects and at the same time to harmonize with them.

Let's look at fruit and vegetables

Fruit and vegetables may be bought all year round. Although Cézanne proved the feasibility of painting a whole batch of the same kind of fruit, your best bet is to select a variety of shapes, sizes, and colors, but not all different ones, as if you wanted to show the world that you could paint anything with equal ease. Place fruit or vegetables on plates, in bowls or baskets, or spread them out on the paper bag in which you brought them home. Make sure they aren't all facing or standing in the same direction like soldiers at attention: one item ought to cover another here and there. A taller object makes a nice break in sizes.

Location of fruit and vegetables

Fruit and vegetables don't hang in midair, the way many students paint them, by surrounding all the items with one solid background. You normally place these pieces of fruit or vegetables on a table, which may show the grain of wood, or which is covered with a tablecloth or oil cloth. It may be a shiny formica top, or a varnished, waxed tabletop in which the objects are reflected with more or less clarity.

Keep all items within the picture

Don't compress the subject by bunching every piece close to the other in order to get them all in the picture, but don't scatter them around as if they had been dropped there by accident, either. Use only those items you can reasonably put into one picture, and don't cut off the tip of a banana, or a little bit of a carrot, just because you made a mistake and didn't leave enough room for it.

In general, bear in mind what I said about basic psychological errors in "Psychology in Composition." The "don'ts" refer to every subject in painting. An apple high up on the support may look like a balloon, or an unidentified flying object; it cannot be an apple. (Only Salvador Dali painted what might be called flying apples in a surrealist picture.) A cabbage too low on the support will look more like a rock than a vegetable. Too many items, covering practically the entire support, will make your picture look like a piece of wallpaper or chintz, cut out and put into a frame.

Consider line, tone, and color

By *line* I don't mean the regular outlines of each object, but the invisible line running across each piece in the composition, tying them together, or at least grouping them together. *Flower Still Life with Cat* by Otto Dix is a good example of linear unity. The cat and the vase of flowers are so designed that they're inseparable in the picture.

Still Life with Artichokes by Bernard Buffet gives an excellent idea of how items may be grouped within lines. Buffet uses outlines in all his work. Here, he places realistic bottles, bowl, and artichokes on a geometrically drawn oblong table, with the slanting lines of a tablecloth breaking up the monotony. A curtain, also sharply outlined with diagonal lines, cuts across and covers the upper right-hand corner of the picture.

You can draw a nicely spiraling line across the unusual glass and the peeled and full lemons in a still life by the seventeenth-century Netherlands artist, Pieter Claesz, while *Basket of Plums and Grapes on a Ledge* by an eighteenth-century Neth-

Sketch of Still Life with Artichokes *by Bernard Buffet. The artist has outlined each item, thus giving a clear linear effect. Horizontal and vertical lines in the table are counterbalanced by roundish forms, and the slanting lines of the curtain in the upper right section. Everything is off-centered.*

Sketch of Flower Still Life with Cat *by Otto Dix shows a diagonal composition in which the lines of the cat flow into the lines of the floral group, with a good difference in textures and forms.*

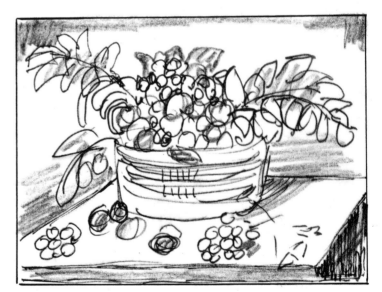

Sketch of Still Life with Lemons *by Pieter Claesz (1627). This has a fine linear connection between the impressive glass goblet, the sliced and peeled lemon, and the full lemon. One can object to the wide dark front edge of the table; a slightly slanting line would have been better.*

Sketch of Basket of Plums and Grapes on a Ledge *by an eighteenth-century Dutch artist is well detailed, but every fruit is round, the table is incorrect in perspective, and the sprigs sticking out of the basket are space-fillers.*

erlands artist is stiff and artificial. The basket is too full; sprigs of foliage stick out left and right just in order to fill the space; other pieces are scattered over the poorly drawn ledge.

Watch tonal qualities: lighter and darker shades, besides actual lights and shadows. Normally, in a still life, articles in the back may not be farther from you than the width of a small table, so that there's little difference in tonal qualities. But if you add a background, you have to subdue its colors; otherwise, it will overpower your still life.

Colors should be as carefully selected as forms. If it's bad to make all items alike in size and shape, it's just as bad to make them all of the same color. On the other hand, it's equally disturbing and irritating to make every piece a different color. It's especially painful to see a still life in which the same few colors alternate regularly—for instance painting a green pear, a red apple, a yellow lemon, a green apple, a red pomegranate, a yellow grapefruit, all in a line. It might be better to place two pieces of fruit of the same hue, but different shapes, next to each other.

Avoid horizontal table line

The average student begins a still life without showing any table or stand. He paints all items, and adds a background all over. This makes the still life look like a stenciled decoration, the way doors of cabinets in the kitchen and children's room used to be prettified a few generations ago. If the student does indicate a table, he invariably draws a horizontal line across the center of the support, and it's difficult to convince him that a table is horizontal only in fact, not in visual appearance, except when you look at it from direct center. From all normal angles, the line of the table goes up or down.

Regardless of perspective, the horizontal line, especially in the center of the support, is not only naive and amateurish, but monotonous as well. It cuts the background into two halves, as if you had a flag with two stripes. A stand is often easier to paint than a table. If it's rectangular, perspective makes it interestingly uneven, like a somewhat distorted diamond shape. If the stand is circular or elliptical, straight lines are completely eliminated. You might place a round doily on a rectangular stand or table or a square tablecloth on a round table for the sake of breaking up the ordinary shape of the table or stand.

I ought to add that experienced artists also face the problem of the table on which a still life is set up, and they try to find a way of making this section of the picture interesting. Occasionally, only one corner, in perspective, is shown. At other times, the near corner is at a slant, thus showing the side of the table, or tablecloth, and this corner is darker than the top. The coloring of the table can also help. Make one side lighter, the other darker, but gradually. Or have shadows cast on it by the objects. Another method is to paint a more or less shiny tabletop, in which the objects are reflected, at least to a certain degree. Your painting needn't look like a TV commercial for a marvelously glossy furniture wax polish, however.

Accessories in fruit and vegetable subjects

It isn't necessary to paint fruit and vegetables alone. You'd normally have something else on the table or stand. Include in your subject anything that doesn't look absurd: gloves, a scarf, a pocketbook, a glass or pitcher of water, a paper bag. Such items, with their different colors, shapes, and textures, contribute to the interest of the picture. Noted modern artists, such as Picasso, Braque, Juan Gris, and many others, painted abstract still lifes in which various materials were carefully indicated. But beware of placing the objects next to each other as if they were on a bric-à-brac shelf.

Let's look at flowers

Flowers are very popular, and some of our foremost modern artists paint them, either as the sole subject, or in combination with figures or interiors. Fresh flowers are available everywhere, and artificial flowers are now so well made that you can hardly tell the difference from a distance, except by the fact that all blooms are the same in size, shape, and color, and so are all leaves. In nature no two flowers and no two leaves, among all the billions, are ever exactly alike. You have to bear this in mind if you work from artificial flowers, and change them a little.

Selection of flowers

Potted plants and flowers have a natural composition; all you can do is to turn them around and

Bad composition is illustrated in the following examples.

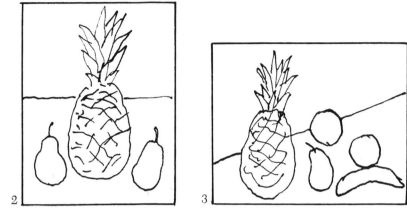

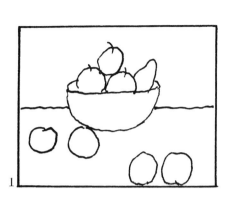

(1) *Table top in center, fruit piled up, almost all alike; those pieces of fruit on the bottom are ready to roll out of the picture.* (2) *Table top again in center; arrangement naively symmetrical.* (3) *Fruit is on a slope, all separate, just filling the space.*

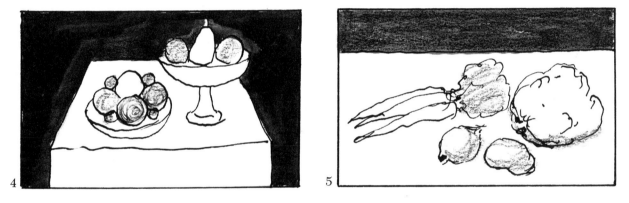

(4) *Subject looks small in the centered position, with poster-like dark background. Fruit too close together; also, piled up like pebbles.* (5) *Vegetables displayed horizontally and individually. Background and table top look like stripes of a flag.*

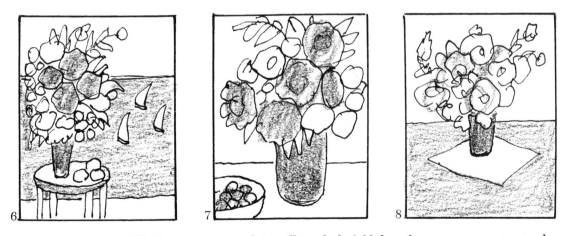

(6) *Flowers too far on left; sailboats look childish, and unnecessary; water stands up straight.* (7) *The floral is too large; the small dish of strawberries, cut off in the corner, is esthetically meaningless.* (8) *Vase is too small, while flowers try to go into the top corners. Table top is too high; tablecloth is too symmetrical.*

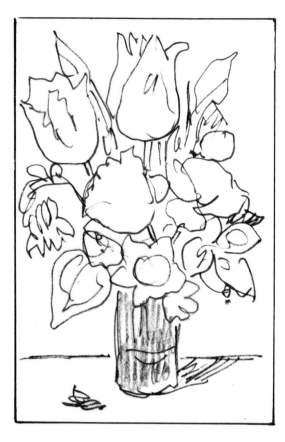

(Above) This diagram of an eighteenth-century Dutch still life in a glass vase makes it clear that the flowers are much too big. They're also too close to the left edge of the support. (Below) A sketch of Roses and other Flowers in an Urn *by Paul Theodor van Brussel (1787) has a superior and more natural composition.*

see which side is the most attractive or satisfying. In bouquets, however, it's up to you to select flowers which go together; or ask a florist to select them for you. It's rather boring to paint a bouquet, no matter how elegant it may be, if it consists of the same species of flowers, and all of the same color. The first step in the composition is to arrange flowers of similar, but slightly different, kinds and hues, and not to make them as absolutely symmetrical as a bridal bouquet.

Containers for flowers

Flowers may be left on the table, perhaps with the original wrapping, usually a piece of green paper, spread open, but that would make a rather flat composition. It's best to place the flowers in a container. You have a wonderful choice here: glass, silver, ceramics, old bottles, pitchers, cans, baskets, bowls in all shapes, sizes, and colors. Select the appropriate one. Don't put American Beauty roses in an old, battered milk can; a small, short-stemmed bunch of violets in a tall vase; tall tulips in a shallow bowl.

Exotic flower arrangements

Largely through Japanese influence, we have come to love special flower arrangements in which containers, flowers, pebbles, certain weeds, and branches, or driftwood, are combined into a sculptural form. Here, too, select ingredients which may be found in the same locality, in the same season, rather than throwing together whatever you can find in and around the house. Once you have a fine floral arrangement, find the best pictorial view of it for your painting.

Consider all the "don'ts"

Placing the flower subject on your support is of vital significance, regardless of how well you might paint individual flowers. Consider all the "don'ts" I listed in "Psychology in Composition." *Don't* let your flowers fly out of the picture, look like a piece of chintz, or sink like a wrecked boat, etc. Adhere to the off-centered composition accepted by most artists since the Baroque, and used for a much longer time in the Orient.

I find that the gravest mistakes of beginners are: *first,* they put the container smack in the center·

of the support; *second,* they paint the flowers to the very edges of the support above the container; *third,* they either make the container too big, and the flowers small, or the flowers huge, and the container tiny; *fourth,* they draw the table line horizontally across the center of the support; *fifth,* they often try to show the near side of the table, also in a horizontal line, thus painting a dark stripe, representing the near side, right above the bottom part of the frame; and *sixth,* they place the whole subject either so high that the bottom third of the picture is empty, or so low that some of the items are sitting on the bottom part of the frame.

Accessories in flower subjects

You might combine flowers with items that you normally find on a table where flowers are displayed: books, glasses, fruit, a statuette or two, or some personal articles. Place them as they'd be in reality: in different positions and directions, one item slightly in front of another.

Make sure that the accessories are of different colors and textures, without introducing startlingly different items or colors. Avoid repeating the shapes and colors of the flowers in the other objects. Why have round red flowers and round red apples, for example? A green or brownish pear, a long, yellow banana, or a bunch of green grapes might enhance the beauty and interest of your flower still life.

Location of flowers

The same principles prevail as in other still life subjects: avoid monotonous horizontal table lines. Flowers might be placed in big containers, colorful Oriental bowls, on special stands. Some flowers hang from a bracket, in a glass, ceramic, or metal bowl. Others are placed on a brick floor, on a balcony, on the window-sill, in which case you have to observe perspective and make sure the colors go well with the containers and the flowers.

Shape of support

I said this before, but I say it again: try the support for all still life subjects, both vertically and horizontally, before deciding how to use it. Don't let yourself be fooled by one tall object in the picture; a flower still life may look better horizon-

tally, if you add certain accessories. A vertical support usually restricts you, whereas a horizontal support gives you a better opportunity to expand your subject. Needless to say, if you want to paint a very tall floral arrangement in a very tall vase, for a high wall space, the vertical support is right.

Let's look at other still lifes

When I was young, I painted every object I found in our house, from heirlooms to empty bottles and damaged china cups; from gloves and scarves, to my mother's fabulous plumed hats, from matchboxes and lighted candles to antique books with torn bindings. Books are especially good subjects, as they come in many colors, and can be set up open or closed, standing or leaning, in different directions. Whatever articles you may assemble, make sure to observe the "don'ts" described before. Also, vary sizes and shapes; make sure the colors don't clash, but don't let them be all alike.

Omnia Vanitas (*All's Vanity*) by Abraham Bosschaert, an eighteenth-century Netherlands artist, is a fine example of interesting as well as attractive still lifes. *Still Life with Flowers, etc.* by Gabriele Münter (1877–1966), is another charming as well as esthetic composition of a vase of flowers. A toy is on the slanting chest-of-drawers, made more interesting with the scalloped cover; a slightly askew painting is on the wall, and there is a good play of lights and shadows.

Green Still Life (Museum of Modern Art) by Pablo Picasso is a semi-abstraction, but it obviously follows the old principles: off-centered composition; slanting lines; diversity of sizes, shapes, and textures; emphasis of lights and darks. *The Persistence of Memory* (Museum of Modern Art), one of Salvador Dali's most famous paintings, also adheres to fundamentals, even though the subject, with its precise execution, is very important.

Backgrounds for still lifes

The background of a painting may be just a color (never a flat color, but a basic color with diverse shades caused by light and shadow, and reflected lights); or it may be whatever you see (or imagine) behind your still life subject. The more complex and colorful your subject, the simpler the background should be. Don't add a colorful backdrop to a colorful bouquet of flowers, or to an

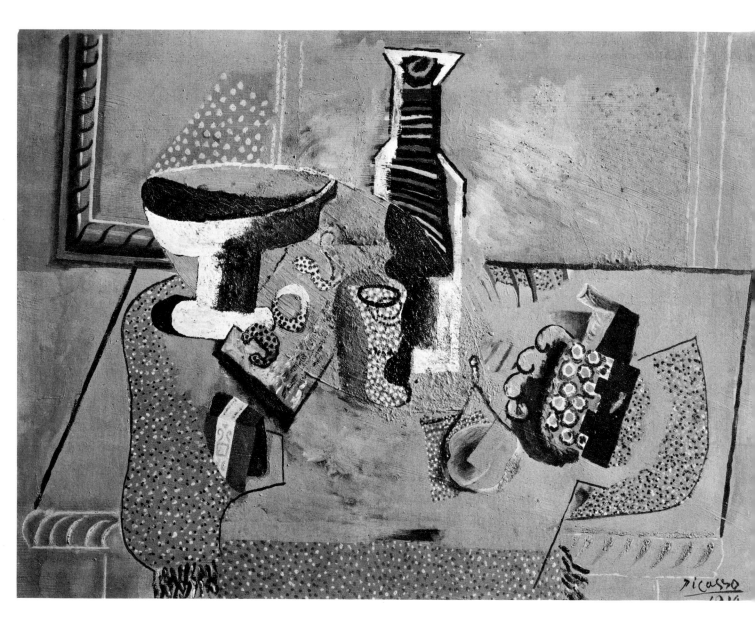

Green Still Life (1914) by Pablo Picasso, oil on canvas
23½″ x 31¼″, has a table similar to the one we see in the
Glackens picture. The rest, however, is abstract, but still
asymmetrical, with a tall bottle off-center. The fringed
tablecloth breaks up the severity of the horizontal table.
There's nothing haphazard about the placing of other
objects of diverse shapes and sizes. Strong contrasts of
darks and lights characterize this work. The Museum of
Modern Art, New York. Lillie P. Bliss Collection.

array of diverse pieces of fruit. Find a soft color which goes well with all, or most, of the hues employed in the articles themselves.

It's a mistake to paint the background white (or leave the support white), or to paint the background black, or some other very dark color. The white background looks empty, the very dark background makes the still life look like a poster. It does bring out all the bright colors, of course, but fine arts ought to be more subtle than that. Dark backgrounds were quite popular in the nineteenth century, which was a more artificial age than ours, at least on the surface. But even then, the color wasn't black; it was a sort of greenish brown, blending into the cast shadows.

Fancy backgrounds

The real trouble comes with the effort of art students to make their still lifes more interesting by adding a fancy backdrop, from memory. One of my students painted a bouquet in a tall vase, on a table, in front of a double door with glass panes. The support was horizontal, the flowers on the far left; the student tried to paint the door frame, but only succeeded in painting what looked like two gray mats placed next to each other. The table for the vase was in poor perspective. To balance the vase of flowers on the left, the student painted a snaky-looking tree as seen through the glass pane on the right. The sea, with an extremely high horizon, ran across both panes, a sailboat on the right.

Even if the student had cut this large picture in half, the flat frames of the two glass panes would have looked like mats, not parts of the picture. The vase of flowers would be too far to the left; the other side, with the slender, wavy tree, and the sailboat on the top of the horizon, would be empty, without any pictorial value.

Other students paint drapery, with very heavy folds, as a backdrop, killing the still life itself with the powerful folds and big differences between light and dark parts of the drapery.

Even if you place a still life in front of a window, all you have to do is to show the window, the light coming through it, and, perhaps, in very faint colors, a suggestion of the scenery you see through the window. Drapery should always be soft-looking, not monumental. Do as Cézanne did: try a variety of colors for the background; make sure the still life articles dominate the picture.

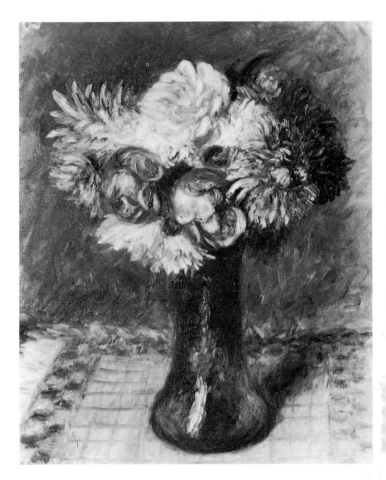

Flower Piece by William James Glackens, N.A. (1870–1938), one of the important American impressionists. This painting was shockingly modern not so long ago. The vase is sufficiently off-center, and its cast shadow gives a good diagonal stripe. The main problem in still lifes is the table or stand. Glackens tried to solve this problem by placing a fringed tablecloth on the horizontal table. In perspective, the checkered pattern, the grid lines on the cloth, becomes narrower and shallower as it recedes, and gives a good illusion of depth to the flat table. Collection National Academy of Design, New York.

Sketch of Omnia Vanitas *by Abraham Bosschaert, eighteenth-century Dutch painter, is an interesting combination of a variety of objects, all different in size, shape, and material—from metal, old book, skull, globe, seashell, to flower. These objects are arranged in the typical baroque asymmetrical fashion. The shadows merge into the background.*

Sketch of Still Life with Flowers, a Toy, etc. *by Gabriele Münter (1877–1966), Kandinsky's close friend. The picture has a striking composition. The slanting cover with the scalloped edge on the dresser is most unusual. The painting on the wall is askew; the vase of flowers and the toy are different in shape and in color. A soft arrangement of lights and shadows unifies the whole.*

In this sketch, one single canvas looks like two paintings of the same size. Flowers on a table (in incorrect foreshortening) are supposed to be in front of a double door with glass panes, through which the artist sees the Atlantic. The vase is far on the left, and the artist tried to balance it with a snake-like tree outside the other glass pane, plus the customary sailboat on top of the horizon. The frame of the double door looks like two mats side by side.

The Persistence of Memory (1931) by Salvador Dali (1904–), oil on canvas 9½" x 13". *This is a very small, but fascinating, picture in which the symbols of the noted surrealist artist aren't difficult to comprehend. We remember things, but incorrectly, vaguely, in distorted forms; little ants eat up a whole watch. Horizontal table, shelf, and waterlines alternate with round and slanting lines. In a painting of this kind, the subject, and the precise execution of detail, are the paramount considerations.* Collection The Museum of Modern Art, New York.

The Old Mill at Sunset by Thomas Cole, N.A., oil on canvas. Here's another of the serene, glamorous pictures of this Hudson River school artist. We may consider oval or round pictures Victorian, but they're difficult to compose, and are actually closer to what we really see than rectangularly shaped pictures. This oval is filled with typical baroque zigzag designs, a repetition of hills in various sizes, and silhouettes. No important point is in the exact center. The Brooklyn Museum of Art, New York.

8
Composition in Scenery

Scenery, in painting, refers to outdoor subjects in which nature is the whole theme, or in which nature predominates, although man-made contraptions may be included. When the scenery is on land, we call it landscape; when it's on water, we call it seascape. This is the subject in which the view-finder I describe in "How to See Pictures" is especially valuable, because scenery, in every form, is huge compared to man. We're not only overwhelmed by its magnitude, but bewildered by its variety. We cannot paint everything we see; how are we to choose a section for painting?

Scan the whole panorama

Scan the whole panorama with a view-finder, or by looking with one eye through a hole formed by your own hand (keeping the other eye closed), or by concentrating on segment after segment, for a moment or two, until you feel you've found the best view.

Once you decide about the main pictorial section, you might decide to make a few visual changes. Take one part out, put another part into the picture; make something more prominent. You may remove any part of the scenery from your painting, but never add an extraneous feature. Add only items which really exist nearby. Otherwise, you might make a fool of yourself, and expose your

painting to ridicule by introducing items which cannot possibly exist in that particular region.

Select shape of support

Almost the first thing to decide in an outdoor picture is the shape of the support: horizontal, vertical, or square. Once again, I warn you not to take it for granted that a high mountain peak has to be done on a tall, vertical support. You can paint the mountain higher, literally, on a vertical support than if you turn the same support lengthwise, but you might not be able to indicate the proportionate height of the mountain—achieved by adding the rest of the mountain range left and right. A view with some beautiful old trees in the foreground and picturesque cloud formations might look much better on a tall support than on a horizontal one, even though the land itself is rather flat.

Composition in landscape

Observe all the usual psychological factors described in "Psychology in Composition." Perfect symmetry in landscape is probably worse than in a figure painting or in any historical, Biblical, or mythological picture. A tall tree, a high mountain or a huge rock in the exact center, with the sides carefully balanced, is pretty dull; nature surely

isn't like that, even if man-made objects often are symmetrical. Be especially conscious of the common error of painting a straight, vertical tree or pole next to the very edge of the support, or having a road, a creek, or any other part go into, or come out of, a corner of the picture. Meandering, zigzagging lines are most natural, as probably nothing in nature is ever perfectly straight.

Rhythm in nature

Nature is rhythmical. Everything that's alive is rhythmical, even in the medical sense. Mountain ranges, hills, rivers, paths, clusters of trees, farmlands (especially in countries where terraced planting is necessary), rock formations—everything is wavy, one wave running into another. You can follow the gradual rising and sinking of the terrain by letting a narrow footpath guide your eyes up and down, left and right. It's true that there may be but one solitary cloud in the sky, but, normally, there are many clouds, and they always look as if they had been separated temporarily; often enough, they look like a flock of sheep, close together, with a couple of sheep straying slightly from the main group. Trees are also repeated alongside the hill or road, in a rhythmic movement.

Avoid repetitious lines

Rhythm is one thing; repetition is something else again. Radio and other waves in nature have their absolute, predictable sizes. In visible nature, however, there's constant variation. Not every hill in the same range is exactly the same in height, length, and wavy shape. Not every tree, even in the same cluster, is exactly the same in shape, size, and direction. Clouds are always different.

Common errors in mountains

Don't paint mountains in parallel lines, going downward on both ends, as this creates the feeling that the mountain is dropping out of the picture. Don't paint them so that on one side the lines go up, and on the other side they go way down, as this design causes the viewer to think that the whole picture is sliding down. Vary the directions, and suggest, rather, that there's much more beyond the section you painted. Hills or mountains continue right and left. As I mentioned before, a

tall mountain peak doesn't really look tall if it takes up a whole vertical support; it just looks clumsy and empty. Show the peak among lower parts of the range, and it'll look majestic, regardless of the size of your support.

Avoid straight diagonal directions, and the dividing of the picture into horizontal strips of equal width. Make the upper or lower section wider, and turn the practically straight diagonal line (which may be really like that on a small sector of a hillside) into a wavy line, which doesn't go into any of the corners of the picture.

Agricultural views

Cultivated lands have a variety of hues and shapes, depending upon the terrain. The season, of course, affects the hues. Growing things can be yellow, green, rust-colored; they vary according to the time of the year. The soil itself, nicely furrowed with the plow, often makes an interesting contrast with the rest of the land. The curves of the agricultural land follow the formations of the soil. Normally, there's enough variety in these lands, especially in conjunction with hillsides and trees, bushes, and perhaps some rocks. Make sure that the variety is noticeable in your painting as well, and that you don't repeat the same sizes, shapes, and colors next to each other.

Trees and bushes

Except in orchards, in which trees are planted in regular rows, and all at the same time, so that they're pretty much the same in size, trees are varied in every form. Whether singly, or in groups, trees follow the land lines, and so do bushes. Very often, such vegetation is left—or planted—in order to divide one farm, or one sector, from another. Trees also usually surround houses and cottages in the country. Always consider the line or lines connecting the various trees and bushes with one another; they aren't scattered aimlessly across the view. In all likelihood, you can find a winding line going across the base of every tree and bush in your picture.

A very attractive, and perfectly natural, design of this kind is clearly visible in a lovely landscape by Hans Thoma, a nineteenth-century German artist, in *The Creek in the Valley*. The meandering line of the creek follows the terrain and continues

Some of the "dos" and "don'ts" of composition are illustrated in these examples.

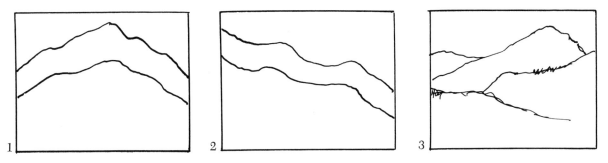

(1) Don't draw hills parallel to each other; and don't let them go downward on both ends; this makes them look as if they were dropping out of the picture. (2) Don't draw the hill lines way up on one side and way down on the other, as this creates a feeling of some accidental stripe in your picture. (3) Vary shapes and sizes of hills or mountains; draw the ends in such a manner that the viewer will know the hills continue beyond the support.

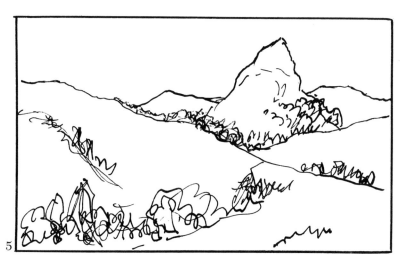

(4) A high mountain peak going up to the top of the support, taking up most of the space, looks like a sugarloaf or a tall haystack. (5) Indicate height in context—by painting the lower parts of the mountain range left and right.

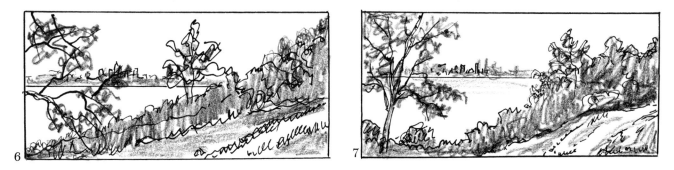

(6) Avoid a completely diagonal division of the support; don't divide the picture into equal parts above and below the horizon or some other important horizontal line. Don't cover up interesting views in the distance with too much vegetation. (7) In this view of Manhattan from New Jersey, the Jersey shore is slanting in a wavy manner, not from one lower corner into an upper corner. The level of the river is raised, leaving less sky; the tree on the left has been moved in.

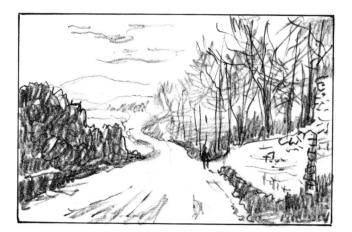

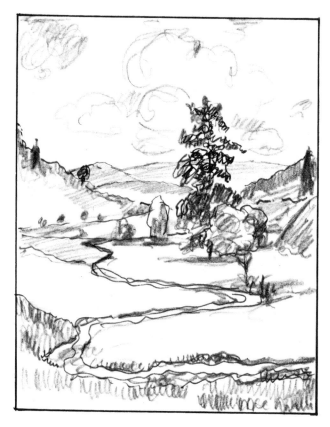

Sketch of The Creek in the Valley *by Hans Thoma, nineteenth-century German artist. This picture shows a lovely linear composition as the narrow creek meanders into the distant hills, passing trees, bushes, and hillsides. The hills are all similar, yet different; the tall tree is off-centered; the round clouds make a nice contrast to the landscape formations.*

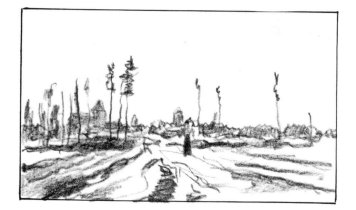

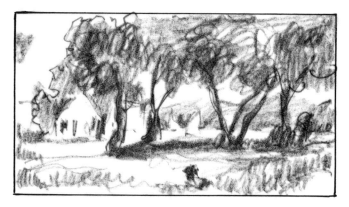

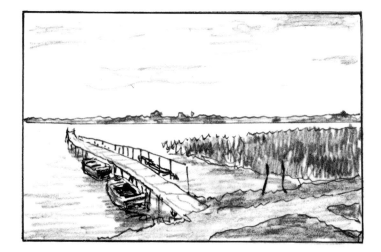

Steamer Landing Stage on Lake Chiem by Wilhelm Trübner, popular nineteenth/twentieth-century German painter, is an unusual view of a rickety wooden landing stage jutting into the lake at an angle. The horizontal waterline is enriched by the low but varied shore, and it's contrasted with the slanting paths in front.

Roads going away from, or coming toward, the viewer are a tough project unless you understand perspective as well as composition. (Above) This sketch of Near Burntisland, Fife *by Atkinson Grimshaw (1871) offers an excellent solution. The snow-covered road is wide in front, without running into the corners of the support. It becomes narrower as it winds into the faraway hills. (Center)* Brabant Landscape *by Vincent van Gogh (1885) is an equally outstanding composition. Here, too, the lines of the road are wide in front, but don't run into the corners; they lead the eye to the low-lying village in the background. (Below)* View of Livorno *by an Italian painter has movement in three-quarters of the picture, but the left quarter is empty. The artist was probably true to what he saw, but an artist has the right to rearrange nature to a reasonable extent.*

into the zigzag hills in the distance. A highly successful zigzag design dominates the *Steamer Landing on Lake Chiem* by Wilhelm Trübner, famous nineteenth and twentieth-century German artist. Horizontal lines of the lake shore on the far side and the cloud formations are contrasted with the landing bridge jutting into the lake, the reed section, and the pathways on the near shore.

Roads going into the distance

One of the most intriguing problems in landscape is the depiction of roads (or rivers, creeks) going from the front to the background. Beginners make such roads seem to be going straight up to heaven, like a long ladder. Vincent van Gogh (1853–1890) solved the problem beautifully in his *Brabant Landscape*. The dirt road goes way back to a distant village, among scrawny trees. The lines of the road are uneven, but correct in perspective, leading the eye far away.

Another excellent solution is seen in *Near Burnt-island, Fife* by the English painter, Atkinson Grimshaw. A snow-covered road, wide in front, but not running into the corners of the picture, winds backward into the hills among shrubs and bare trees. You feel you could walk on this road.

Farm buildings, mansions, etc.

Remember that a landscape may contain houses, but the scenery has to be the biggest part. Houses, cottages, mansions should be shown as integral, but small, sections of the whole view. Draw and paint them in perspective, and avoid placing them in the center. With the help of roads and trees, you can guide the eye of the onlooker toward the house.

There are many possibilities

I cannot overemphasize the fact that there are many possibilities for good composition. I must add that it's a fine idea to try various approaches to a subject. There's nothing wrong with painting the identical theme several times, from different angles, in different layouts.

Piet (Pieter Cornelis) Mondrian, originally Mondriaan (1872–1944), a Netherlands artist who became world-famous with his horizontal/vertical-striped paintings and the declaration that the square and the oblong are the most beautiful forms in the world, was a very realistic artist at first, and turned to abstraction gradually. He did seven versions of *Trees Along the Gein* between 1905 and 1908. Some were done in charcoal, others in oils, and they show the sincere efforts of an artist to find the right pictorial presentation for a place he manifestly loved, a row of about a dozen trees in his flat homeland. (The seven pictures are shown in sketches, and speak for themselves.)

Composition in seascape

Seascape includes lakes as well as the ocean; it may be just the water, or part of a large body of water combined with land, wharves, landing stages, ships, boats, beaches, fishermen, etc. Thus, the subject is vast. Painters of seascapes are usually specialists in their particular field. They may paint just waves and rocks; only boats, only ships, only sailing ships, and so forth. Each field requires a great deal of study. And love, too. But any artist might paint a seascape, usually combined with land, and the problems of composition are exactly the same as in any other subject, with one additional problem: *the eye level.*

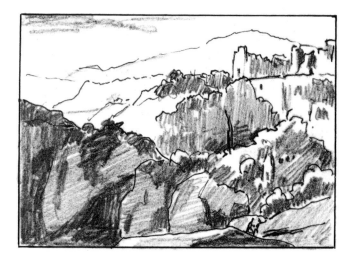

Sketch of View of Tivoli *by Claude Lorraine (Gelée, 1600–1682) offers an ideal pattern of mountains, hillsides, rock formations broken up by the old buildings, and an excellent play of lights and shadows. Claude observed nature, but did all his work in his studio, after careful consideration of each detail.*

The sketches on the left are from photographs; they are shown altered on the right.

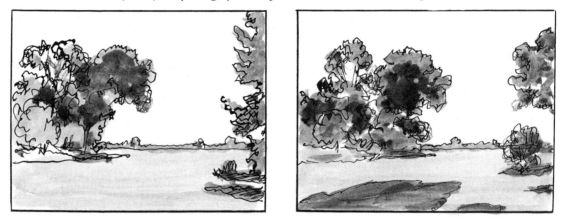

(Left) The tree on the right is cut in half and looks like a bit of lace accidentally caught in the frame. The tree near the center is topheavy, bending over; the meadow looks empty. (Right) The trees on the left are slightly altered and moved to the right; the bent-over tree is now reasonably straight.

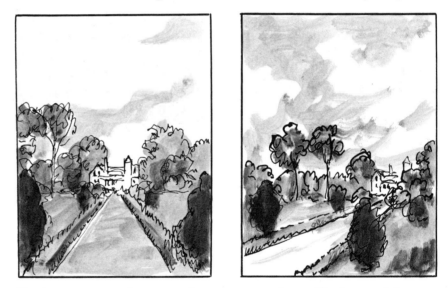

(Left) A nice country house is in the exact center, the road leads up to it in perfect symmetry and the vegetation is almost exactly the same on both sides. The sky is nearly empty. (Right) The same view from an angle creates a slanting road and unevenly distributed vegetation; yet, the house remains visible.

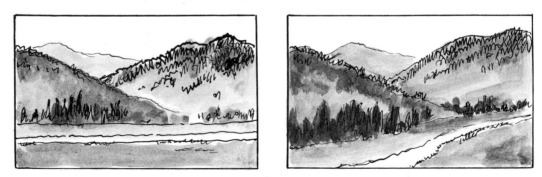

(Left) The road is almost like a ribbon stretched across the bottom, horizontally. The mountainsides are nearly equal, in reverse, and the trees at the foot of these are insignificant. (Right) Turned slightly, the road winds upward; the hills are different in size; the trees are more powerful, and indicate the terrain.

On the left are travel photographs; the same scenes, on the right, are shown altered.

(Left) Tropical beach—the big branches of a palmtree cut across the picture; the background is too big; the figures in the foreground are too much in the center, and artificial. (Right) The same branches now include the trunk, away from the edge; the background is smaller, creating a sense of distance.

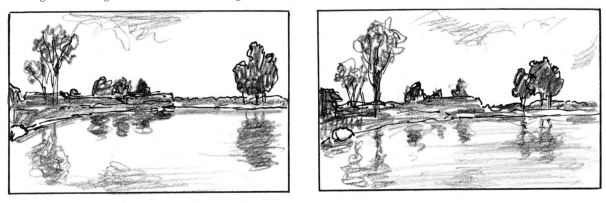

(Left) The view is too symmetrical; the waterline is across the center of the picture; the reflections in the water are too exact. (Right) The waterline is lower; the trees have been shifted and changed in size, so as to be less monotonous. The reflections are not so exact, and the water is darker.

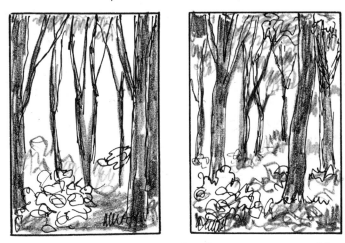

(Left) The trees are too close to the edges, forming a sort of frame; the other trees are symmetrical; the foliage is weak. (Right) The larger trees have been pulled away from the edges; they are on different levels and more varied.

The pictures shown in sketches on the left are not as good, compositionally, as the ones on the right.

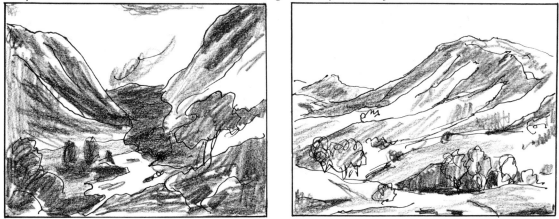

(Left) Highland River Landscape *by Sir Edwin Landseer (1802–1873) has a totally symmetrical pattern of hills, river, and clouds. (Right)* Finder's Ranges, South Australia *by Sir Hans Heysen (1933), has rhythmically changing forms and lines, with alternating lights and shadows, nicely placed clusters of trees.*

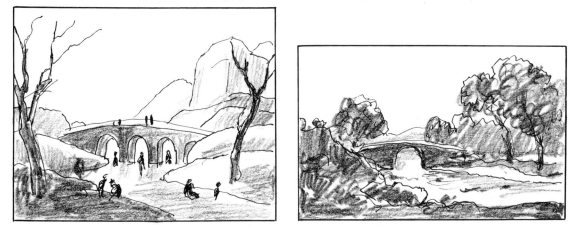

(Left) Winter River Landscape *by Hendryk Willem Schweickhardt (1792) represents a triple-arched bridge, with one figure in each arch; hills which are almost alike on left and right; two bare trees, one at either end, each leaning toward its edge. (Right)* View of Douglas Bridge, Inverary *by Patrick Nasmyth (1818) is very similar to the Dutch painting, but it represents the view at an angle.*

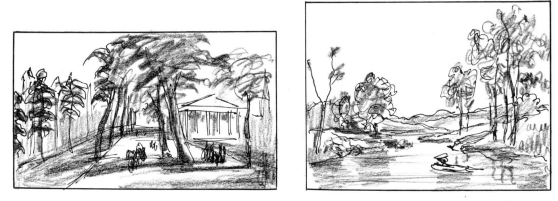

(Left) View of Yale, *English painting (1840), has tall trees in the center, as if they were on a highly curved terrain. The classic building on the right isn't balanced by anything on the left. The figure groups are similar in size and strength of hues. (Right)* Wooded River Landscape *by Alfred G. Vickers (1859) has a zigzagging shore, with each section different from the others.*

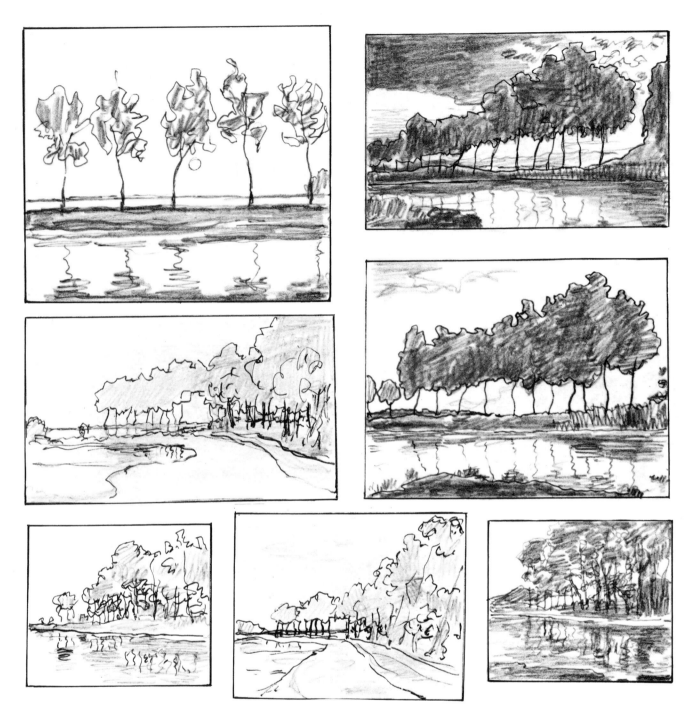

Sketches after seven versions of the same subject, Trees Along the Gein, *drawings and paintings by Piet Mondrian. These were executed between 1905 and 1908, when the Netherlands painter was still quite realistic, although his colors were often far from natural and prove that a serious artist can be intrigued by diverse possibilities. Atmospheric conditions as well as the views are different in each picture. He obviously loved these trees and this corner of his flat homeland.*

Eye level in seascape

Seascapes painted by beginners invariably have a very high horizon, as if the water were standing up straight, like a wavy pane of glass. Boats near the shore are usually placed so low that they appear to be riding on the frame, or ready to sink; sailboats and steamships are painted right on top of the horizon, which is the same as the eye level, and almost always are painted much too large for the distance. The first thing in the composition, therefore, is to establish the eye level.

The eye level is also called the *horizon,* and it's clearly visible only on the open sea, or on a very large lake, where the end of the water is a horizontal line meeting the sky. In landscape, this horizontal line isn't visible, but it's still your eye level. This eye level isn't a static, permanent line. It goes wherever your eyes go: up to the top of a mountain, or down to a beach. If you are low, the top line of the water is also low; if you go higher up, the line of the horizon also goes up. Whenever you paint the sea, with or without any land sections, consider its visual height.

The simplest method of determining the visual height of the waterline is to compare it with something on the shore. Look at a person sitting on the beach, on a rock, from a distance; or look at the trunk of a tree, and observe at what point the horizon crosses the sitting person's body or the tree. If the waterline is higher, how much higher is it? If you are on a high level, looking down, you'll find that the water may be much higher, but that sailboats, for example, aren't riding on the very top of that line, but far below it. If you are on a low level, the horizon crosses the tree or the person very close to the shoreline. In that case, the sailboats appear to be higher.

A ship in the distance is always bound to be very small, compared with anything on the shore; if it's nearer to the shore, its waterline is below the horizon. This may seem strange, as you think the ship floats on top of the water. That's true in reality, of course, but not visually. Observe, instead of painting memory pictures; you can't always rely on your memory—it may play tricks on you.

Waves and ripples

Waves or ripples are parts of the composition of a seascape. They form a pattern which has to be observed over a long period of time in order to grasp the optical rhythm of the water. Especially at a beach, where the waves run up, roll over, and glide back, again and again, in similar, but always slightly different, scalloped formations. On a rocky shore, the waves pound the rocks, break into foam, run over, turn into beautiful lace-like designs, and roll back into the sea.

Consider distance: the biggest waves are smaller, visually, the farther away they are. The so-called "white caps" aren't all alike; they rise, and roll down unevenly, endlessly. On a quiet shore, you not only see, but also hear, the rhythm of the waves. *Marine* (National Academy of Design), an oil painting by Thomas Alexander Harrison, N.A. (1853–1930), beautifully renders waves near a sandy shore. You can feel the salty foam, and almost hear the sound of the waves.

Reflections in water

Water reflects whatever is above it, but the reflections are clear only on smooth water. Otherwise, the waves or ripples smash the images into thousands of fragments, although the general atmosphere is invariably reflected in even the stormiest water. It's possible for the ocean to be stormy under a bright blue sky. Full reflections offer a most fascinating subject, but avoid making the reflected image exactly the same as the actual view above the water; avoid, above all, a composition in which the actual view and the reflected image occupy the same amount of space, as this would give your painting the stiff and unrealistic effect of a playing card.

Reflections are in perspective. The upper part is normally covered by the shoreline; the lower parts recede according to distance. With the exception of small reflecting pools on an absolutely calm day, all reflections, no matter how astonishingly clear, have ripples; they're broken up by veil-like tones floating across the water.

You might make the reflections the main theme of your painting; or make the actual view your subject. *Les Nymphéas* (Museum of Fine Arts, Boston), one of the many depictions of water lilies by Claude Monet (1840–1926), shows only the small islands of flowers and leaves floating on the water. Reflections of trees indicate, without actually showing, the nearby shore.

The pictures on the left show some of the ideas common to beginners and untrained artists; the pictures on the right have sound composition.

(Left) Don't place a big ship on top of the horizon. The biggest ship looks small so far away. Two or three rocks at the bottom don't amount to a shore. (Right) A lower waterline is what you actually see, unless you look at the sea from a high hill or building.

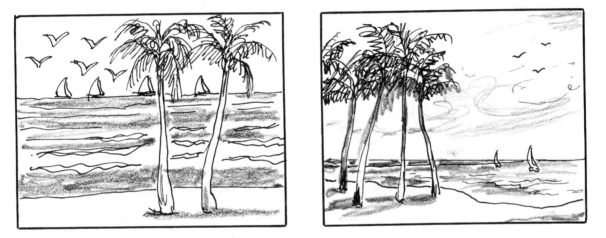

(Left) The horizon is much too high, palm trees and boats are mechanically distributed wherever there happened to be room for them. The birds are big and all alike. (Right) This is the horizon as you see it from the shore: palms are likely to be in groups; the shoreline is curved; sailboats are bound to be closer to shore.

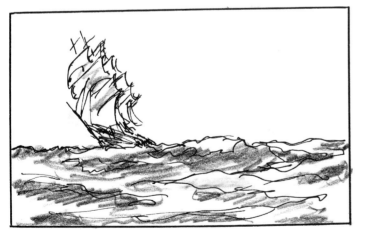

(Left) This sailing ship appears to be ready to fly off the choppy sea. Leaning toward the upper left-hand corner, the boat leaves a great deal of empty sky. (Right) Sketch of The Sea at Saint-Vaast by Eugène Boudin, noted impressionist. The scene is simple, calm; everything in it seems to be just right in size and position.

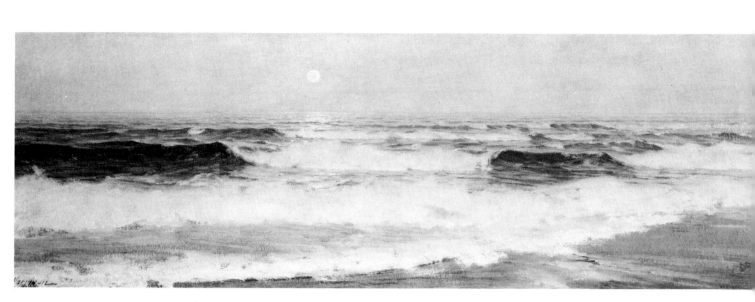

(Above) **Marine** by Thomas Alexander Harrison, N.A. (1853–1930). An early example of the long horizontal support, perfectly suited to the subject. The waves rise and fall in endless rhythm, breaking into lace-like frills on the beach. You can almost hear the murmur and swish of the water. A pale, full moon glows off-center. Collection National Academy of Design. Photograph Frick Reference Library, New York.

(Right) **Les Nymphéas,** or **Water Lilies** (1905), by Claude Monet (1840–1926), one of many similar themes by the famous impressionist. All he shows here is the water with small islands of lilies and leaves floating on it. Reflections of trees indicate the nearness of the shore. Again, you find rhythm: the diverse sizes of the floating vegetation, and the generally diagonal direction of these forms enhanced by the off-centered reflections in the water. Museum of Fine Arts, Boston. Gift of Edward J. Holmes.

Boats and ships

First of all, permit me to warn you not to paint boats or ships of any kind unless you have an opportunity to study them, or unless you have excellent, clear pictures from which you can copy them. And the pictures must represent the boats in the correct positions according to your layout. Boats are among the most graceful contraptions of man.

A badly drawn boat in a painting looks ludicrous. Clipper ships are especially complex. Small sailboats, however, are often good in seascapes. Make them small enough, according to distance, and place them according to the angle from which you depict them. Here, too, good, large photographs are recommended. Don't rely on your memory. I've seen too many sailboats painted as if they were sailing in either direction, or as if the flags flew against the wind.

The illusion that a boat is just sailing in, or just sailing away, is especially noticeable in this subject, because boats are in motion, except when they're moored or anchored. If you want to show the arrival of a boat, paint it near one end of the support, with its bow pointing inward. A boat sailing out of the picture ought to have its bow closer to one end of the support, with its stern inside. Waves at the bow, and waves radiating from the stern of any boat, add interest to the design of a seascape.

Composition in sailing ships

Besides knowing all about the shapes and gears of sailing vessels, you must have the knowledge of composition required in other themes. Some artists paint boats as if they were sliding on slopes, rather than riding the sea; others cut a lovely sailboat in half. In many instances, the ships are all right, but not the rest of the seascape. Netherlands artists usually place the horizon and all depicted items very low, probably because they're accustomed to the low level of their country.

Joseph Mallord William Turner (1775–1851), the famous English artist, was one of the greatest seascapists. His oil painting, *The Dort Packet Boat from Rotterdam Becalmed* (collection Mr. and Mrs. Paul Mellon), is reproduced in color. We have reason to believe that John Constable (1776–1837) referred to this work when he described one of Turner's paintings as "the most

(Above) In the sketch of Banburgh Castle, *a watercolor by John Varley (1811), the scene fills the long, narrow support. The castle is off-center; the hills have a natural rhythm of similar, yet different, shapes and sizes. The beached boat is just right, and the clouds fill the large sky. (Center) In the sketch of* View of the Thames *by an eighteenth-century English painter, the composition has a low eye level. The bow of a barge with a man is pushed into the lower left corner; a sailboat on the right is sliced in half. The skyline is attractive, but the boats spoil the picture. (Below) The sketch of* The Seine near Vernon *by Claude Monet (1883) represents a painting in which the reflections are as important as the actual scene. But note that the two sections aren't the same in size and color. The branch and foliage sticking in from the right, and their reflections in the water, create a pleasing design.*

Calm Sea with Ships *by Willem van de Velde the Younger
(1633–1707). This picture is crowded with sailing ships
and boats of many sizes and types, with sails turned in
different directions in an asymmetrical balance. Most
Netherlands seascapists appear to have the habit of
placing the eye level very low, probably due to the fact
that Holland is a low country. The low sea level, however,
leaves a huge sky above, and to a foreign observer the
objects in such a seascape often appear to be sinking.*
Collection Mauritshuis, The Hague.

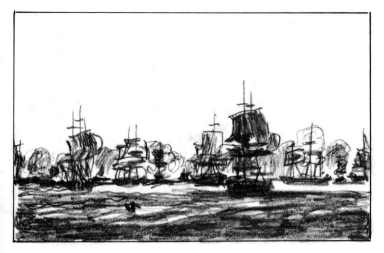

(Above) View of Gravesend *by an eighteenth-century English artist has some very obvious flaws. The boats on the right appear to be on a slope, rather than riding the waves. The men standing on them seem likely to fall overboard any minute. (Below) The English seascapist, Thomas Luny, who painted this* Naval Battle between Dutch and English Men-o'-War (1784), *had to know all about naval battle formations as well as the ships themselves. There's much smoke in the distance, and a couple of ships are aflame. It appears to be customary to paint the front section of the sea darker, as if it were in shadow, in such naval scenes.*

complete work of genius I ever saw." (Constable and Turner are generally regarded as the precursors of impressionism.) I made a little test with this painting. I traced it (from a photograph), rearranging the eye level and the positions of boats, but not altering any size or detail in the picture. Look at the sketches, and perhaps make some of your own. The original painting seems to have the only really good composition.

This doesn't mean that another artist, even Turner himself, at another time, might not have found a different, yet equally good composition for the subject. All I want to emphasize is that, as the painting is, you couldn't change any part of it without damaging its appearance.

Structures on the shore

Whatever you paint on the shore should be sensible, an integral part of the picture. Here, too, you have to decide what's most important: the wharf, some other structures on the shore, or the water itself. The structures may require a certain amount of change in size or direction, in order to look good in the picture. Avoid the ever-present danger of too many parallel lines: the shore, the wharf, the roof of the dock, etc. One or another line may be turned at a slight angle.

Birds in seascapes

One can hardly imagine a seaport or any part of the sea near the shore without seagulls and perhaps other birds. Seagulls are fascinating creatures, sitting often for long periods of time on stakes or right across the length of a rooftop. They also fly in dense formations behind ships, swooping down to catch food. There's seldom a time of day when birds aren't flying over the sea. You can do nothing more amateurish than paint a large number of huge birds, all alike, above the water, in dark colors, as if they were vultures.

Observe birds in flight as well as when they're still. Get photographs, if possible, to study their proportions and main shapes; and use them only sparingly, in spots where they look perfectly natural—two or three small, light-toned, barely noticeable seagulls over the sea; some sitting on top of a dock. And don't paint them all in the same size and position.

Human figures in seascapes and landscapes

Human figures may be practically anywhere, of course, but don't put them into your scenery unless you know what they're doing there. A man is unlikely just to walk in a landscape; he must have something to do there, or some definite place where he wants to go. He may be a farmer, a hunter, a man going home, and this should be indicated by his appearance, his pose or gestures. In a seascape, men may be fishing, rowing or sailing a boat, leaning against the parapet on a wharf. Paint them in the right sizes, colors, and postures.

In this subject, photographs are very important, in addition to good observation. Figures usually make a picture more interesting from the layman's viewpoint, but never put a figure into your painting just in order to please your friends.

It's better to have no figure at all than to have a badly drawn one. The placing of the figure depends upon his activity. If he is going away, put him close to the end of the support, his nose pointing outward. If he's coming in from somewhere, his nose should point inward, but this doesn't mean that you have to paint his nose. Not at all. Omit tiny details. I mentioned the nose merely as a directional guide.

Shape of support in seascapes

As in landscapes, decide about the shape of the support according to your subject. Although most seascapes are likely to fit on horizontal supports, it's quite possible that some will look better on vertical shapes. Try your subject in both directions. You might find a most attractive high shoreline, with rocks and lighthouse, requiring a tall support. On the other hand, you might depict this tall lighthouse on the high, rocky shore on a horizontal support, if the shoreline is interesting enough to carry across the whole width of the picture, or if a handsome ship is included in the view.

Colors in landscape and seascape

In no subject is color more important than in landscapes and seascapes. Still lifes, figures, and portraits are nearby objects. They are right in front of you, while landscapes and seascapes are enor-

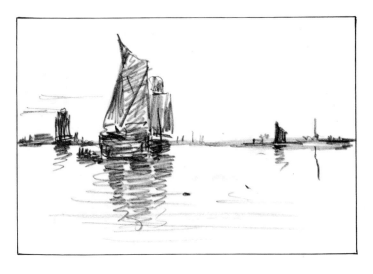

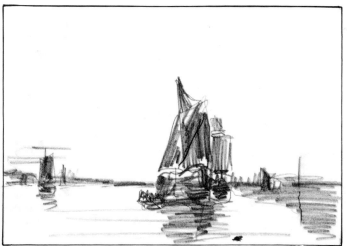

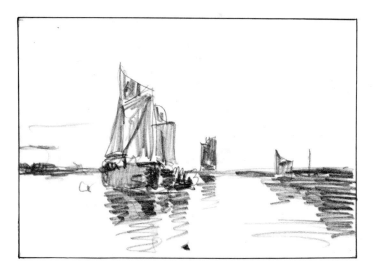

Here are three tracings of a photograph of The Dort Packet Boat from Rotterdam Becalmed *by Joseph Mallord William Turner (1775–1851), which is reproduced in the color section of this book. The subject may appear simple, but Turner arranged boats, shore, sea level, and other details with such sure sense of composition that any change would damage the view.*

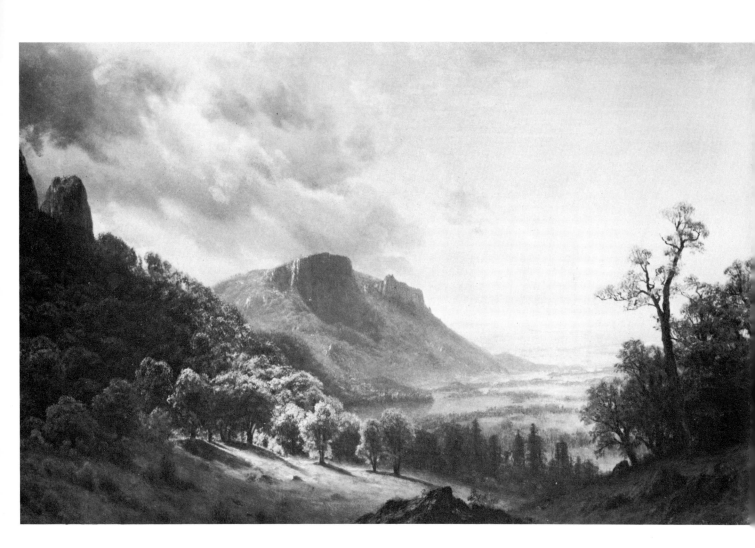

South Pass, Wind River Mountain by Albert Bierstadt (1830–1902), who carried the Hudson River school's ideals into the West. The painting is an oil on panel 14½″ x 23½″. Once again, slanting and wavy lines create an off-centered composition. This isn't a formula among artists; it's a general feeling. Each painting is different, with similar fundamental elements. Trees, rock formations, clouds, lights, and shadows are juxtaposed to achieve a picture which is well balanced, even though different on each side. Collection Mr. and Mrs. Julian Ganz, Jr. Photograph Courtesy The Los Angeles County Museum of Art.

mous spaces. You have to consider the distance in reference to color. Everything becomes hazier, more bluish in the distance, regardless of its so-called local color; that is, the color nature or man gives an object. A red house or roof isn't nearly as red a thousand feet away as it is right next to you. The same is true for green trees and bushes, green meadows, blue seas, white waves, gray docks, bright flags or any other object imaginable.

In the distance, they're all less distinct.

The visual top of the sea may look very blue to you. It's blue, all right, but not as bright and dark as the same kind of blue a hundred feet from you. Color is a vital part of your composition. It can cause your painting to fall apart or some sections of it to jump out; or it can make your picture look unified, complete, a true and successful composition in every way.

Summer Landscape near Deadham (c. 1820) by John Constable (1776–1837), oil on panel 5½" x 8¾". This painting is almost a miniature in size, but it's great in concept. A precursor of Impressionism, Constable painted from on-the-spot observation. However, he either selected, or slightly rearranged, the scenery, so as to make it good in composition. He slanted horizontal lines and alternated the straights and curves in a rhythmic fashion. Bushes and trees carry the viewer's eye along the terrain. The cloudy sky is part of the general view. The National Gallery of Art, Washington, D.C. Collection Mr. and Mrs. Paul Mellon.

Peace and Plenty by George Inness, N.A. (1825–1894), oil on canvas 77⅜" x 112⅜". One of the first American impressionists, Inness painted large landscapes. The composition again rests on the baroque zigzagging line leading the eye to the faraway hills. Note the repetition of lights in the meandering river and the shadows on the dense foliage of trees and bushes. A few figures are scattered over the foreground. The hills go slightly up at both edges, suggesting a continuation of the range. The Metropolitan Museum of Art, New York. Gift of George A. Hearn, 1910.

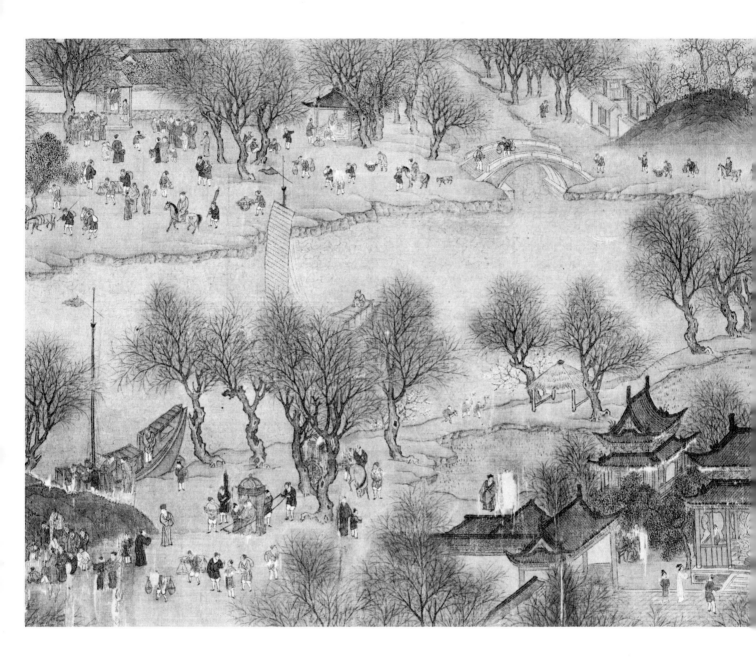

Ch'ing Ming, or Spring Festival on the Yellow River,
detail from a Chinese scroll on silk. It is a Ming dynasty
(1368–1644) copy of a Sung dynasty (960–1279) original
(copying outstanding pictures by artists of later generations
has been a sort of ritual in the Orient). In the typical
perspective of Oriental art, everything is seen from a higher
level, and from the same side. Buildings and trees are
distributed in an off-centered fashion; the river goes up
from left to right. People walking, playing, vending,
buying, horseback-riding, carrying pails of water on
shoulder poles; boats, foot bridge, and the pavement in
front of a shrine are all finished in every detail. The
Metropolitan Museum of Art, New York. A. W. Bahr
Collection. Purchase, Fletcher Fund, 1947.

9
Composition in Cityscapes

A cityscape is a pictorial work in which houses, streets, and other parts of cities, towns or villages constitute the main subject. There may be trees, parks, hills, a river, a lake or the sea in a cityscape. This branch of art is as varied as landscape or still life, but it requires a sound knowledge of perspective if it is to look realistic and professional. In abstractions, of course, perspective is neither required nor desirable.

How much of the city to paint

One solitary, old, perhaps spooky, house may be the sole subject of a cityscape; the roofs and chimneys of a few houses have often been painted. You may depict the upper floors alone, or only the street level, with shops, signs, and awnings; a street corner; or a view of a park with big houses beyond it. You might paint a deserted town, a traffic-jammed street, a dark alley, a brightly-illuminated amusement center; construction, demolition, excavation; or a panoramic view from a distance, any time of the day or night, in any season, and in any weather. You have a big choice.

Composition in a single house

A house may be built to stand alone, on a hilltop or in a garden; an unusual house may exist be-

tween ordinary buildings, and might be painted by itself, as if the other houses had been demolished, but don't paint such a house covering the support from one side to the other. Leave a little sky above it, and show it at an angle, so as to see at least a little of one side. Otherwise, the house will look like a movie set, an empty façade. Such single houses have to be neatly detailed, and demand considerable knowledge of architecture.

Composition in a street

Most beginners paint houses as if they were directly in front center, with all the doors and windows in their basic rectangular shapes. In reality, we seldom see streets in this manner. It can only happen where we have a view from a considerable distance, as when we look at a shoreline from across a river or lake, or from a boat several hundred feet from a beach. Normally, we see streets from an angle, with receding lines and diminishing forms.

Consider the psychological and optical problems I've already discussed. Watch the slanting lines: don't let them come from, or go into, corners; don't leave too much space on the top, unless you want to show a big sky; don't leave too much space on the bottom, unless you wish to concentrate on the people and the traffic.

Here are some "dos" and "don'ts" in depicting cityscapes.

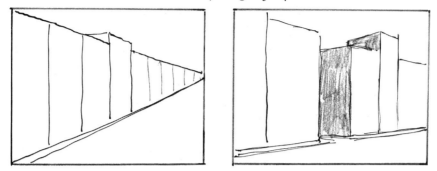

*(Left) Don't let lines go into corners, and don't slant them too much in perspective.
(Right) If the slanting lines are not so drastic, you have a more reasonable view.*

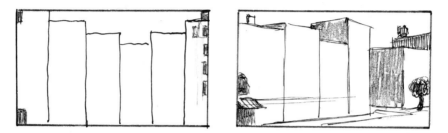

*(Left) Avoid houses of equal widths and roofs which look like long steps going up or
down. Don't push doors or windows into corners. Don't let vertical lines coincide
with the edge of the support. (Right) Break the vertical edges with an awning, a sign,
or a tree bending away from the edge. Interrupt a long row of houses with a cross street.*

*(Left) Too many parallel lines spoil the picture. Even the clouds slant in the same
fashion as the rooftop, in this picture. Don't place a pole close to the edge of the
support. (Right) Perspective can be modified, made less steep; it can be counterbalanced
by lines and shapes running in other directions.*

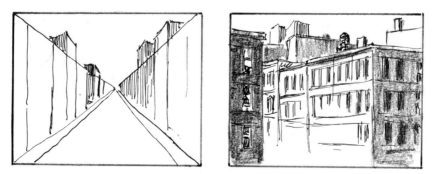

*(Left) We seldom see a street, in perfect symmetry, from the center of the road. (Right)
The view is more interesting, more intricate, from an angle and from a higher level.*

Watch vertical lines, so as to avoid the feeling of an impending disaster—all the buildings toppling over. A serious problem in cityscapes is not to make the left or right edge of the support coincide with vertical lines in the picture, such as a lamppost, or painting the vertical sides of windows exactly even with the edge of the picture. You can always break this dull coincidence by moving the vertical objects a little to the left or right, or cutting it with a slanting awning, a sign, a tree curving away from the edge, or by painting a cast shadow at a slant. (Make sure such a shadow would be possible if a certain building, or a tree, were standing there.) Beware, especially, of placing a window, a door, a chimney or any other rectangular object right into a corner, as if it had gotten stuck there.

Rhythm in cityscapes

Houses on a street are often repetitious in size, shape, style, and perhaps even in color, as many are built at the same time, probably by the same landlord. Such streets are uninteresting, and lack pictorial qualities. Mostly, however, houses of different heights and colors alternate; modern buildings can be seen among old ones. Windows, entrances, chimneys, cornices, roofs are varied in size, color, and form. There's enough variety, yet there's a rhythmic repetition of architectural ingredients. If the variations aren't sufficiently strong, use your imagination and make little changes.

Monotonous roofs

Occasionally, roofs of neighboring houses look like wide steps, going down or up. At other times, roofs are alternately higher and lower by about the same amount. Nobody can forbid you to change the heights of roofs so as to make them more diverse, more interesting. In places where you can see the roofs, you might also change their colors.

Cross streets are helpful

Cross streets or small plazas break up a row of houses pictorially as well as literally. The wall facing you in a cross street is darker, or lighter, than the other houses, depending upon the position of the sun. In the evening, artificial illumination also causes picturesque differences. There's a

difference in the directional lines of roofs, and of curbs at the corner. Good pictorial breaks are caused by buildings rising sufficiently above their neighbors to show a wall with a different illumination. You may make such sections higher than they really are, or introduce them where they don't exist in order to help the composition.

Churches, public buildings

Every locality has at least one church and some municipal building, a public monument, a city library, or an old mansion with trees and perhaps a garden. Avoid the temptation to paint such buildings clear across the support in order to make them look important. Place them in context, so to speak. Show the surroundings to better indicate the elegance, interest, or charm of the main theme. When such a building is on a hilltop (this is often the case in the Old World), depict the hill as well as the building.

St. Patrick's Cathedral on New York's Fifth Avenue might be made to look like a huge cathedral if painted all by itself. But what makes it so charming is that it's surrounded and flanked by tall, modern structures, and that's the way an artist ought to depict it. It suffices to suggest the formidable city around the cathedral in big masses, without overwhelming the spired St. Patrick's with thousands of windows next to it, but it will look more picturesque among the other buildings.

Lights and shadows in cityscapes

Lights and shadows play a much greater role in cityscapes than in other subjects because they are more massive on buildings and streets than on apples, bananas, books, trees, and hillsides. A sunlit wall or long street can be broken up with shadows cast on it by buildings across the street.

At night, a city may have a fairyland illumination not found in any other subject. At noontime, when the sun is almost directly above the city, long, fascinating shadows are cast underneath architectonic items, such as balconies, shutters, decorations. Many artists have been inspired by such long shadows. At other times of the day, shadows are on one side or the other, with less prominent shadows under these architectonic units. Here again, there's an ever-varying rhythm which can be incorporated into your composition.

Fourth of July, Washington Square by the author, oil on canvas 24" x 28". The Square looked sad on that holiday, with the rain coming down in buckets. Suddenly, a woman appeared with a completely useless umbrella, running fast. I painted the scene, with Number One Fifth Avenue in the background, off-center. I paid special attention to the slanting paths glistening in the downpour. The roundish forms of the trees contrast with the architectural forms, in a variety of shades, of the buildings. Some windows reflect the light coming through broken clouds. The single figure may look funny, but she was real.

Color composition in cityscapes

Besides lights and shadows, which are, of course, less pronounced on cloudy, rainy days than when the sun is out, houses have colors of their own. In certain countries, houses are painted in all shades of pastel colors; in American cities, the colors range from so-called white (actually off-white) bricks or white plaster, to red brick, brownstone, black plate glass, and almost black bronze or cast stone. Age and soot may make buildings look distressingly dirty, but they become more picturesque.

Utilize the colors; don't exaggerate them, but you're free to select your favorite hues. That is, you may paint a dark gray building light ocher, if you feel it'll look good in your composition, or turn a shiny, new yellow house into a dull gray in order to keep it from jumping out of the picture.

Night lights of the city

Multi-colored lights, illuminated signs, streetlamps, bright shop windows are especially fascinating. In such themes, the illumination is the main subject. Compose light just as you'd compose anything else. Don't scatter lights and darks alternately, like a sort of chessboard; arrange them in an off-centered fashion, in various sizes and shapes, as signs and brilliantly-lit entrances actually are. Don't place a bright sign or window in a corner of the support. Don't rely on drastic contrasts between lights and darks; have some intermediate hues as well.

Figures and vehicles

Streets can be absolutely deserted, as on a Sunday morning, or on a stormy day. Years ago, I celebrated a rainy Fourth of July by looking out my large studio window on Washington Square, New York City, and painting the Square with Number One Fifth Avenue in the background in the terrific downpour. There wasn't a soul outside, not even a car, when suddenly, a woman appeared in the center of the park, running fast, with an umbrella held precariously over her head. The wind almost blew it, and the woman, away. I painted her, too. The picture is true to life, although it probably looks funny.

Streets may have just a few pedestrians, or big crowds; there can be heavy traffic, or just a single vehicle. Use your judgment about adding or not

*Les Coteaux de l'Hermitage, Pontoise (c. 1867) by Camille
Pissarro (1830–1903), oil on canvas 59½" x 78¾".
Impressionist or academic, the same principles prevail:
forms may be repeated, as in nature, but not monotonously.
Here, the curving road guides you up or down. Shadows
and lights enhance forms; straight lines are intermixed
with roundish ones. Nothing is in the center. Even the
usually parallel lines in the roofs are somewhat changed
in direction or size in order to achieve pictorial variety.
The lines (the middle and the two sides) of the road don't
run into a corner.* The Solomon R. Guggenheim Museum,
New York. Justin K. Thannhauser Collection.

Madison Square, New York (1890) *by Childe Hassam* (1859–1935), *oil on canvas 18⅛″ x 20½″. Compare this painting with the Chinese view of city life: slanting street, instead of a slanting river; more foliage on the trees; different architecture; hansom cabs; women in long dresses and men wearing top hats. Yet the basic principles of good composition are still present, and not accidentally, but* deliberately. The Metropolitan Museum of Art, New York. Gift of Miss Ethel McKinney, 1943, in memory of her brother, Glenn Ford McKinney.

adding figures and cars to your cityscape. If you add any, they must fit into the picture. They have to be of the right size, and do what people in such places, at such times, would actually do. People don't walk in Indian file, and cars don't drive in a straight and even row.

My advice is that you paint people and vehicles only on the basis of good photographs, but don't copy them slavishly. For instance, a figure may seem to be the lower part of a lamppost in a photograph; move him right or left. The best method is to finish your painting, let it dry, cover it with a sheet of acetate, and sketch all figures and vehicles on this sheet. You can change, shift the acetate easily enough. When satisfied with the results, trace the figures and cars onto the painting.

Shape of support in cityscapes

As usual, I suggest that you make sketches, and try both directions. Some cityscapes look more natural on a horizontal support, others are better in a vertical format. I've found a square support satisfactory more than once. Remember: a building looks bigger when surrounded by small houses, than when you paint it all by itself, unless you indicate the size of a skyscraper by painting every story and every window.

Sky and the city

The size of the sky, compared with the cityscape, depends upon your idea. If you depict a beautiful sunset, make the sky large enough to show the brilliant colors. On a stormy day, the billowing clouds may well be the dominant part of your picture. Many times, however, the sky may be just a small corner of blue or gray between roofs or cornices. On a stormy day, compare the darks in the clouds with the darks in the houses. Too dark a sky will look like a shapeless monster.

Nature and the city

Many cities, large and small, have mountains or hills all around. Avoid parallel lines between the shapes of hills and the shapes of roofs. Above all, paint the hills or mountains in very soft and light tones, so as to keep them in the distance. Trees break up the sometimes too regular widths of houses, but don't paint them as if they were

This sketch is based on a watercolor by Michael Angelo Rooker, A.R.A., entitled View of the Painted Chamber, Westminster Palace. *As the sketch shows, the artist succeeded in placing this bulky building in such a fashion that it looks picturesque among smaller, lower structures. The shadows break up, or camouflage, the drab side of the building.*

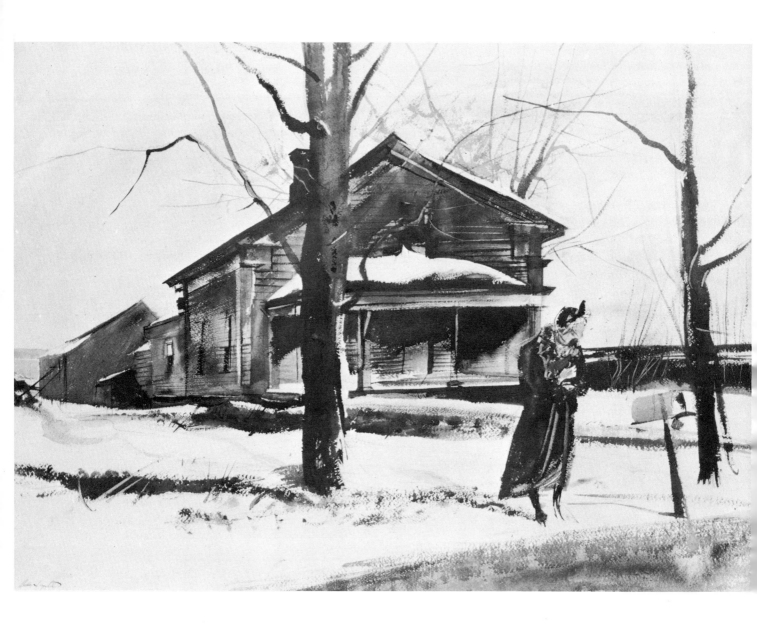

Waiting for a Bus by Andrew Wyeth, N.A. (1917–), watercolor. In this painting by one of our foremost realists, slanting road lines contrast with the horizontal lines of the clapboards and the roof of the porch. Note the sloping lines of the roofs; the one tree off-center, left, the other tree slanting away from the right edge of the paper. The rural mailbox is also at a slant, and so are the cast shadows in the snow. The woman is sketched in, with more attention to her tilted head and her hands holding her coat tight, than to details such as her legs and shoes. Strong lights and shadows add power to this sketch. Collection National Academy of Design, New York.

the main subject. If the houses are on or near the shore of a body of water, show enough of the water to make clear that it's water, not a road; and never place the waterline in the center of the support. The shoreline, just like the line of a table top, isn't necessarily horizontal.

Shipping on the water

In many instances, the houses are on a nice, natural slope on the water's edge. In other cities, there's a big stone embankment. Usually, there are trees on the shore. In harbors, or places where there's much shipping, as on the Rhine or the Danube in Europe, the Mississippi and the Hudson River in the United States, you ought to add some ships and barges, but in an impressionist style, omitting small details. The ships and docks may be the main theme of your picture, with the city indicated as a backdrop. Or give a panoramic view, including river, boats, city, and far-distant hills. The rules (or, rather, the "don'ts") are identical with those in other subjects.

Realism and realism

Oriental artists painted cityscapes many centuries ago, with great skill, but with primitive perspec-tive; they always seemed to be looking down from a high hill or tower. One of the loveliest Chinese city scenes is in The Metropolitan Museum of Art, New York City. A detail of a silk scroll shows *Ch'ing Ming,* or *Spring Festival on the Yellow River,* a later copy of an original painted during the Sung dynasty (960–1279). It represents houses along the river, people walking, vending, buying, playing, horseback-riding on both banks. Each figure and tree is done separately, minutely. Still, the picture has the diagonal, zigzag composition the Western world has come to prefer.

Compare the Chinese painting with *Madison Square* (Metropolitan Museum of Art) by Childe Hassam (1859–1935). Living in a different age, a different period, the American artist also has a slanting design. Trees, carriages, figures aren't executed in fine detail, and the buildings are very different from the Chinese. But outstanding artists of all eras, all corners of the earth, have very much in common. Perhaps, above all, they paint with love as well as with knowledge. One cannot help feeling that Hassam loved the hansom cabs, the long-skirted women, the men with top hats, the fancy lampposts, the big trees of his period just as much as the Sung dynasty artist loved the neatly dressed people, the trees, pavilions, boats, and the graceful little arched footbridge of his day.

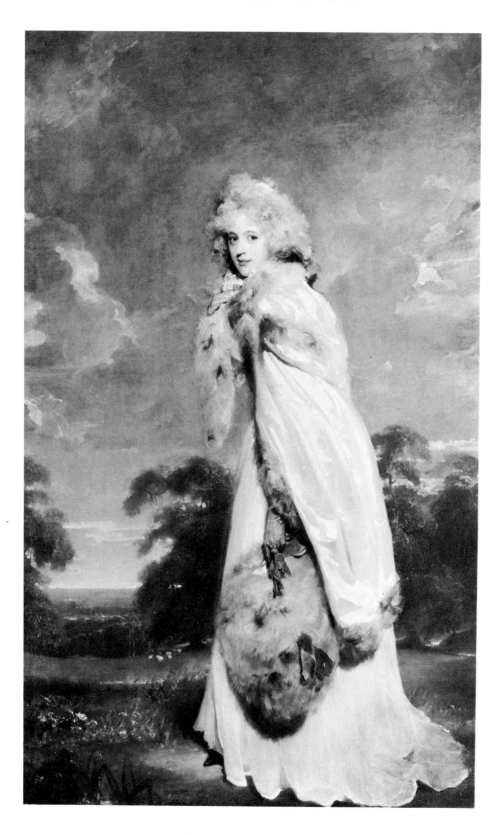

Elizabeth Farren, Countess of Derby *(c. 1759–1829) by*
Thomas Lawrence (1769–1830), oil on canvas 94″ x 57½″.
It's typical of English socialite portraitists to place the
full-length figure practically on the bottom part of the
frame, and to leave plenty of sky above the figure. The
British love fresh air, and their portraits usually have a
scenic, and asymmetrical, background. The Metropolitan
Museum of Art, New York. Bequest of Edward S.
Harkness, 1940.

10
Composition in Portraits and Figures

Portrait paintings were popular in the Roman Empire. In the Christian Era, it was customary for people who donated paintings to a church to have themselves, usually with their families, depicted in one corner of the large painting representing some Biblical scene, or the martyrdom of a patron saint. The donor and members of his family were shown praying, but in such a manner that the faces could be clearly seen. Eventually, likenesses were separated from religious pictures, and the Western tradition of portrait painting was born.

Composition in portraits

You might think that a portrait is a portrait. It has to resemble the sitter (probably in a flattering manner), and that's all. Why talk about composition in a simple portrait? The same belief is shared by many artists painting nude or costumed figures. A figure's a figure, as long as the foreshortening is correct, and the colors are good. This notion is entirely erroneous. A portrait head can be good or bad in composition, and this is true for any figure painting.

Where to place the head

Not only students, but artists as well, have the bad habit of placing the head in the exact center of the support. This places the top of the head at the upper edge of the support, if the support is small; or they start the head about one-third of the height below the top of the support if it's a large one, so that the top part of the support is empty. Because I explained the psychological effects before, I will merely mention here that a head close to the top suggests a very tall person; a head far below the top indicates a very short person, regardless of the size of the support and the painting itself. In a portrait, such effects are damaging, to say the least.

Another common psychological error is to place a head looking left in the left half of the support, or a head looking right in the right half, thus creating the feeling that the person is walking out of the picture. When the torso of the person is included, on a larger support, the effect of walking out is even more pronounced. A normal portrait should be two or three inches below the top, and slightly off-center, leaving more space on the side toward which the sitter is looking than on the side behind the sitter's head.

What view to choose

Normally, the best view is a three-quarter face, in which most typical features come out. A full-face portrait is, as a rule, neither easy for the artist

The following sketches illustrate composition in portraits.

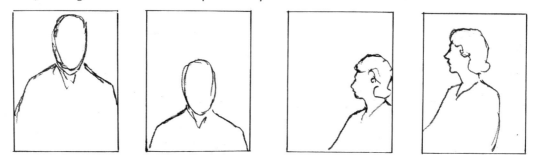

(1) A head placed high on the support looks like the head of a giant. (2) The sitter looks very small, if you place his head too low. (3) Head and torso in a corner look frustrated, or as if the person were just coming into the picture.
(4) A person looks uninterested, ready to walk out, if you place the head and torso near the edge close to the nose and leave plenty of room behind the back.

Sketch of Portrait of a Young Woman *by Roger (or Rogier) van der Weyden (1400–1464). Big headgear fills a lot of space.*

Sketch of Male Portrait *by Dirk Bouts (fifteenth century) has a fez-like hat; the empty space is filled with a corner of a window. Note also the hands on the frame.*

Sketch of Man's Portrait *by Joos van Cleve (1485?–1540) has ample room for both hands, and the big costume fills much of the support.*

Sketch of Self-Portrait *by Peter Paul Rubens also shows both hands. The broad-brimmed hat and snappy dark cloak fill a great deal of space. Note also the column.*

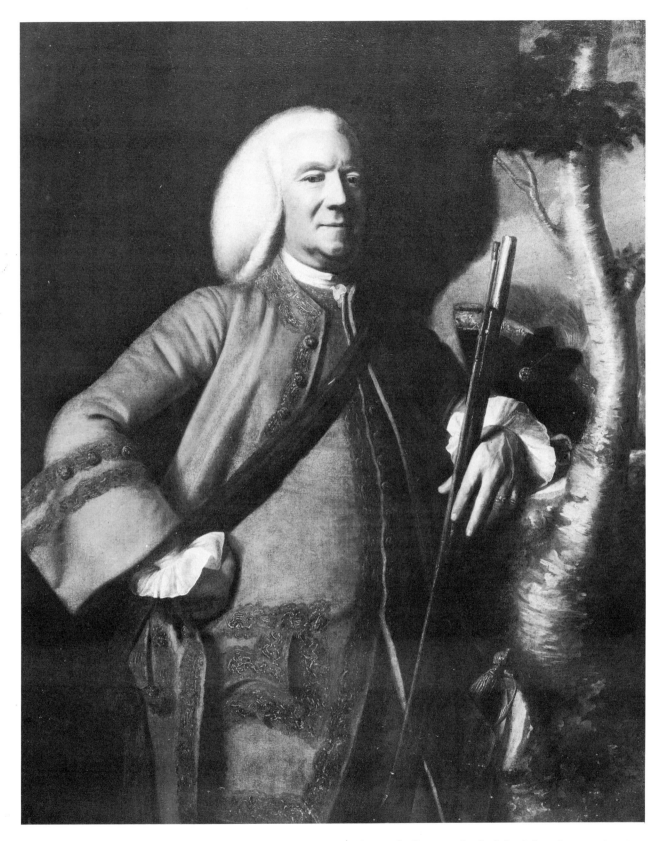

Portrait of Jacob Fowle *(1763) by John Singleton Copley (1738–1815). This is an excellent three-quarter length portrait in oils by the American-born artist, who fled to England during the American Revolution. The belt across the garment and the long-muzzled rifle give the work a* *diagonal effect. Copley had the habit of mixing interior and exterior in his backgrounds. Here, Mr. Fowle stands in front of a huge, dark curtain, but at the same time he leans against a curving tree, and we see a glimpse of sky.* The Corcoran Gallery of Art, Washington, D.C.

nor satisfying to the sitter. The nose and the chin, perhaps the most characteristic features of any face, can hardly be seen from the front; a profile (sideview), on the other hand, may overemphasize a not-so-good nose, and a very big or very small chin. Profiles are painted when someone is famous for that view, as, for example, John Barrymore was. Royalty has been shown in profile on coins and low reliefs since classic Roman times. British postage stamps have a tradition of showing the king or queen in profile.

Composition in the torso

Torso is the name we apply to the upper part, or trunk, of the body, but artists never call it the trunk. Ancient Egyptian art had only stiff figures and heads. The Greeks were masters of graceful human postures and gestures, especially in sculpture. The Romans continued this in their art, and we all prefer a graceful, relaxed, slightly tilted pose. Even in formal, aristocratic portraits, the artist tries to show his sitter as a human being, alive and relaxed, rather than as a plaster cast (or what we could call a stuffed shirt).

It's best to turn the torso slightly in one direction, the head a little in the other direction. This posture causes one shoulder to be a little bigger than the other, so that the portrait looks more lifelike, and it has what we call *motion* in it.

Three-quarter length and full-length portraits

The same principles prevail in the three-quarter and full-length portrait, but the latter can hardly fit the average home as it needs a large wall space, and one cannot see it without stepping back fifteen or twenty feet. Full-length portraits are for royalty, public buildings, and for rich people living in mansions. A three-quarter length portrait isn't too big for a normal house, but big enough to include the hands of the sitter.

What to do with the hands

Hands are very expressive and revealing. Most of us use gestures. We constantly move our hands even while resting. In a portrait, the sitter keeps his arms and hands in the same position as long as the portrait exists. The artist has to select a pose for the hands characteristic of the sitter.

Leonardo da Vinci succeeded in painting the hands of the *Mona Lisa* (Louvre) in a perfectly natural position. The onlooker feels as if she might change their position any minute. As a matter of fact, Leonardo introduced the custom of painting portraits just large enough to include the hands, one of the most important features of this famous portrait. Previously, hands were fully shown only in three-quarter length or full-length portraits. Smaller portraits often had hands in some awkward position, on the frame, for instance.

Choose a natural pose

Ask your sitter to sit comfortably, as if he or she were at home, all alone, or with close friends. But what's natural for the sitter may be odd in the picture. Too much foreshortening in arms and hands looks impossible to the lay viewers, and portraits are mainly done for the sake of lay people—friends and acquaintances of the sitter. What you can do is this: when the sitter feels comfortable, move your easel left or right, until you have a less foreshortened view of arms and hands. All other principles are the same as in a portrait bust. Take special precautions not to let a hand touch a corner of the support, not to cut fingers off.

Full-length portraits

The large size of a full-length portrait requires accessories. In a royal portrait, these accessories would be the huge, ermine-edged cloak and the symbols of power. British socialite portrait painters usually depicted their portrait subjects with scenic backgrounds. The English love of fresh air isn't always sensible. For example, ladies dressed

(Right) **Church Interior,** *oil on canvas 43½" x 33⅜", signed and dated 1668 by Emanuel de Witte (1617–1692), one of the outstanding Dutch artists who enjoyed painting complicated interiors. This kind of subject demands knowledge of architecture and perspective. You have to know how to construct the fundamental forms of the edifice before adding details. The off-centered composition gives the picture more depth; vertical lines are balanced by pointed arches; darks alternate with lights; the back section is lighter than the middle part; rectangular and diamond-shaped decorations or hangings add variety and color.* Collection Mauritshuis, The Hague.

Max Schmitt in a Single Scull, *oil on canvas 32¼" x 46¼", signed and dated 1871, by Thomas Eakins (1844–1916), now recognized as one of the greatest American painters. Eakins was interested in sports, especially rowing. This painting looks like a color snapshot, but every item is placed deliberately where it belongs: the carefully painted steel structure of the bridges in the background; the shores, with the beautiful cluster of trees on the left; the slightly varying angles of sculls and oars; the white undershirts of the men; the red boat in the middle ground; the reflections and patterns nicely filling the otherwise empty sections of the water. The boats, the oars, the arches in the back, the slanting stripes on the water, and the trees on the other shore are all rhythmic forms.* The Metropolitan Museum of Art, New York. Alfred N. Punnett Fund and gift of George D. Pratt, 1934.

Sunday Afternoon on the Island of La Grande Jatte,
oil on canvas 81" x 120⅜", painted in 1884–86 by
Georges Seurat (1859–1891), French pointillist. The
semi-scientific application of colors in dots lends these
figures a certain stiffness; but the composition, based
on baroque asymmetry, is a perfect example of
creating a cohesive linear design. This design runs
up along the curved shoreline, to the more or less
vertical trees on the right, and to the horizontal stripe
of the embankment on the left, in a Z shape which
is echoed in the shadows cast on the grass. Forms
close to the upright edges of the canvas are slightly
curved; boats and figures are distributed with the
utmost care. Nobody has come up with a suggestion
for moving the main figures one way or the other, to
make a better composition. The Art Institute of
Chicago. Helen Birch Bartlett Memorial Collection.

(Above) **Stag at Sharkey's,** *oil on canvas 36¼″ x 48¼″,
by George Wesley Bellows (1882–1925), a member of*
The Eight, *a group of artists banded together to fight
academic formulas in New York in the 1910s. Bellows
caught the best possible moment of the fight in this
painting: the fighters are dynamically curving into
each other; the referee is eagerly watching; the
crowd, many of them cigar-smoking characters, is
tense and excited. The main figures fit into a low,
wide-based pyramid. The post and the slanting ropes
precariously keep the fighters in the ring, both
literally and visually. The composition is as old as the
Baroque, but the technique and the subject are new.
The broad brushstrokes help create a sense of motion.
This is a work in which nobody has been able to move
any part to make a better composition.* The Cleveland
Museum of Art. Hinman B. Hurlbut Collection.

(Right) **Deep Brown, No. 271,** *oil on canvas
32¾″ x 28½″, painted in 1924 by Wassily, or Vasily,
Kandinsky (1886–1944), Russian-born artist and one
of the founders of nonobjective painting. Painted by
an artist who knew how to paint realistically, this
work raises certain questions. What does it mean?
Where's the composition? Perhaps the best answer
is to suggest that you turn it upside-down, or on
either side, and see whether the painting is truly
created in such a fashion that it can only be correct
when it's hung rightside-up. It has the elements of
all good composition: a variety of lines, forms, colors,
and tones. Some of the pieces glow like electric bulbs;
others appear to be in motion. The zigzag line near
the lower right-hand corner has the effect of some
strange lightning.* Collection The Solomon R.
Guggenheim Museum, New York.

The Harvesters, *oil on wood 46½″ x 63¼″, signed and dated 1565 by Pieter Bruegel (or Breughel) the Elder (1525?–1569), Flemish. This painting is asymmetrical, with a zigzagging line going from the lower left upward to the right. It's also a new subject, introduced during the Baroque period: a landscape. In addition, it features common, ordinary peasants, a favorite subject for Bruegel, but not popular in previous times. Note the rhythm of forms in the background as well as in the wheatfield.* The Metropolitan Museum of Art, New York. Rogers Fund, 1919.

Still Life, *oil on canvas 53¼″ x 73″, by Jan Davidz de Heem (1606–1683/4), Dutch (Netherlands). Still life subjects flourished in Holland, where Biblical and mythological paintings were frowned upon by the Protestants. Every imaginable article or object was depicted. Note the wide variety of forms, sizes, and colors in this typically baroque composition, as well as the slanting back of the chair, and the slanting curtain on the right, the slanting tablecloth, and the high pedestal. Note, too, how the trees in the background (left) break the monotony of the vertical edges of the canvas.* The Metropolitan Museum of Art, New York. Charles B. Curtis Fund, 1912.

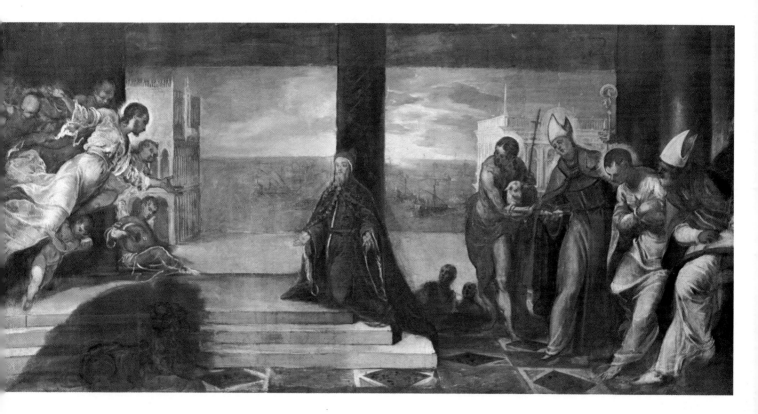

Doge Alvise Mocenigo Presented to the Redeemer,
*oil on canvas 38¼" x 78", by Tintoretto (Jacopo
Robusti, 1518–1594), Venetian. Typical Renaissance
symmetry prevails in this painting, but Tintoretto,
much of whose work is in the asymmetrical baroque
style, has succeeded in creating differences between
the right and left halves. It's especially interesting to
observe how he managed to have each of the figures
on the right, in the presence of the apparition on the
left, show his humble respect in a slightly different
kind of bowing. Architecture plays an important role
in this composition: the pillars accentuate the two
figure groups and the Doge, and the strong horizontal
at the top joins the three together. Note also how the
use of steps leads the eye from the group of figures
(right) to the figure of the Doge (center) and up to
the figure of Jesus (left). The eye is lifted up through
this device, even though the difference in actual
height between the group on the right and the group
on the left isn't very great.* The Metropolitan Museum
of Art, New York.

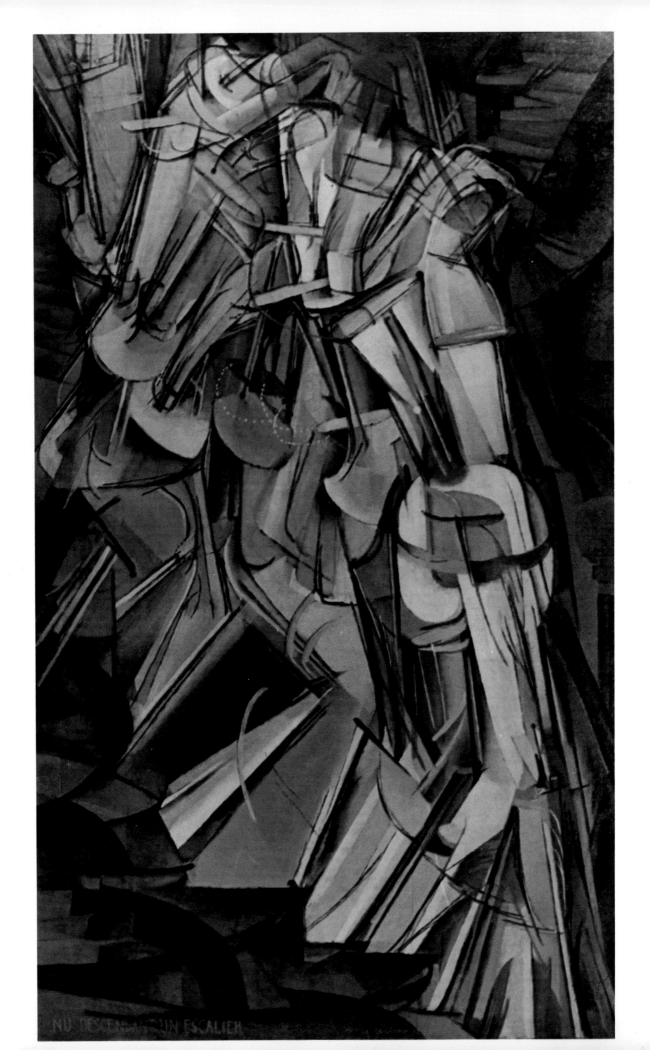

NU DESCENDANT UN ESCALIER

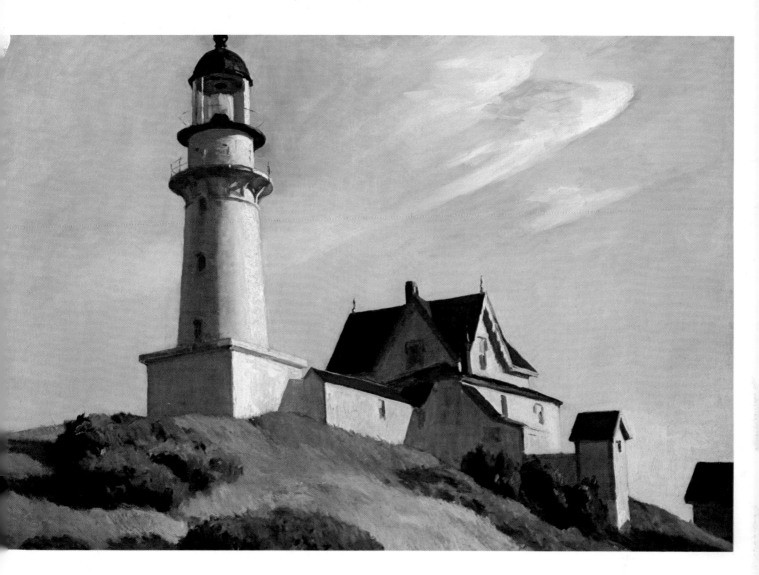

(Left) **Nude Descending a Staircase, No. 2,** *oil on canvas 58″ x 35″, painted in 1912 by Marcel Duchamp (1887–1968), the French artist who shocked the world with this picture (of which he made several versions). Artists of the past gave their paintings a three dimensional feeling. Duchamp added a fourth dimension to width, height and depth: the dimension of time. It does take time to descend a staircase. Inspired by the cubist paintings of Picasso and Braque, Duchamp analyzed the motions of the figure: head, shoulders, chest, arms, and legs swing slightly as they move down the stairs. He separated and simplified each section. The rhythm of motion plays the biggest role in this composition, but at the same time it's off-centered, and has a variety of lines and shapes.* The Philadelphia Museum of Art. Louise and Walter Arensberg Collection.

(Above) **The Lighthouse at Two Lights,** *oil on canvas 29½″ x 43¼″, painted in 1929 by Edward Hopper (1882–1967), famous American realist, who could paint the mood of loneliness, even in a lighthouse. The composition is asymmetrical; the forms are massive, giving only the essential details. Slanting and vertical lines in the structure are broken by curves in the top of the tower, and by the rhythmically curved segments in the ground, which soften the hard, crisp lines of the architecture. The blue sky and the cool shadows enhance the warmth and brilliance of the sunlit walls and the rusty-green and brownish terrain. The eye of the viewer is carried up and down, and all over this serene and solid painting.* The Metropolitan Museum of Art, New York. Hugo Kastor Fund, 1962.

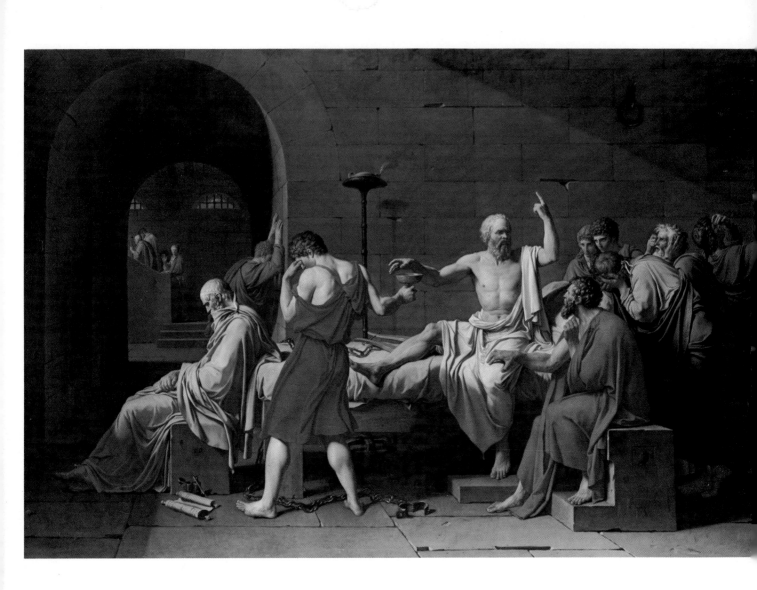

The Death of Socrates, *oil on canvas 51″ x 77¼″, signed and dated 1787 by Jacques-Louis David (1748–1825), French master of the Classic Revival period. Although the theme is from ancient Greek history (Socrates ready to drink the hemlock, the Athenian form of capital punishment), the painting isn't executed in the classic Greek symmetrical form, but follows the asymmetrical composition of the Baroque. Most of the figures are massed toward the right, an arrangement which is balanced by the arched doorway to the left. Every detail is perfect according to academic formulas, but the picture, because of its static quality of arrested movement, leaves us cold.* The Metropolitan Museum of Art, New York. Wolfe Fund, 1931.

The Dort Packet Boat from Rotterdam Becalmed,
*oil on canvas 62" x 92", by Joseph Mallord William
Turner (1775–1851), an English artist and lover of
nature, who didn't mind walking as much as twenty
miles a day. We have reason to believe that this is
the painting to which John Constable, a fellow
nature-lover, referred as "the most complete work of
genius I ever saw." (Constable and Turner are
considered the precursors of Impressionism.) The
painting has a misleading simplicity, but every part
appears to be the right size and in the right spot.
Trace the picture, and try to rearrange any part of it;
you won't come up with a better composition.*
From the Collection of Mr. and Mrs. Paul Mellon.

in silks, bedecked with jewelry, lean against dusty old columns in a garden.

One of the best known of these portraits is *Master Buttall*—the son of a wealthy hardware manufacturer—by Thomas Gainsborough (1727–1788). The painting is universally known as *Blue Boy* (Huntington Library, Pasadena), because he's dressed in blue, presumably a difficult color to use in figure painting, at least according to Sir Joshua Reynolds, who warned his students against the use of blue.

Blue Boy stands outdoors, but the scenery looks as if it had been painted on a big screen for a theatrical backdrop. Similarly artificial outdoor effects are found in a great many of the British portraits. For instance, in *Elizabeth Farren, Countess of Derby* (The Metropolitan Museum of Art) by Thomas Lawrence (1769–1830), the lady appears to be standing almost on the frame, with plenty of scenery behind her. John Singleton Copley (1738–1815), an American-born artist who fled to England during the American Revolution and worked there, combined interior and outdoor settings: people may be sitting on an elegant couch with a beautiful rug under their feet, but this interior, somehow or other, grows into trees and sky. In his beautiful *Portrait of Jacob Fowle* (Corcoran Gallery of Art), the man is leaning against a curving tree, but standing in front of what looks like a huge drapery.

John Singer Sargent (1856–1925), also an American-born artist who lived in England, combined some very "modern" brushwork with the British

Etruscan Vase, tempera on canvas 32" x 23¼", by Odilon Redon (1840–1916), French mystic and poetic painter. Redon expressed his sensitive, delicate, beautiful (but occasionally somewhat bizarre) dreams, or daydreams, in a modern idiom, in which realistic forms aren't necessary. The vase is symmetrical, but the flowers aren't. Nothing is positively defined: some of the blooms, buds, and leaves look almost like insects; there's no visible table or background; and the leaves could very well be feathers. Truly, this is a strange world. The painting proves that the artist can depict inner thoughts as well as visible subjects, and that he can adjust both composition and technique to his temperament or emotion. The Metropolitan Museum of Art, New York. Maria De Witt Jesup Fund, 1951. From the Museum of Modern Art, New York. Lizzie P. Bliss Collection.

standards of elegance in dress and scenic background. Another famous American expatriate, James Abbott McNeill Whistler (1834–1903), painted his portraits under Japanese influence, in the impressionist style. The backgrounds were either dark, merging into the shadows cast by the sitters; or, on the basis of Japanese woodcuts, he indicated an interior—with a screen, flowers, and perhaps a picture on the wall. (Unlike the Japanese, however, he always worked with lights and shadows.)

The most popular of Whistler's portraits showing Japanese influence is *Arrangement in Black and Gray: The Artist's Mother* (Louvre), known as *Whistler's Mother*. It should be remembered that, not so long ago, female costumes and hats were voluminous and picturesque, and it was easier to fill a large canvas with one figure dressed like Whistler's mother than it would be to fill it with a woman dressed in a miniskirt. One of Whistler's most beautiful three-quarter length portraits, *Mme. Camille d'Avouille* (Phillips Academy, Massachusetts) is a perfect example of the kind of composition in which nothing could be moved in any direction without destroying the effect.

Mary Cassatt (1844–1926) also left America to live in France. She painted her sister, Lydia, several times. Two of these portraits are very similar and give a fine idea of how an artist tries to make changes in his own work. Lydia is in the identical pose in both paintings: reclining in an easy chair, reading a book or magazine. In one picture, at the Joslyn Art Museum, Omaha, the couch is darkish, and the background is light and empty; in the other, called *La Liseuse (The Reading Woman)*, at the Norton Simon, Inc. Museum, Fullerton, California, Lydia is in a light-colored easy chair, while the background is darker, showing a garden through the window of a balcony.

Symmetry or asymmetry?

All through the Renaissance (though not without a few exceptions), portraits were as symmetrical as other subjects. The *Mona Lisa* was not only in the center, but it originally had a column on either side, to make it more symmetrical in appearance. A contemporary copy shows the two columns, and we still see the bases of the columns in the picture. We don't know just when, or why, the columns were cut off the panel.

Self-Portrait, 1892, by John Singer Sargent, N.A. (1856–1925). Sargent was an American-born artist who preferred to live in England, but he visited his native country many times. This self-portrait, painted for the National Academy of Design, is one of his boldest and most celebrated works. No flattery was necessary. Even a small portrait like this is off-centered, with more space on the side toward which the face is turned. The light hues of the face are carried down through the collar, the lapel, and a vertical fold in his jacket. The background is lighter on the left than on the right. In order to separate the portrait from this dark section of the backdrop, Sargent painted a very strong highlight around his hair. It looks almost like a skullcap. Collection National Academy of Design, New York.

Mme. Camille d'Anouille by James Abbott McNeill Whistler (1834–1903). This is one of the most striking portraits by the American expatriate. Once again, the figure is off-centered. The charming hat with its veil, the wide lapel, and the puffed sleeves undoubtedly help in creating an interesting design, but none of this is accidental. It's up to the artist to select the right view. The armchair fits into the corner. Lights and darks form contrasting masses which carry the design from a considerable distance. Collection Addison Gallery of American Art, Phillips Academy, Andover, Massachusetts.

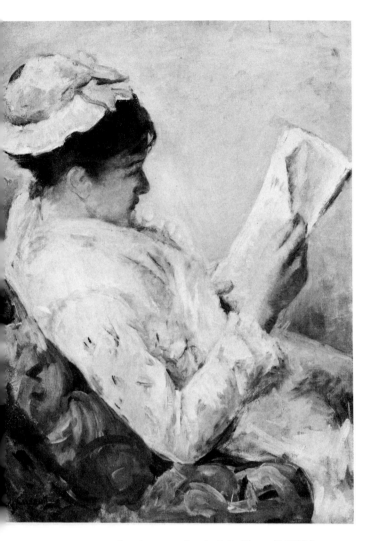

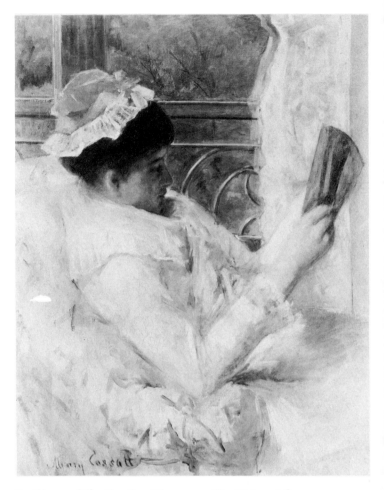

Portrait of Lydia Cassatt, the Artist's Sister (1878) by
Mary Cassatt, oil 30½" x 22¾". The slanting figure, her
upper right arm forming a V-shape with the lower arm,
and the hand holding the paper she is reading, is sitting
in a green easy chair. The background is a simple light
pink color. The left thumb sticks out from behind her
bosom, holding the other corner of the paper. It's a
perfectly natural, relaxed pose, but it had to be selected
by the artist herself. Joslyn Art Museum, Omaha, Nebraska.
Museum Purchase, 1943.

La Liseuse (The Reading Woman, or The Sister of the
Artist, c. 1878) is another portrait by Mary Cassatt. Lydia
is in a similar pose, perhaps in the same cap, but it's
a different dress, and she's holding a darker paper or
magazine. This painting is 32" x 25½", a little larger than
the other canvas, but the figure looks smaller, because the
head is placed lower. The easy chair is light-colored, but
the background shows the most noticeable difference: it
has a light lace curtain on the right; the rest is a view of
trees and foliage through an open window, which must
have a balcony with a railing. The interesting fact is that
an experienced artist often does the same subject in
several versions, with minor or major alterations. Collection
The Norton Simon, Inc., Museum, Fullerton, California.

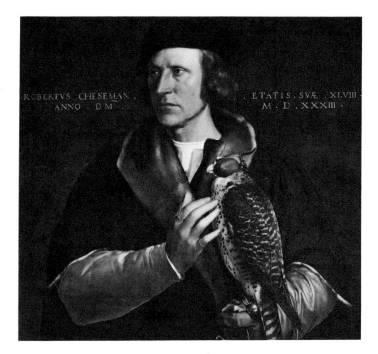

Robert Cheseman, Falconer of Henry VIII by Hans
Holbein the Younger (1497–1543), the German artist who
worked chiefly in England. One of the most interesting
features of this powerful portrait is that the canvas is
wider than it is high. Holbein felt that the wide-sleeved
coat would look better on the wider support. The half-
figure fits into a pyramid, slightly off-center. The lights
on face and neck are carried down the V of the neckline,
through the graceful fingers, into the claws of the falcon.
Otherwise, the bright face would almost jump out of the
picture. Collection Mauritshuis, The Hague.

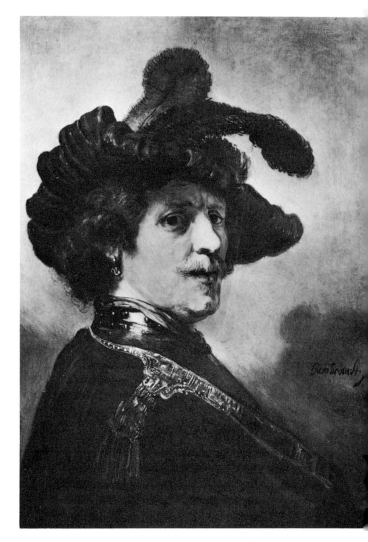

Self-Portrait as an Officer by Rembrandt van Rijn, who
painted himself many times. These paintings leave us a
complete set of mercilessly truthful pictures of a once
young, handsome, dashing man physically deteriorating
through the years, but retaining his indomitable spirit as
an artist. Here he's wearing a plumed hat which easily
fills the upper part of the canvas. He turns his head
slightly right, and looks straight into his own eyes, and
into the eyes of the onlookers. This is the kind of portrait
in which the eyes seem to follow the viewer. The darks
and lights, the variety of forms in hat, garment, and
shadow, make this one of the master's most striking works.
Collection Mauritshuis, The Hague.

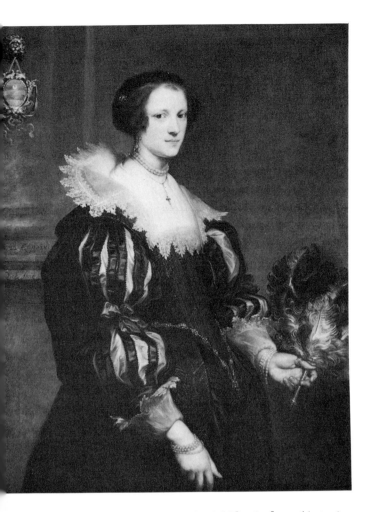

Anna Wake, Wife of Sir Sheffield by Anthony (Antonis, or Antonius) van Dyck (1599–1644). Today, a woman's portrait could hardly fill a big canvas as easily as it did in the seventeenth century. Our most fanciful gowns aren't as huge as those women used to wear. But one has to admit that even van Dyck had some trouble with the hands of this sitter. The right hand is stiff, the left is holding the feather fan with apparent reluctance. The beautiful head, with the lace collar and nothing else, would be a perfect masterpiece. Collection Mauritshuis, The Hague.

Portrait of Albert Pinkham Ryder (1847–1917) by Julian Alden Weir, N.A. (1852–1919), painted for the National Academy of Design. A first-rate portraitist succeeded in catching the personality of Ryder, whose mystical and imaginative paintings were later accepted as some of the finest in American art. Slightly to the left, in order to give the left hand enough space, the bearded artist appears to be ready to step out of the picture and talk to you. Trace this simple work, try to move head or hand in any direction. You'll see that it cannot be done. Collection National Academy of Design, New York.

Head of an Italian Woman, 1887, by Frank (Decker) Duveneck, N.A. (1848–1919). The complex headgear, fashionable in fourteenth- and fifteenth-century Europe, still exists in some sections as part of the national or folk costume. Such a headdress makes a good design, even if it isn't executed with all the detail customary in past periods. Note that the head is off-centered, one shoulder is lower than the other, and there's plenty of space on top and on the sides. Collection National Academy of Design, New York. Photograph, Frick Reference Library.

Albrecht Dürer (1472–1528), Hans Holbein the Younger (1497–1543), Lucas Cranach the Elder (1472–1553), and other great artists of the period painted in symmetrical fashion. Some of Rembrandt's formal portraits are centered, although he was a Baroque master (1606–1669). Peter Paul Rubens (1577–1640), Anthony Van Dyck (1599–1641), and other baroque artists followed the off-centered style, and most modern artists stick to this composition in portraiture.

Cutting off the top

It may sound like an exaggeration, yet it's the simple truth that almost all art students and inexperienced artists begin the head on the top edge of the support. Very often, the artist realizes later that the head is too small, or that he's forgotten about the hairdo, so that there isn't any space for enlarging the head or adding to the hair on the support. Thus, the top of the head is cut off, while there's plenty of space at the bottom. Such cutting off is as bad as placing the head in a corner.

You occasionally see an advertisement in which the top of the head is cut off, as in a certain hair-coloring ad. A double-spread shows the profile of a beautiful woman, the top of the head and the bottom of the chin cut off in a picture bigger than life. The hair takes up the rest of the pages, with the name and qualities of the hair-coloring announced in the space left in front of the face. This isn't a portrait, it's a commercial piece of work. There are many other instances of cutting parts of the head off in order to emphasize a commercial product, but this shouldn't be done in a fine arts painting.

Backgrounds for portraits

I've already mentioned the British love for outdoor location in portraits, or in the combination indoor-outdoor location settings typified by Copley and also used by other English portraitists. In medieval portraits, many men as well as women were shown wearing hats or headgear, which in many eras was very large and/or complicated. Such headgear took up most of the support. Yet, we often find a window in the room with a view through it. Most small portraits, however, had only color as a background, with the proper shadows. Larger portraits not only had scenery, but interiors depicted

with as much precision as the face and clothing. Columns and drapery often filled empty spaces.

Although Gothic artists painted whole cities and other outdoor scenes in the finest detail as backdrops for portraits, it was Leonardo da Vinci who popularized a soft-hued, romantic background with his *Mona Lisa* (Louvre). This portrait has many "firsts," even though it isn't a true portrait, but an idealized head, with the same features, the same smile, that the master employed in all his heads, male or female (except in the *Last Supper*, and here nobody had any reason for smiling). His blue-green background of a mysterious landscape was imitated by many European artists.

In baroque portraits, more than in those done during the Renaissance, drapery, and huge, billowing curtains, furniture, and all kinds of objects filled the space. A *Portrait of Louis XIV* (Louvre) by Hyacinthe Rigaud (1659–1743) shows the Sun King with so much, and so heavy a kind of drapery, besides his huge cloak, that the king appears to be standing in a gorgeous cave about to fall down on him. A lovely portrait of *Madame de Pompadour* (Louvre), celebrated mistress of Louis XV, by Maurice Quentin de La Tour (1704–1788), depicts the Marquise, in her voluminous, brocaded dress, sitting at her table, which is loaded with books, a globe of the earth, and backed by heavy drapery.

The seventeenth and eighteenth centuries constituted almost a different world. Compare the portrait of *La Pompadour* with that of *Walter Rathenau*, noted German industrialist, statesman and writer, by Edvard Munch (1863–1944), painted in 1907, and you'll understand what differences in taste and style can exist in the history of art. Most recent portraits have very simple backgrounds, although a room, perhaps a window, a door, a curtain, or a desk may be indicated.

Keep the background in the back

The importance of a background is to enhance the portrait, not to overwhelm it. Keep it subdued, simple, so it won't jump forward. If you do add an interior or a scenic backdrop, avoid lines and forms which are parallel to parts of the figure, or which appear to be growing out of an ear, a chin, an elbow, or some other part of the sitter. Does this sound funny? Well, it's much funnier to see than to hear. Among many examples I could give

It's alright to cut off a chin, the top of a head, an eye, a forehead, etc., in an advertisement. (Above) In a double-spread color advertisement for Roux hair-coloring, the hair is the important thing. (Below left) In this ad for Wear-Dated shirts, only the shirt matters. (Below right) This corner of a face urges you to give Piaget jade.

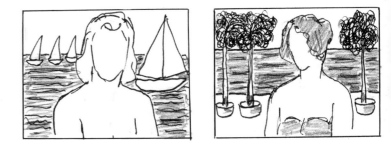

Many art students think that a realistic background adds value to a portrait or figure painting. It does, if it's well done, and if it's in keeping with the appearance and mood of the portrait or figure. In the sketch to the left, however, a sailboat practically sits on the woman's shoulder. In the sketch to the right, trees are placed on a sandy beach in the kind of concrete containers used in some sections of New York City, where the planting of trees in the ground is impossible. The water stands up in both pictures, instead of receding to the horizon.

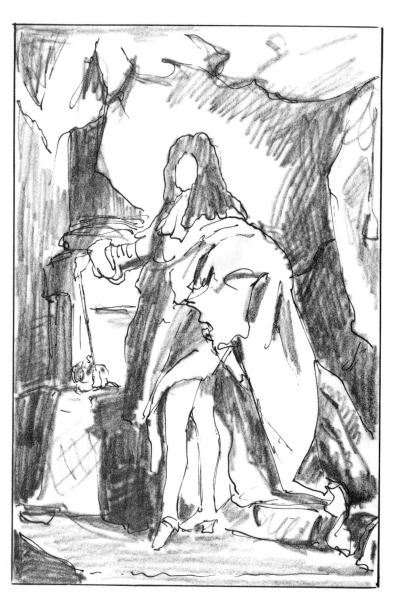

Royalty, in full length, had to look impressive. In addition to the ermine-bordered, voluminous cloak, we find a column, a table with the royal crown, and heavy drapery on top and on the right. All this fills the space in this sketch of a Portrait of Louis XIV by Hyacinth Rigaud (1659–1743) in the Louvre.

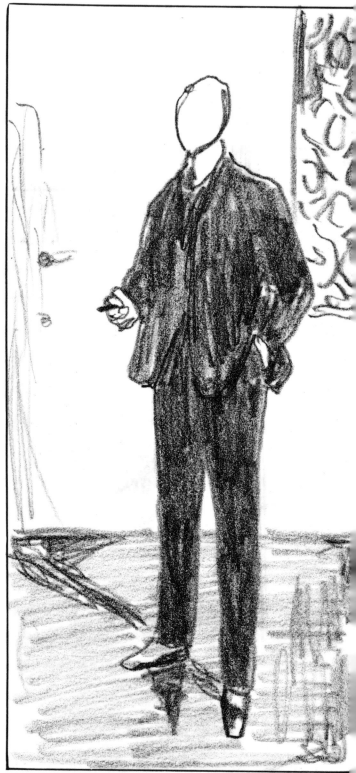

Compare the portrait of the Sun King with that of Walter Rathenau (1907), the famous German industrialist, writer, and statesman, by Edvard Munch (1863–1944). Of course, there's a difference in rank as well as in era, but even royal portraits are executed in a simpler, more straightforward, manner in the art of our time.

you, I'll mention only one: a student of mine painted an exotic-looking face and the upper body, and then added a tropical background consisting of two coconut palms which appeared to come out of the woman's head. Several coconuts were dangling like costume jewelry worn in the hair, rather than on a garment.

Above all, don't paint scenic or other backgrounds from memory. Use at least good photographs, and copy them correctly, in proportion to the portrait. Nothing is more ludicrous than to see a huge sailboat practically resting on the shoulder of a woman, or finding trees in concrete containers on a sandy beach, merely to fill the space.

Colors in portraits

Most portraits are commissioned: the artist is engaged to paint a portrait in a predetermined size and at a certain price. It isn't a work in which the artist can do whatever he likes. More often than not, the sitter has a color scheme in mind which the artist has to follow, in background as well as in the apparel worn by the sitter, so that the portrait will go well with the rest of the room in which it will hang.

I once had the difficult task of painting a woman in a dress she liked, but in a different color, as she didn't like the color of her own dress. These are deplorable conditions, just as it's disagreeable, to say the least, to be forced to eliminate lines, birthmarks, double chins, etc., in order to flatter the sitter. Still, a good artist can paint a pleasing portrait by being aware of the "don'ts" in composition, and by harmonizing portrait and background in color and value.

Composition in figure painting

I'm speaking of figure painting as it's practiced in all major art schools, and by a great many accomplished artists, who consider figure painting the apex of the pictorial arts. A figure is more complicated than a portrait; it's also more creative. Artists like to paint figures in unusual poses or performing some kind of action. Props are often included: furniture, drapery, scenery—and these aren't simply space-fillers in a serious painting; they're integral components of the whole picture.

Shape of support for figures

Perhaps more than in any other subject, the wrong shape can kill a figure painting. Make sketches and try to visualize the figures with their backgrounds before deciding whether the composition fits a horizontal, a vertical, or a square format. The size matters, too, as a very small figure may be difficult to paint—unless you're practically a miniaturist, and have small brushes, or work in aquarelle, in which medium small figures are fine. In oils or polymer, a larger size is recommended. If the support isn't big enough, don't try to paint the whole figure.

Major mistakes

In figures, just as in scenery and still life, a head placed too high with a lot of empty space at the bottom is ridiculous; head and figure placed too low, with a huge empty space on top, is also bad —unless you're painting a figure reclining in the grass, with a beautiful sky above. I've seen beginners paint a reclining figure across the center of the support, as if the figure were being levitated by a magician.

An everyday error is to place the head in the center, even when the body, especially the legs of the figure, is extended to the left or right, perhaps touching the edge of the support. This layout leaves about half the support behind the figure empty, as if the person depicted were mad at the world, and were turning his or her back on it.

The most common mistake is to leave a great deal of space above the head and cut the feet off, or to have the head up at the top, the feet dangling in mid-air. Grave errors of taste as well as of judgment are occasionally involved, as when a back view represents the model sitting exactly on the bottom of the frame; or when a front view of a nude is painted so that the lowest point of the pubic area stands exactly on the frame. Taste is taste, even in our permissive age.

Where to cut the figure

If you don't paint the entire figure, don't cut it across the nipples, across the pubic area, or across the knees. Terminate the picture above or below such sections. Perhaps I needn't repeat that little bits, such as toes, fingertips, the top of the head

Here are some of the common mistakes made in figure painting.

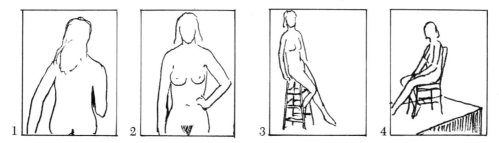

(1) Don't let the model literally sit on the bottom of the frame. (2) Don't let the pubic area stand on the frame. (3) Don't push the figure too far on any side or into any corner. (4) Don't cut off one part of the figure, while there's ample space for it.

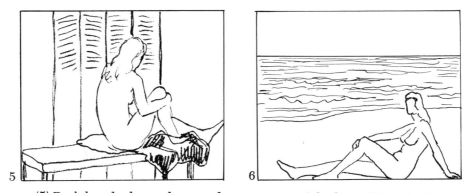

(5) Don't let a background seem to be growing out of the figure. (6) Don't place a sitting or reclining figure on the bottom section of the frame.

(7) Don't make a reclining figure look as if it were being levitated by a magician. (8) Make sure the figure occupies as much space as is necessary.

A student of mine began a painting by placing a small head at the center top of a 30″ x 18″ canvas (left). He explained that the model was sitting in a chair, on a platform. He drew four slanting lines, in incorrect perspective, suggesting the platform. Then he added the chair, in fairly correct proportions (center). I took a stick of charcoal and connected the small head on top with the chair (right). The moral: *make a layout before you start painting.*

or a corner of the elbow shouldn't be cut off. Move your figure left or right, up or down, in order to avoid such accidental cut-offs.

Accessories

Chairs, sofas, stands, and anything closely connected with the figure and the pose have to be selected with care and "posed" just as the figure is posed. They have to be drawn and painted together with the figure. In my experience, students do the figure without indicating chair or sofa. They expect to place such items underneath the figure afterward. In composition, there's no such thing as afterward. Everything has to be composed at the same time.

One of my students, working on a 30″ x 18″ canvas, tried to paint a model sitting on an ordinary chair, on a platform, directly with paint and brush, instead of making a charcoal layout first. He put the head of the model, a two-inch-high ellipse, in the center, right below the top. I asked him why he put it so high. He said the model was high as she was sitting in a chair, and the chair was on a platform. I asked him to show me where the platform and the chair would be. He drew, with the brush, four lines, slanting in different directions, in absurd perspective, and he drew the chair on it, in correct proportions. I then took a piece of charcoal and drew the rest of the figure, from the head down to the chair. It turned out to be an incredibly tall person, with short legs dangling over the edge of the platform (see illustrations). My sketch spoke for itself.

You have to calculate the size of the figure by the size of the head, and place it on the support accordingly. This is the first step in figure composition. You can still have a good enough picture if a tree is too big in a landscape, or if a pear is in the wrong place in a still life, but when anything is wrong with the figure, it's a bad painting.

Floors in figure paintings

Full-length figures have to stand, sit or recline, and you have to show where they are. The floor is very often a necessity. Don't draw it at random, with a line across the center of the support, as artists do with tables in still lifes. Look at the visual position of the floor line, as compared with other parts, normally the legs, of the model. Make sure the floor is big enough for the figure and any possible furniture you are going to add to it. If the figure is leaning on a dresser, the floor has to be underneath the dresser.

Backgrounds for figures

Practically the same principles prevail in backgrounds for figures as in backgrounds for portraits, except that a figure, nude or costumed, may very well be on a beach, in a meadow, in a forest, in a room, on a terrace, in a garden, and so forth. Such complex backgrounds, however, are only possible when there's plenty of room for them. When the figure covers practically the whole support, a simple floor and a simple background are the best. When you add a scenic backdrop, have pictures or photographs to work from. I constantly warn artists against painting from memory, unless they have a great deal of professional experience. Even then, the result is usually a *kitsch,* that is, an artwork without any esthetic value, done for the sake of satisfying popular, cheap taste.

Different styles, identical principles

Individuality is highly regarded today, often to the detriment of sound knowledge. Artists try to be "different." Yet, the artists who created the most famous pictures in modern times have studied in art schools and scrutinized the works of Old Masters. They became famous by adding a new touch to what they had learned. Fine and occasionally unforgettable figure compositions have been produced by members of the expressionist school.

Edvard Munch (1863–1944), Ernst Ludwig Kirchner (1880–1938), Chaim Soutine (1893–1943), Max Beckmann (1844–1950), Oskar Kokoschka (1886–), Pablo Picasso (1881–) in his earlier works, and many others, have painted figures in new styles. Basically, though, they all followed the established principles of composition. Trace the linear forms in their pictures, and you'll find them very similar to those in works by Baroque masters. A Picasso composition might be finished to look like a Rembrandt, while a Rembrandt composition might be finished to look like a Picasso, by merely changing the style and the level of execution.

Le Foyer by Hilaire Germain Edgar Degas (1831–1917), oil on wood 7¾″ x 10⅝″. It's hard to believe that so much could be painted on so small a panel, but composition knows no size limitations. Every figure and object is in the right place, including the dancer on the far right, the lighted crack between the door wings, the standing mirror with its reflections, the elderly violinist, and his violin case on the floor. The picture is full of life, but every detail was caught by the artist. The Metropolitan Museum of Art, New York. Ḥ. O. Havemeyer Collection.

11
Composition in Illustrative Subjects

There's a difference between illustrations and illustrative art. Illustrations are intended to depict events, actions, and episodes in books or magazine articles. Illustrations are reproduced in the text, and usually have captions from the text. Mostly, illustrations are done by artists who did not write the books or stories. Occasionally, the author does his own illustrations, combining his word images with his pictorial images in a highly personal and effective way.

Illustrations may be world-famous, as in the Bible illustrations by the French artist, Gustave Doré (1832?–1883); spiritual as well as highly individual, as the illustrations of William Blake (1757–1827), the English artist-poet, who illustrated and etched or engraved not only the pictures, but often the entire text as well; exciting, somewhat pornographic, as the pen-and-ink drawings by England's Aubrey Vincent Beardsley (1872–1898); satirical, as the thousands of lithographs by Honoré Daumier (1808–1879), the French caricaturist and painter.

Illustrative fine arts

In the fine arts, the term *illustrative* is applied to pictorial works which represent stories from history, religion, mythology, or events of any sort, in a self-explanatory fashion, with a title, but without any caption. The story as it is painted is the artist's own creation; his own personal vision or visualization of a scene.

Until the popularization of still life, landscape, *genre*, and interiors in the second half of the sixteenth century, practically all art in the Western world, except portraits, was illustrative. Today, the term is often employed in a derogatory manner. Story-telling pictures are frowned upon by many people who forget that Botticelli, El Greco, Tintoretto, Titian, Rubens, Leonardo da Vinci, Michelangelo, Rembrandt, and so many others, were all illustrative artists. There's no reason to believe that a present-day artist painting an illustrative work might not be equally great.

Composition in illustrative subjects

The artist has to be thoroughly familiar with every detail of his subject. In the old days, in the absence of reference libraries and photographs, there was plenty of copying, imitating, even downright plagiarism in art. There were plenty of anachronisms, too. Armies of Biblical or classical times were depicted with the armor and weapons of the fourteenth or fifteenth century. The main idea was to make the story clear to all those who were supposed to know what it meant. A Christian had to understand all Biblical pictures, and a certain kind

of education was required for the understanding of mythological or historical pictures.

Composition was symmetrical in the Renaissance, asymmetrical in the Baroque and afterwards. Beauty, effective coloring, a good contrast between lights and darks, can always be found in the fine paintings of these periods. Every important artist had his own personal preferences in color, form, and design, as well as in such details as faces and figures, and the amount or kind of action depicted. El Greco liked narrow faces, hands, and figures, with striking, lightning-shaped highlights, and powerful darks; Rubens loved plump, overfed men and women, with a great deal of action; Titian painted his daughter, red-haired Lavinia, in most of his paintings; Rembrandt used refugee Jews in Amsterdam for his Biblical paintings and etchings, and his nudes were typical, simple Dutch women.

Not all old paintings are great

It should be remembered that not every painting executed a few centuries ago, not even every work by a truly great artist, is equally good. Some are surprisingly bad, for example Leonardo da Vinci's painting *Virgin and Child with St. Anne.* The face of St. Anne is superb, but the figures are in a clumsy composition. This work isn't far from the center of the long gallery in the Louvre where the *Mona Lisa* hangs, protected by plate glass and constantly admired by crowds. Hardly anyone stops to look at *St. Anne.*

The fact is that, regardless of style and subject, the works which have grown on us are the ones without the compositional errors, the many "don'ts" I've described and explained from a psychological and optical viewpoint. You can look at a painting like *The Adoration of the Shepherds* (The Metropolitan Museum of Art) by El Greco any number of times and you'll like it more and more. You see lines and forms moving around and returning to wherever you started to look at the painting.

The Rape of the Daughters of Leukippos (Alte Pinakothek, Munich) by Peter Paul Rubens is in an entirely different vein, with prancing horses, stalwart men (Castor and Pollux), and fat, kicking, rosy-cheeked girls, plus a cupid on the left. Somehow or other, you always see the whole picture; one line, one form, carries your eye to the next, all around, and all over. You may not like

the extra-plump women of Rubens, or the extra-tall figures with their peculiar legs in the El Greco painting, but you'll admire both works.

Similar satisfaction for the eye is found in *Le Foyer* (The Metropolitan Museum of Art) by Hilaire Germain Edgar Degas. Although the picture looks like a snapshot catching a moment in a group of ballet dancers, everything is in the right place, including the violin case on the floor, the standing mirror which cleverly reflects a couple of ballerinas, the single girl at the wall on the right, and the bright vertical crack between the wings of the door. Try to cover up any of the sections: you'll see that nothing could be moved in this picture without ruining it.

The Day of the God (Art Institute of Chicago) by Paul Gauguin (1848–1903) is also an illustrative painting, but completely individual and picturesque.

The age of formulas

Artists of the Classicist or Classic Revival period firmly believed in definite, irrevocable, infallible formulas in art. Perhaps the most important torchbearer of this period was the French painter, Jacques-Louis David (1748–1828), a fanatical admirer of Napoleon. His large painting *The Coronation of Napoleon and Josephine*, in the Louvre, has as accurate a draftsmanship, and as perfect an off-centered composition as one can ever hope to see. Yet, to us, the painting is a huge photographic enlargement, in full color, of a glittering scene on a marvelously realistic stage.

His *Death of Socrates* (The Metropolitan Museum of Art), a typical example of his pictures based on classic Greco-Roman history, is also done in every detail, from the highlights on the men's toenails to cracks in the wall. Socrates is about to take the cup of hemlock he has to drink—the ancient Greek form of capital punishment. It would be impossible to correct the drawing or composition in this picture, yet it leaves the onlooker cold. It proves that academic ingredients aren't enough (see color plate).

Illustrative subjects in modern times

Biblical subjects are only used in some churches; mythological and historical subjects may be found

The Day of the God (*Mahana no Atua, 1894*) *by Paul Gauguin (1848–1903), oil 27⅝″ x 35⅝″. With all his originality (derided at the time), Gauguin utilized the same principles of horizontal, slanting, zigzagging, spiraling, meandering lines, the asymmetrical arranging of figures, which were the foundation of compositions by Rubens and other Old Masters. The roundish clouds and swirls in the water add variety; the exotic colors harmonize with the scene and its location.* The Art Institute of Chicago. Helen Birch Bartlett Memorial Collection.

COMPOSITION IN ILLUSTRATIVE SUBJECTS 143

(Left) **The Adoration of the Shepherds** by El Greco (1541–1614), oil on canvas 43½" x 25⅝", signed in Greek, as usual: "Domenikos Theotokopoulos made it." This, of course, was his real name, but the Spanish called him simply El Greco, that is, The Greek. Done three hundred years before present-day exaggerations and distortions, this work is full of peculiar features, such as the odd-shaped legs of the tall figure on the right, the long torso of the kneeling shepherd, the head of the cow between the two figures, the billowing drapery. These impossible details vanish from your mind as you observe the total composition. Lightning-bright strokes come down from the flying angels, through all the figures, and go round and round among the darks of the background. The Metropolitan Museum of Art, New York. Bequest of George Blumenthal, 1941.

(Above) **Guernica**, 1937, by Pablo Picasso. This 11'6" x 29'8" mural in oil on canvas memorializes the destruction of the small Basque town of Guernica in Northern Spain by German planes serving the insurgents in the Spanish Civil War, in 1937. Picasso made many sketches before executing the huge painting, which signals his "monster" period. There's nothing the viewer couldn't understand in this abstraction: a mother holding her dead baby, a man trampled on the ground, his sword broken, and so forth. The asymmetry of the composition is obvious, its linear quality enhanced by the outlines employed in the work. These lines create a sort of jigsaw puzzle as they cross and recross each other, up and down. There's no central subject, every part of the painting is of equal significance. On extended loan from the artist to The Museum of Modern Art, New York.

This book has a color reproduction of Sunday Afternoon on the Island of the Grande Jatte *by the pointillist painter, Georges Seurat (1859–1891). I made a number of sketches by tracing the main figures in the picture, then moving them one way or another. In each case, the painting looked very bad. I am showing two of these traced sketches; the others were even worse. Seurat was very scientific, and much thought went into his work. As a result, I don't believe that anyone could make improvements in this painting. I don't mean to imply that another artist, or Seurat himself, might not be able to paint the Grande Jatte in a totally different manner. But the present composition is as good as it can be.*

in libraries, public buildings, post offices, some banks, and even cafeterias. Most of these, unfortunately, have to please lay audiences, and are more like aggrandized posters than artistic creations. Still, there are outstanding muralists working in contemporary idioms.

In the United States and abroad

Pierre Cécile Puvis de Chavannes (1824–1898) was one of the most respected muralists in France in the nineteenth century. His long mural running around the rotunda of the Panthéon in Paris depicts the life of St. Geneviève, patron saint of the city, in soft colors. Mexican artists created a Renaissance of true fresco painting in recent times. They were given a free hand by the Government, which paid them according to the scale of ordinary housepainters, but enabled them to produce some of the largest as well as most remarkable frescoes in the world.

José Clemente Orozco (1883–1949), Diego Rivera (1886–1957), and Alfaro Siqueiros (1898–) were among the most celebrated of these Mexican muralists. They depicted their own revolutionary ideas and events, in a style combining baroque composition with Mexican folk art conventions and colors, and proved that modern murals can be highly individual.

In the United States, John La Farge (1835–1910) and Edwin A. Abbey (1852–1911) became immensely popular, but they followed in the footsteps of European academic artists. Among the most famous artists of our time, Picasso has painted a mural on canvas: *Guernica* (Museum of Modern Art). The painting is an indictment of the destruction of a Spanish town by Hitler's air force in the Spanish Civil War. Painted in 1937, the mural is 11′6″ x 29′8″, and the artist prepared scores of sketches before starting to paint the big canvas. No matter how modern it may be, it contains the same elements of good composition you find in baroque art.

A much more cheerful painting of an illustrative nature is *Sunday on the Island of the Grande Jatte* (Art Institute of Chicago) by Georges Seurat (1859–1891), the French pointillist who applied

small dots with the tip of a brush to achieve interesting color effects. The almost scientific application of paint, to which Seurat fanatically dedicated his life, manifestly caused a certain stiffness in the figures and forms. Yet, the painting is alive if you watch it for a few moments.

Consider the color reproduction of Seurat's painting and look at the sketches I made on tracing paper, moving some of the main figures this way or that way. I am sure another artist, or Seurat himself, at another time, might have painted the Grande Jatte in an entirely different composition, with different figures, and the painting might have been just as good as this one. The point, however, is that in this particular picture you cannot move any of the main groups or figures (except for some of the small figures in the distance, which aren't so important) without destroying the composition.

Look at the color reproduction in the color section of this book of *Stag at Sharkey's* (Cleveland Museum of Art) by George W. Bellows (1882–1925), a member of *The Eight,* a group of artists banded together around 1910, in New York, in rebellion against academic authority in art. The free, bold brushstrokes give this painting a feeling of powerful action. Bellows caught the most vivid moment: the fighters pummeling each other, the referee watching eagerly, the public tense and excited. Try to move the figures one way or the other, and the picture will be that much weaker.

These and other present-day, or recent, illustrative works prove very clearly that any type of art can be great when the artist is great and knowledgeable. You might spend a little time looking at reproductions of masterpieces: place tracing paper over them; trace the most important features, and move them left or right, up or down; make them bigger or smaller. You'll find that you couldn't make the pictures better, even if you feel you could have done an entirely different picture of the same subject and yours would have been better. And, oh yes, you might make such tracings of your own paintings, and see whether you might not be able to improve certain things in them. I've done it with my own work, and it was a profitable experience each time.

Stag at Sharkey's *by George Wesley Bellows (1882–1925), painted in 1907, has motion and dramatic power (see the reproduction in color). In this sketch, I tried to move the figures to the right. The result is a big empty space on the left and too much subject in the diagonal lower half. Here, too, it's best to leave well enough alone.*

Lady with a Lute by Jan Vermeer (Jan van der Meer van Delft, 1632–1675), oil on canvas 20¼″ x 18″. This is a typical interior by the Netherlands artist famed for his ability to depict light streaming in through a window. Horizontal lines, vertical lines in the window frame, the wall map, and chair alternate with slanting lines in the curtain, the musical instrument, the table top, and the table cover. Darks and lights are important features of the composition. The Metropolitan Museum of Art, New York. Bequest of Collis P. Huntington, 1925.

12
Composition in Interiors

Interiors are a very fine pictorial subject, and perhaps the most difficult outside of figure painting. In European countries, the French word, *intérieur,* is usually employed. French words, such as *collage, genre, en grisaille,* and *trompe-l'oeil,* are as common internationally in art as Italian words and terms are in music.

Interior, or *intérieur,* means that the main subject is the inside of a house, a room, hall, church, palace or any other building. The variety is colossal, as interiors range from the leaky garrets of Bohemian artists and hovels of poor people to the ornate dining or reception rooms of baroque palaces, the naves and aisles of Gothic cathedrals, or to the dungeons and the imaginary jails of Giovanni Battista Piranesi (1720–1778).

Interiors as backdrops

Early Christian pictures showed little, if any, background other than some color or gold leaf. In the Renaissance, artists obviously enjoyed their perfected knowledge of perspective, and painted exquisitely detailed classic interiors, even when such an interior couldn't possibly have been the location of the event depicted. Jesus and his Disciples can hardly be imagined in sculpture-laden Roman palaces. But despite the Renaissance fascination with perspective, figures remained the main theme. In the Baroque, the interiors, still great architectural representations, were more vivid. This was due particularly to the fact that the view wasn't symmetrical, and the off-centered composition enabled the artist to see more space behind the figures.

Interiors as main subjects

Interiors done as easel paintings became popular in the seventeenth century in the Netherlands, in certain German states, and in other sections of Europe where Protestantism objected to the glorification of human beings in art. The subjects acceptable to the most puritanic Protestants were equally acceptable to Roman Catholics, especially among the ever-growing middle class, which preferred pretty and easily comprehensible conversation pieces.

Architecture and perspective

Architectural knowledge and a full grasp of perspective are of equal significance in interiors, which are more complex than exteriors. The outside walls of houses have a comparatively simple perspective: a change in the direction of horizontal lines, and a diminishing of sizes with distance. If you can draw one house, you can draw a whole

*Fair Student by Daniel Huntington, N.A. (1816–1906),
an academic, sweet Victorian subject, to be sure, but a
perfect example of composing a girl reading in an interior.
Note the slanting lines of table and book, and how the
design of the candle-holder on the left breaks its vertical
shape. Note also how the light carries diagonally from the
upper right-hand corner down the face, neck, shoulder,
right hand, arm, and the book. Compare this picture with
Picasso's Girls with a Toy Boat (p. 166) and imagine the
girl, the book, and everything else in the style of that
painting. Or, vice-versa, imagine that painting executed in
this Victorian style.* Collection National Academy of
Design, New York. Photograph Frick Reference Library.

street. The interior, on the other hand, includes doors, alcoves, arches leading to other rooms, often ornate floors, ceilings, and windows through which you see the outside world.

Then there are the details: furniture, curtains, mirrors, chandeliers, pictures on walls in homes; altars, choirs, pews in houses of worship, not to mention the innumerable small items. Human figures are often added—on a small scale in churches, and on a large scale in *genre* pictures, in which the interior and the figures may be of equal importance. As a matter of fact, figure compositions of any kind often require at least a suggestion of the interior in which they are depicted.

Composition in interiors

Select the best view of the interior you wish to paint. But how? In a large public hall, the nave of a huge church, you can see a great deal from a certain point. A house, however, is normally small, and you can hardly go back far enough to see any part of it clearly. There are objects in the center, a table with a vase of flowers, for instance. Movie-makers have stage sets for small interiors, with one end wide open, so that the camera can be set up very far from the actual scene. The artist cannot do this, but he can imagine himself to be at a considerable distance from the corner he's trying to paint.

With a sufficient knowledge of perspective, this isn't as difficult as it may sound. The basic forms of a room are very similar: you're in a box, although a big one. Vertical lines remain vertical, but horizontal lines slant downward if they're above your eyes, upward if they're below your eyes. Once you establish the angles of the slanting ceiling lines and the slanting floor lines, the rest is easy.

Design main lines first

Draw the room or any other interior as if it were empty; otherwise, you can be lost among all the details. The most ornate hall has simple enough architectural forms. The decorations and furnishings come later. The ceiling isn't always necessary in an interior, but, as a rule, you do see at least a corner of it. (Oriental artists never mastered the view of a ceiling; they omitted it, or replaced it with conventionalized cloud formations. But you

cannot very well do that when painting an interior in the Western world.)

Beware of coinciding lines and stripes

Vertical lines have to be placed so that they aren't at equal distances from each other. A wall on one side, the door, the other wall, a window, might be evenly spaced in reality; but when you paint them, alter them slightly: make one section narrower, another one wider. Avoid the coincidence of vertical or slanting lines in various parts of the subject which run into each other. For example, a vertical line in the door may accidentally be even with the vertical back of a chair. Move the chair left or right, so that the door and the chair will be separate items. In slanting lines, the top of a table may be running into the window-sill. Again, all you have to do is to raise one or lower the other in order to obtain a clearer view.

Lights and shadows

Lights and shadows play a starring role in interior composition. By day, the light comes through a window, or windows, on one side, casting definite shadows in the opposite direction. If there are windows on different walls, you have to indicate them, in order to explain the over-all light in the room. The light on one side is bound to be stronger than on the other, due to the position of the sun; but enough light comes through the other window to eliminate, or lighten, the shadows cast by the light streaming in through the brighter window. Careful observation is the key to all this. Don't take anything for granted. Look at it before painting it.

On sunny days, the light may stream through a window in a shaft. This slanting shaft breaks the verticals dominating most interiors. It also illuminates objects on its way to the floor, where it creates a patch of brightness. Every object casts shadows when hit by light. Shiny articles, silver, glass, ceramics, all have sparkling highlights which add to the interest and beauty of the subject.

In artificial light, the contrast between lights and shadows is greater, and the shadows aren't all on the same side as in daylight which comes through one window. A lamp or a candle casts shadows all around. When there are several lights in a room, the shadows overlap each other in lacy

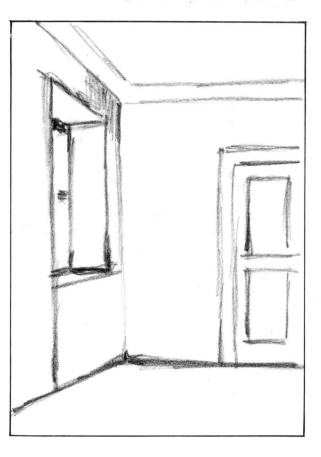

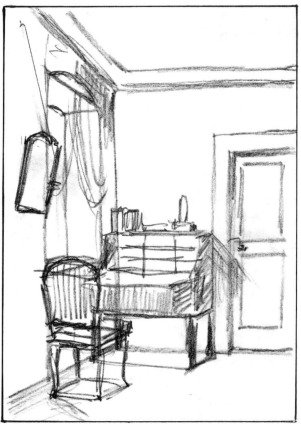

(Above) If you want to paint an interior subject, a room, hall, church, or cellar, lay out the fundamental architectural forms in correct perspective first. (Below) Add the furniture, including mirror, curtain, and so forth, after the basic space has been layed out and is ready.

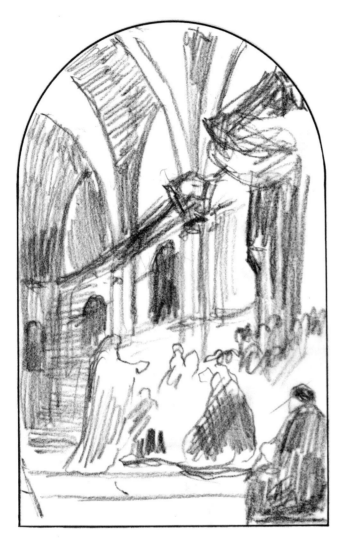

Interiors are employed in many paintings, if only as important backgrounds, or locations. Simon in the Temple *(Royal Gallery, The Hague), one of Rembrandt's most sensitive paintings, depicts Solomon's Temple as if it were a Gothic cathedral with Roman-style arched windows. Historical research was just beginning in the seventeenth century. Today, we wouldn't want even a modern Rembrandt to paint an incongruous, historically impossible interior. Otherwise, despite the fact that it's an anachronism, this temple interior is done with a full comprehension of architectural forms.*

patterns. In a ballroom with hundreds of lights in chandeliers and wall brackets, there's hardly any shadow, except in small corners.

Lights and shadows have to be interwoven with your composition: one wall is dark against a lighter wall; a room or niche in the back, or on one side, is lighter or darker than the hall next to it. A large wall covered with shelves, cabinets, tall-backed chairs, and curtains can be pulled together by having an over-all shadow on the whole section. Lights are stronger near the source of light; darks are deepest in the farthest corners; but both lights and shadows are hazier, more subdued, in the distance.

Figures in interiors

Many artists add a figure or two to an interior. The Netherlands artists especially liked this, and popular taste always enjoys seeing figures in paintings. Any figure you place in the interior must have a legitimate reason for being there and must be in a pose fitting the circumstance. In a church, you expect to see worshippers; in a hall or museum, there may be visitors, sightseers, and a few loafers. In a library or sitting room, a person is likely to be reading a book; in a kitchen, a woman is expected to prepare food; in a studio, an artist may be seen painting a picture.

The figure must be part of the setting, in pose, size, apparel, action, and color. All the principles in regard to figure composition have to be observed. In large buildings, you might show some people coming in, others leaving. Such figures add to the feeling of motion.

Color composition in interiors

Color is also a problem in interiors. How can you change the colors you actually see? Naturally, if you're commissioned to paint an interior, you have to render it as you see it. But if you paint it for art's sake, you are entitled to make changes in colors. You might paint a drapery reddish, instead of blue, if a warmer tone seems desirable. It's easy to change the color of a table cover. Or you might place books of the right hues on the table, in order to make a corner more vivid. A vase of flowers on a stand might help. But do place the actual articles where you want them, instead of painting them purely from memory. A false note is perhaps more

noticeable in an interior than in most other themes, and it may jump out of the picture—straight into your own face.

Who paints interiors?

Many impressionists painted interiors, especially their own studios. Vincent van Gogh's interiors, such as his simple little room in Arles, or a café with a billiard table, are among the most sensitive, the most moving, works of this artist. Henri Matisse often painted interiors with vivid, ornate wall decorations, probably inspired by his familiarity with Muslim patterns acquired during his stay in North Africa (many of those countries were French colonies at the time). There's hardly an artist who hasn't tried his hand on this subject.

Interiors can be magnificent pictorially and naive in other respects, as in the background in Rembrandt's *Simon in the Temple*, for example. The Temple of Solomon, in the characteristic, mysterious tones of Rembrandt, is a strange mixture of Gothic arches and Renaissance windows. Historical accuracy was only just beginning to interest artists in the seventeenth century.

Adolph (Friedrich Erdmann von) Menzel (1815–1905), a famous German artist, painted interiors as well as figure paintings. His *Room with Balcony* is a delicate rendering of an airy room: the curtain waves in the breeze; the chairs cast shadows onto the floor. An interesting idea is a tall mirror on the wall, in which the invisible part of the room is reflected. Another excellent interior is *On the Stairs* by Alfred Rehfous, a nineteenth-century Swiss painter. It depicts a simple hallway, centrally designed, but broken up by the top exit of the stairway and its wrought-iron fence with a figure emerging from the staircase. Lights and shadows enhance the charm of the view.

Lady in Black (National Academy of Design, New York) by Hamilton Hamilton, N.A. (1847–1928) looks simple enough, but you'd have to design the room, the chair, and table before adding the woman, the vase of flowers, and the lamp in a way that would leave enough space. Many paintings, such as *Le Foyer* (The Metropolitan Museum of Art) by Edgar Degas, show a full interior without which the scene would be meaningless. *Lady with a Lute* (The Metropolitan Museum of Art) by Jan Vermeer (1632–1675)

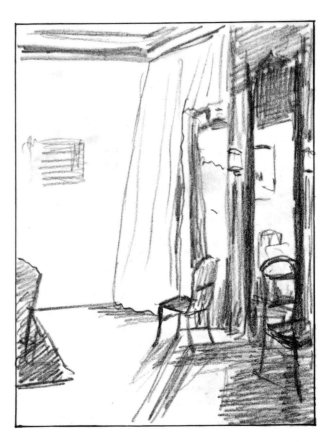

(Above) In this sketch of The Room with Balcony *by Adolph (Friedrich Erdmann von) Menzel (1815–1905), we see an airy, lovely room; the gentle breeze causes the curtain to wave. Shadows are cast onto the floor. The invisible part of the room is reflected in the tall mirror on the wall at the right. (Below) A rather symmetrical composition dominates* On the Stairs *by Alfred Rehfous. The long hallway is seen from the center, its arrangement broken by the top exit of the stairway.*

is a typical example of the love and ability of Netherlands painters to compose figures with interiors. The window on the left allows the daylight to illuminate the woman and a section of the wall. The rest is in shadow, with a remarkable pattern of lights and darks making the otherwise simple, domestic scene dramatic.

Many artists rendered large studios or exhibition halls filled with paintings, each picture done in recognizable detail. *In the National Academy of Design* (National Academy of Design) is a wood-engraving published in *Harper's Weekly,* on April 29, 1882. It's the work of William St. John Harper, A.N.A. (1851–1910). Such an engraving or painting is a real *tour-de-force,* demanding patience as well as skill. This particular item has a true historical value: it shows how paintings used to be hung from practically the baseboard to the ceiling. Today, artists scream and protest when their paintings are hung in the upper one of two rows!

In the National Academy of Design by William St. John Harper, A.N.A. (1851–1910), a wood-engraving published in Harpers Weekly, on April 29, 1882. Interiors depicting *pictures on walls have been painted by a number of artists. Such a subject demands patience, skill, and a good hold on perspective. The view is asymmetrical; figures are employed as in a genre picture, indicating various cute or amusing types. The greatest value of this graphic is historical: it shows that pictures in the old days were hung from the floor board to the ceiling. Today, an artist screams if his painting is "skyed"—hung in the upper row.* Collection National Academy of Design, New York.

Lady in Black by Hamilton Hamilton, N.A. (1847–1928).
*The dress dates the picture, naturally, just as a miniskirt
painted in the 1960s will date a picture in a later period.
Yet, composition remains the same. You'd still have to
make sure to have enough space for the chair, the woman,
the table. And you'd still have to place everything in a
sort of esthetic balance. (See the sketch of the layout for
this picture to the right of the reproduction.) Note that
the tablecloth on the left and the chair on the right both
slant; they aren't parallel with the edges of the canvas.
The slanting lines in the dress, the arm, the bottom of the
tablecloth, table top, and chair back are contrasted with
the vertical forms in the lamp, the vase, and the wall
decorations. The rug itself is a component of the pattern.*
Collection National Academy of Design, New York.
Photograph, Frick Reference Library.

Faust, one of Rembrandt's most admired etchings, has the same baroque composition he employed in his paintings. *The darks are far more difficult to achieve in an etching than in a painting, as they consist of thousands of crosshatched lines scratched into the plate. Note the vertical drapery hanging from a bracket on the left side.*

The artist broke it up with darker and lighter folds, and added some horizontal design and cross lines at the bottom. Such a print is the reverse of the design made upon the plate, so that it must be done in reverse on the plate in order to come out right in the print. This is extremely important in making lettering legible.

13
Composition in Graphic Arts

The term *graphic arts* is confusing and misleading. Commercial printers officially call their own work graphic art, but, in this field, the word *art* is employed as it is in the art of carpentry, or some other craft. In the fine arts, *graphic arts* may refer to any of the pictorial arts, including painting, in contrast to sculptural, or three dimensional, arts.

Normally, however, when we speak of graphics, we mean drawing and printmaking. Printmaking includes the arts and techniques of woodcut, linoleumcut, engraving, etching, lithography, serigraphy (silkscreen), and variations or combinations (mixed media) by which prints of an original design are made, or pulled, by hand. The originals are executed by the artist in a wood or lineoleum block, on a steel, copper, zinc, or celluloid plate, on lithographic limestone, on fine silk, and so forth. Strangely enough, it isn't the work the artist originally does in wood, plate, stone, silk, etc., that we call original. The true original graphics are the prints on paper. These are normally signed and numbered by the artist. He also usually writes the title on the print, all in pencil.

Black-and-white

Until recent years, graphics, both drawings and prints, used to be called black-and-whites: most drawings were done in pencil, charcoal, or pen-and-ink, and prints were in black or dark brown ink, on white paper. Black-and-white is now as anachronistic (and apparently as permanently so) as talking about the sailing of ships which have no sails at all. Many graphics are executed in color, and an exhibition of graphic arts often looks like a watercolor show.

Types of drawing

Drawing is a representation of forms through lines. It has been practiced since the most ancient times. The prehistoric cave paintings of Europe were outlined first with fire-charred sticks, and those of Africa with neatly cut sticks of ocher (a natural earth mixture of hydrated oxide of iron with other materials of earth). The classic Greeks and Romans worked with a sharp-pointed stylus (a word still very much in use as *style*), which had a shape almost exactly like our pencil. Egyptians and Orientals worked with pointed brushes. Silverpoint was employed for centuries. Also, quill pens and sepia ink. Lead and graphite were introduced later.

India (or, more correctly, Chinese) ink, also called *tusche* (pronounced *toosh*), took the place of sepia, and we have a large variety of steel penpoints and nibs for fountain pens. India ink comes in about twenty colors which can be mixed with each other. Color crayons were introduced in the

seventeenth century. Nicolas Jacques Conté (1755–1805), the French mechanical genius, chemist, and painter, invented the crayon which still bears his name. We also have felt brushes in a great many colors. Some people talk about pastel drawings, but pastel is considered a painting medium, except when an artist works with pencil-like thin pastels, in lines.

Monochrome drawing

In monochrome drawing, we have two main kinds: contour drawing, done entirely in outlines, a technique highly favored by Picasso, among other modern artists; and shaded drawings, in which tones are applied with the same tool we use in the outlines. Similar differences exist in pen-and-ink drawings. In the shading of these, however, we either use lines, usually crosshatched in the shading, or apply ink washes with a brush. We call these wash drawings.

Composition in monochrome drawing

The principles of composition are the same as those employed in painting, except that in contour, or pure line, drawing we rely entirely upon linear composition. Such drawings aren't planned to be seen from a distance; they rely on esthetic appeal rather than dramatic power. Picasso's drawings, inspired by Attic vases, have a simplicity of design which makes the figures, however delicate, stand out clearly. This clarity is of great importance. You also have to watch out for items in the background which appear to be growing out, or running into, the main objects. Avoid overcrowding the paper with outlines, as this would seem to be a wallpaper design. Aubrey Beardsley's pen-and-ink drawings are among the finest examples of absolute clarity in pure line composition.

In shaded drawings, or wash drawings, we add tonal values to the composition. Artists of the Renaissance and Baroque usually prepared wash drawings to show their patrons how the finished paintings would look. The tonal forms have to be considered as carefully as the linear forms. It isn't enough to shade a few sections, and make them three dimensional in appearance; the tones themselves have to form an interesting pattern, rhythm or balance. Don't place big white or big dark spots in the exact center, too high or too low, or too far

on one side or the other. A shaded, or wash, drawing, is satisfactory if it carries—that is, if its general pattern is visible and interesting from a reasonable distance.

Composition in colored drawing

A drawing is fundamentally a work of art in lines; color may be applied to these lines, but color doesn't constitute the total work, as it does in a painting where line is subservient to color. Furthermore, colors in drawings aren't as powerful as in the average painting, but once you have color, compose it as well as the tones and lines. The rules are the same as in painting, in a lower key.

Composition in printmaking

Serigraphs (silkscreen) are executed on a piece of silk stretched on a frame directly as they'll look in the finished print. By directly, I mean that they are in the same position as the finished print will be. All other prints, whether in monochrome or in color, done in lines or tones, pose a problem that doesn't exist in other pictorial arts: the finished print, which is the work of art we see and judge, is the reverse of what the artist executed on stone, block or plate. In other words, the result is like a mirror image.

This may sound unimportant, but it isn't. A right-handed figure becomes left-handed; lettering occasionally seen in cityscapes (Café, Dancing, Restaurant, etc.) is also reversed. You may not notice that a bridge is reversed, as such an object is normally the same from both sides; it may make little difference whether a hill or a cluster of trees is on the left or on the right. But you wouldn't want to reverse the two wholly different towers of Chartres Cathedral in your print. (I mention this, because I did see such an etching, years ago. It looked quite disturbing.)

Above all, you'd be surprised what difference a reversal can make in practically any picture. When you make a layout, you do it according to your esthetic sense. If you place an important object on the right, you do it because you feel it belongs there. In the print, that object appears on the opposite side, and it may give you a real shock. Many artists paint pictures, and turn them into prints later. Anders Leonhard Zorn (1860–1920), a noted Swedish painter and etcher did this, work-

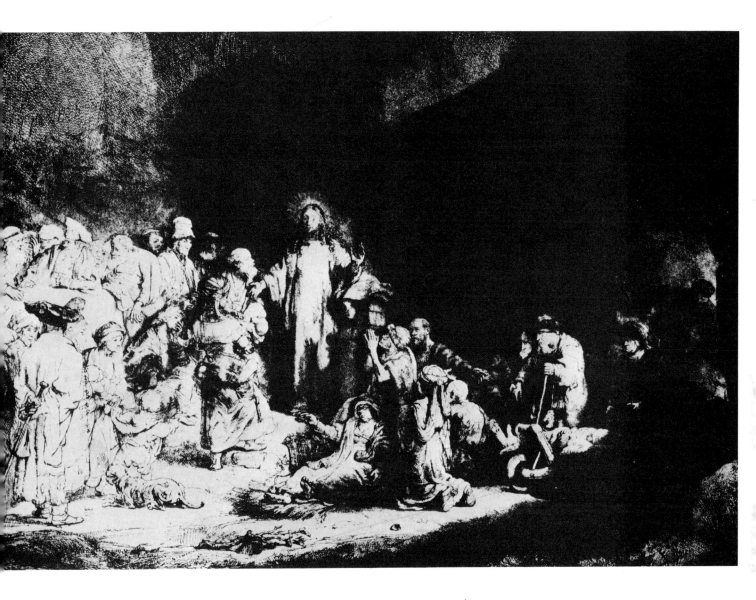

Christ Healing the Sick by Rembrandt van Rijn (usually
called **The Hundred Guilder Print**, because an itinerant
art dealer gave Rembrandt a hundred guilders' worth of
materials for the plate). The reproduction makes the darks
appear a solid black. Actually, it consists of innumerable
lines. Disregarding the amazing details in the pathetic
faces and figures, the etching has a perfect baroque
asymmetrical composition. You can break it down to the
kinds of forms we find in landscapes.

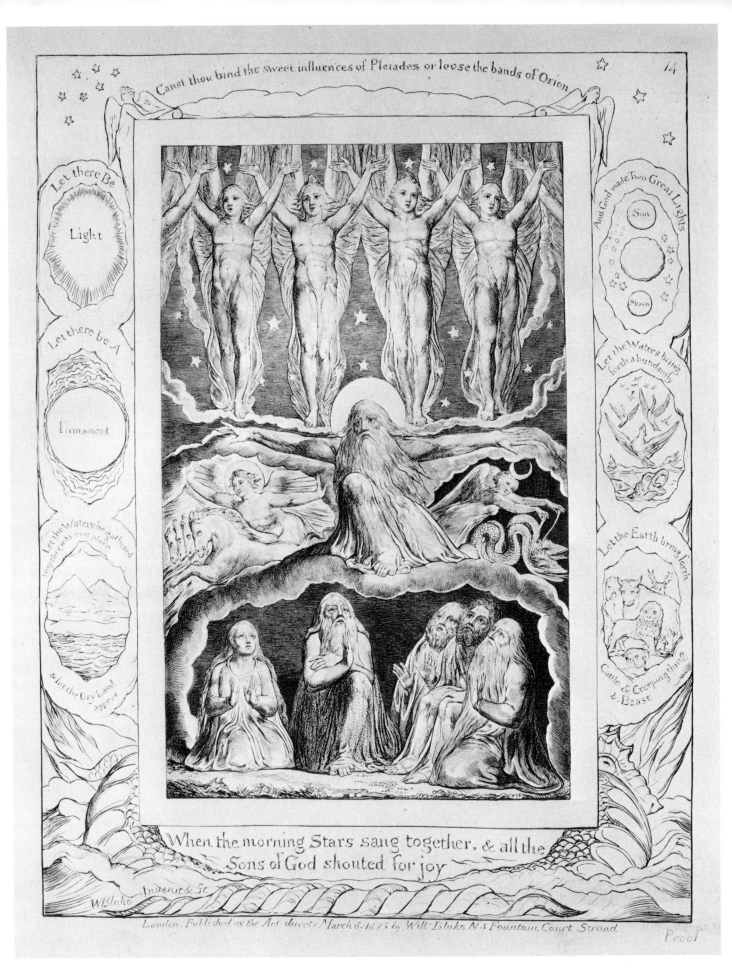

(Left) **When the morning Stars sang together**, *a plate from **The Book of Job** by William Blake (1757–1827), the English poet-artist, who illustrated his own books, often including the text in the plate so as to be able to print his books more cheaply. Few people were interested in Blake's spiritual approach to life until more recent times. The over-all pattern is what makes this plate one of his best: lines and shapes flow into each other; the morning stars, represented by sexless figures, are in an endless rhythm; light and darks balance each other.* Photograph Courtesy The Metropolitan Museum of Art, New York.

(Above) *"We will be good" by Georges Rouault, from a series entitled **Demagoguy** (1924–1926). This 11⅝" x 8⅞" lithograph is in the same spirit as his paintings, with dark, heavy outlines enhancing bright spots. The almost caricature-like simplicity of the work reveals the composition: the stiffly slanting right arm on the desk, the stiff left arm in midair, the small heads of the audience in the back—everything is calculated to suggest the power of one demagogue over a crowd of followers.* The Solomon R. Guggenheim Museum, New York.

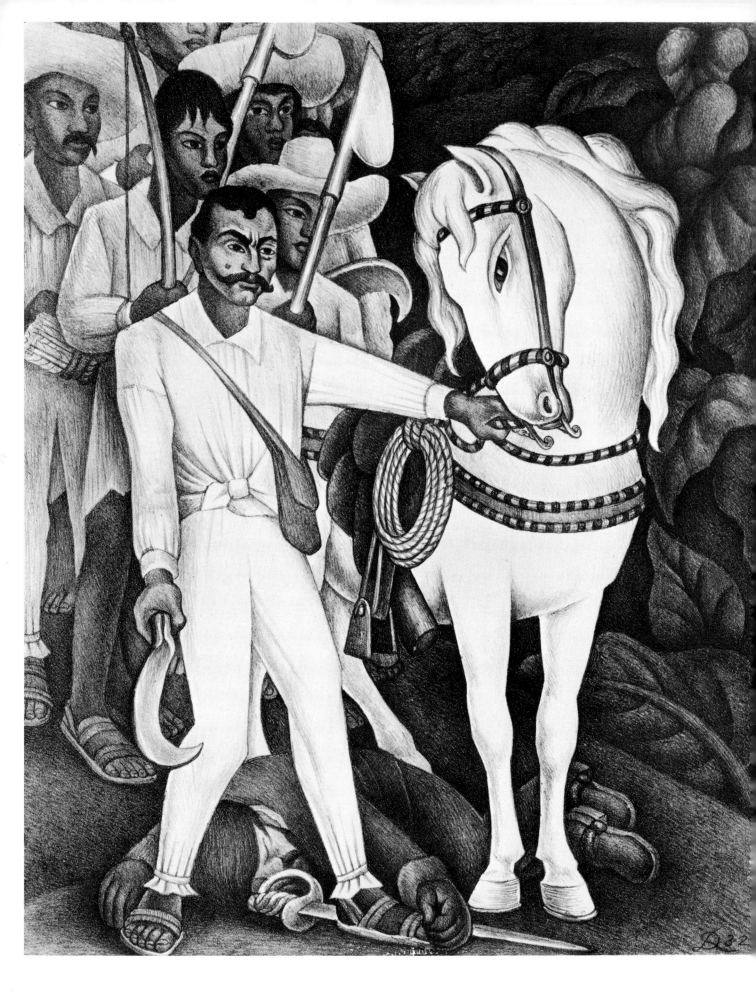

ing directly from his own finished paintings. The etchings show each scene, each figure in reverse, with the shadows on the opposite side. Although done with great skill, the reversed image is seldom as satisfying as the original painting.

The only occasion on which this reversal is good is when you do a self-portrait, as Rembrandt so often did, in etching, or any other graphic technique (except silkscreen). What happens is that you see yourself in the mirror in reverse, but come out just right in the print. You then see yourself as other people see you, or as you see yourself in a photograph.

Trace the original in reverse

My advice is that you reverse your original drawing before transferring it onto a block, plate or stone. Trace the outlines on a sheet of tracing paper, then turn this over, and retrace it on the material in which you're working. For details, many printmakers place a mirror in such a position that they see their original drawing in it, in reverse. It's easy to execute lights and shadows, and all details in this manner, so that the final print will be the same as the original drawing.

Composition in monochrome prints

In a contour print, the linear principles prevail. Most prints are in tones, however, and you can obtain much darker tones in prints than in drawings (except in black India ink drawings), so that powerful effects are feasible. Whether your style is realistic or abstract, and whatever your subject may be, consider the carrying power of your print. In a good print, a pattern is visible from as far as the print can be seen, even though you have no idea what the subject is.

(Left) **Zapata**, *1932, by Diego Rivera (1886–1957), transfer lithograph 16³/₁₆" x 13¹/₈". Except for the coloring, this graphic is just like Rivera's paintings. The darks, whites, and gray shades give the work great depth. The peasants, with their home-made weapons, are just arriving. The enemy, with his elegant sword, is trampled underfoot. The figures are made to look strong; the white horse is part of the revolution. The dark, very nicely designed vegetation on the right suggests the tropical climate as well as territory to be conquered. Compare this victorious advance with* **Retreat from Marignano**. *The Museum of Modern Art, New York. Gift of Abby Aldrich Rockefeller.*

Rembrandt's etchings have the same strong, almost eerie tonal effect that characterizes his paintings. Goya also observed all pictorial qualities in his often mysterious and/or sarcastic aquatints (a form of etching). Georges Rouault also created graphics in the dramatic, expressionist style of his paintings. Diego Rivera's graphic style is equally as powerful as, and typical of, his painting style.

Composition in polychrome prints

In a regular print, you have to prepare a separate block or plate for each color. I say "regular" because there are trick prints, in which all colors are applied onto the same plate or block with brush and fingertip, and the entire color print is pulled at once. Other prints are hand-colored, with only the outlines and a few main tones actually printed from the artist's original block, stone or plate. Such prints are immediately recognizable, as no two prints are ever alike, and the colors usually intermix, instead of being separate.

Making three or more plates or blocks for different colors is a great deal of work, and registering the colors in the printing requires skill and care. Although printed colors don't mix (each color has to dry before the next one is applied), it's possible to obtain different hues by overlapping certain colors: for instance, yellow over blue gives green. You have to consider this fact when planning your colors. Many artists use color in their graphics merely because "color sells the stuff," as they put it. Several bright colors make a colorful print, to be sure, but not necessarily a good one. Compose the colors, including the overlapping shades, with the same care you'd invest in a painting.

I cannot tell you what colors to use, or what design you should create. There are tens of thousands of possibilities. Just contemplate the over-all effect: will your finished color print look interesting, striking, charming, in color and design from a suitable distance? Or will it look like a number of colored swatches accidentally dropped on a table? A soft-toned print can be quite impressive; it isn't at all necessary to have startling contrasts. A mere exercise in lines, tones, and colors on a plate, on a block, stone or silkscreen has the same relationship to a creative work of art as a finger exercise has to the performance of an accomplished musician.

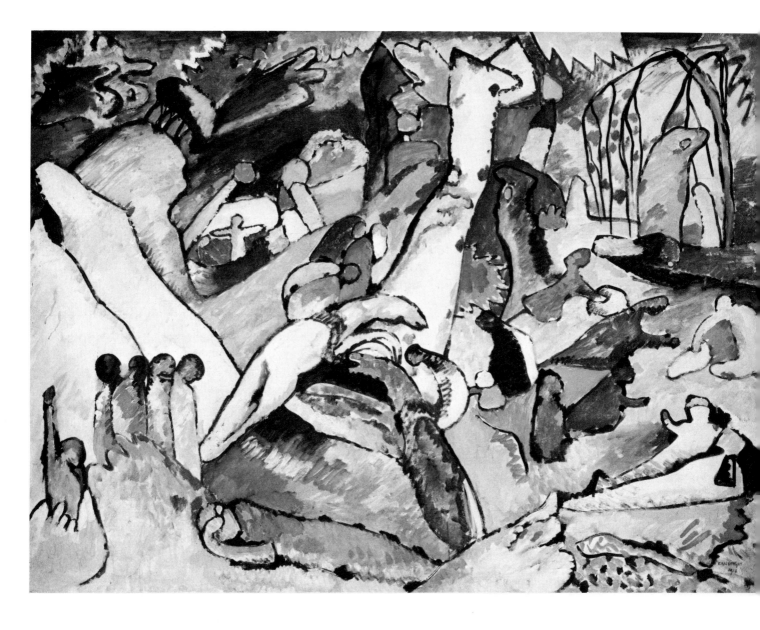

Composition No. 35 (1910) by Wassily, or Vasily, Kandinsky (1866–1944), oil on canvas 38¼" x 51¾". Kandinsky considered colors a form of music, and gave his works titles common in music. This painting, however, is still an abstraction in which humans, animals, trees, and clouds can be discerned. A strong linear composition guides the eye up and down, perhaps in search of meaning. There's a large variety of colors, shades, lights, and darks, precursors of Kandinsky's later paintings in which tastefully chosen colors and often purely geometric shapes constitute the whole picture. Collection The Solomon R. Guggenheim Museum, New York.

14 Composition in Abstractions

Japanese art, with its emphasis on the essentials, its simplification or omission of backgrounds, may have prepared the ground, but abstraction as a school of art was born early in the twentieth century, largely under the impact of African sculpture, which became widely known in Europe after the Anglo-Boer War (1899–1902). From African-style distortions, such as we find in the works of Picasso, Matisse, Modigliani, and Brancusi, to Cubism, ascribed largely to Picasso and Braque, many forms of non-photographic art were practiced in Western countries.

Abstractionists disregarded perspective, foreshortening, realistic details, not to mention the prettiness and sweetness previously taken for granted in art. They turned pictures into more or less decorative patterns. Many of the abstractionist works were almost like sketches for flat design, while others retained a feeling of three dimensional space, even exaggerating it, as in Cubism.

The subject of a true abstraction is recognizable, even if it requires a little scrutiny. Many artists began their careers as academic realists, turned to impressionism, then to abstractionism. The works of Russian-born Wassily, or Vasily, Kandinsky (1866–1944) are especially interesting as they evolve from realism, through impressionism, fauvism, to abstractionism and, ultimately, into nonobjective art.

Free or geometric abstraction

Whether an abstraction is done in free strokes or in geometric precision, it's foolish to assume that "a five-year-old child can do it," as the common saying goes. On the contrary, abstraction requires skill and care; otherwise, it's a bad painting. Let's remember that a realistic picture can also be bad. A good abstraction can only be achieved with sound draftsmanship, good composition, and, generally, on the basis of a good color sense.

The fractured abstractions of Picasso, Juan Gris (1887–1927), Georges Braque (1882–1963), and many others, have composition, technical skill, pictorial effect, and originality, just as good realistic works do. As a matter of fact, mediocre realistic work may be saved by its charming or popular subject, depicted without any artistry, or even sufficient technical knowledge, whereas in an abstraction, the subject is camouflaged, and thus secondary. Its effect depends entirely upon pictorial design and power, or on its charm. Many of Kandinsky's abstract and nonobjective paintings have a poetic quality.

Symmetry or asymmetry in abstraction?

We find both main approaches in abstraction. Many of the cubist paintings seem to be sym-

Girls with a Toy Boat (1937) by Pablo Picasso, oil, pastel, and crayon on canvas 50½" x 76¾". You may not want to meet girls of this kind, typical of the Spanish artist's "monster" period, but if you consider the main forms and the composition, you're bound to realize that if the girls, the toy boat, the peculiar sun peeking from beyond the horizon, were turned into realistic forms, the picture would be a pleasant one. It could be very pretty. But would it be as memorable as it is now? The Solomon R. Guggenheim Museum, New York. Peggy Guggenheim Collection.

The Seine by Milton Avery (1893–1965), oil on canvas 41" x 50". Avery seldom used shading; he worked in large, simplified surfaces that formed an understandable design, as in this work, in which the river Seine, trees, shore, and barge can be distinguished. Slanting and curving lines, darks and lights are intermeshed, but only the essence of the objects shown is given. Collection The Whitney Museum of American Art, New York.

metrical in color effect, but the majority are composed in the off-centered fashion. Observe Picasso's *Guernica*, and his *Green Still Life* (both reproduced in this book), and you'll notice the asymmetrical design. This is true for such very abstract paintings as Kandinsky's *Composition No. 35* (The Solomon R. Guggenheim Museum), also reproduced, in which figures, trees, clouds, and other forms could be parts of an action-packed baroque painting if each item were carried into realistic form.

Flat and three dimensional abstractions

In a flat abstraction, the picture resembles a kind of patchwork quilt, in which pieces of diverse shapes are stitched together into a more or less recognizable work. Milton Avery (1893–1965), a well-known American artist, worked in this style. *The Seine* (The Whitney Museum of American Art), a scene from Paris, is typical of his work; it may look empty and unfinished, but the off-centered elements of composition are clearly visible. It isn't my aim to tell you what I personally like or dislike in these or any other kinds of paintings. I merely want to point out to you that these paintings are done with deliberation and knowledge.

Girls with a Toy Boat (The Solomon R. Guggenheim Museum), one of Picasso's best-known paintings, is three dimensional. Each form is outlined, as in a Japanese woodcut, but each section is also shaded with considerable care. The composition is strictly baroque. The picture is from what we call the artist's "monster period," and nobody will call it a pretty scene. Probably nobody would want to meet such girls; you'd run away as fast as you could if you accidentally bumped into one. But take a magic wand, turn the monstrous girls into attractive, lifelike figures, add some waves to the sea, and make a sun out of the queer form above the horizon—and you'd have a most charming picture of two nude girls playing with a toy boat. Would that picture be as interesting and as fascinating, or as memorable, as Picasso's abstraction? You have to give your own answer to this question.

Another famous abstraction is *Nude Descending a Staircase No. 2* (The Philadelphia Museum of Art—there are other versions of the same subject) by Marcel Duchamp (1887–1968). The reputation of this painting rests not only on the fact that it

was called monstrous, absurd, ridiculous, and scandalous when he painted it in 1912, but also on the idea that the artist added a fourth dimension to the usual three of width, height, and depth: the dimension of motion, or *time*. It takes time for anyone, nude or otherwise, to go downstairs, and the artist shows the time by breaking the figure and its motion into rhythmically repeated forms (see color plate).

Lights and shadows in abstraction

Lights and shadows play as vital a role in abstraction as in realistic work, but the artist is freer here to make changes according to his own compositional requirements. A realistic picture has to have realistic shadows, all on the same side, whereas an abstractionist may alternate lights and shadows as he pleases to create a more interesting pattern in his picture. Here, too, avoid the appearance that an object has been stuck onto the picture by accident by painting a section unduly bright; and be careful not to create the effect of a hole or a big gash in your picture by painting some parts much too dark.

Color in abstraction

Since you are free to change, to simplify forms, shapes, and sizes in abstract painting, you're naturally free to make changes in coloring as well. If you think that colors are always true to life in realistic works, you're very much mistaken. Figures, as well as backgrounds, have very different shades of colors in the works of various artists.

Look at Rubens, Veronese, Tintoretto, Rembrandt, El Greco, to mention but a few, and you'll see formidable differences, ranging from the mother-of-pearl tones of the women in Rubens' paintings, to the greenish tones in El Greco, and the very strong shadows in Rembrandt's figures, etc.

In an abstraction, the artist often simplifies colors, and paints just a plain cadmium red where a realistic painter would show many variations in the color; but many abstractionists paint lights and shadows, with soft blending, except that their colors are deliberately not realistic. As I pointed out before, the colors employed by a good artist form a pattern, just as his lines and forms do. He won't apply a spot of blue in one corner, a spot of blue in the opposite corner, just for the fun of it. Not even in so-called automatic art. An artist who has taste and skill applies colors of his choosing to places of his choosing—and not by accident.

What about top and bottom in abstraction?

One often hears wisecracks about which is the top of this or that painting. Let's be frank: some paintings might be turned upside-down without anyone noticing the error, especially when there's no signature on the painting. Such a thing can hardly happen in a realistic picture, no matter how bad it may be. In a good abstraction, though, you have to see the work as the artist plans for it to be seen. You'll find that there *is* a difference; that the painting does look correct only rightside-up. Whether this is true for nonobjective art as well, we'll see in the next chapter.

N. R. F. Collage #2 by Robert Motherwell (1915–),
oil and collage on paper 28⅓" x 23⅓", is the kind of work
that made this artist famous. He applied bold, broad
strokes of paint and allowed it to run down. This is
perhaps one psychological reason why one feels that, in
this particular work, the top must be the end from which
the paint runs downward. Yet an impartial viewer who
disregards literal meaning in art, and who looks upon
such works as if he were looking at cloud formations,
rocks, or anything else in nature, can hardly help
discovering that a painting or collage of this kind may be
very attractive and well-balanced, even if he considers
the pasting up of wrapping paper, with customs and other
labels, unwarranted. The paper might have been torn in
a clumsy, inappropiate fashion; the painted forms, too,
might have been totally incongruous. I believe that
Motherwell weighed every shape with care. Collection The
Whitney Museum of American Art, New York.

15
Composition in Nonobjective Painting

Nonobjective is a somewhat peculiar word. It denotes a kind of art in which there's no formal subject. *Nonsubjective* art would be clearer. If *objective* means careful, impartial unprejudiced observation, *nonobjective* would mean careless, personal, prejudiced observation—but such an approach would be totally subjective, so that the correct name for the nonobjective school would have to be *subjective*. But how could we then say that subjective art is art without any subject? Confusing, isn't it? Be that as it may, *nonobjective* is a generally accepted term; we also call it *nonrepresentational*, which is a better term, but long.

Dada and nonobjective art

The founding of this school of art is usually attributed to Wassily, or Vasily, Kandinsky, whose revolutionary work was done in Germany after World War I, until Hitlerism made all nonacademic art, including the entire Bauhaus, taboo—irrespective of race, religion or national origin. Kandinsky, like so many other artists, had to flee. Actually, nonobjective art was already in the air. Jean (Hans) Arp, and others, experimented with shapes and colors devoid of any subject in Switzerland during the First World War, when Dada, or Dadaism, was established as a form of art "as absurd and meaningless as people are."

It's undeniable, however, that Kandinsky carried the new style to perfection in its own way. Kandinsky, as I've already said, reached the nonobjective stage gradually. A similar transition can be found in the works of Piet Mondrian, best known for his horizontal-vertical stripes, and very limited use of unshaded colors. Mondrian believed, or asserted that he believed, that the square and the oblong are the most beautiful shapes in the world—the only shapes possible, of course, in a vertical-horizontal arrangement. It's surely difficult to understand why the square and the oblong should be more beautiful than the circle and the ellipse.

Strange titles

Nonobjective artists have the general habit of giving their works strange titles, or no titles at all. Mondrian called his paintings by the names of the colors he used in them. For instance, *Composition in Green, Red, Yellow and Blue; Composition in Red, Blue, Black and Yellow-Green*. Some had titles like *Fox Trot A*. One of his most famous paintings is *Broadway Boogie Woogie* (Mondrian fled to America when Hitler occupied the Netherlands and France). Kandinsky considered painting a form of music. Colors were used instead of music notes. Rhythmic curlicues, short or long lines,

*Broadway Boogie Woogie (1942–1943) by Piet Mondrian,
originally Mondriaan (1872–1944), oil on canvas 50" x 50".
This Netherlands artist became world-famous with his
horizontal/vertical-striped paintings. Is there any
composition in these works? Many people consider them
decorations, rather than pictures. Others swear that not
one little stripe or square could be moved in a Mondrian*
*painting without destroying its composition. The fact is
that the artist was extremely precise in his geometric
patterns, and his early works give ample proof of his
great talent, as well as his knowledge of drawing and
painting. As he left many paintings unsigned, it isn't
always easy to determine the top of the painting.*
Collection The Museum of Modern Art, New York.

disks, triangles, wiggling forms, in his estimation, have the same effect on the eye as music has on the ear. He employed titles common in the music field: *Composition No. 7* or *8*, or *Variations* and a number.

Is there composition in nonobjective art?

It must be understood that nonobjective art isn't the same as abstract-expressionism, popular among artists in the 1950s and early 1960s. In that school, the method was to throw, pour, squirt, drip or heap paint on the support. Nonobjective painters, who preceded, and also survived, abstract-expressionists, try to produce beautiful or interesting forms which have no "meaning" in the ordinary sense of the word, but with a very deliberate esthetic concept. Kandinsky often prepared complete paintings on a small scale, before applying the same shapes, colors, and composition onto often mural-size canvases. There were no accidents in his paintings. His technique was nothing less than exemplary.

Which side is the top?

Mondrian also executed his works with geometric precision. Worshippers of Mondrian who assert that nothing could be moved, changed, added or removed in a painting by their idol are surely exaggerating, however. A number of years ago, *The New York Times* magazine section published a reproduction of Mondrian's *Trafalgar Square*, a composition of strictly vertical and horizontal lines. Several readers informed *The Times* that the reproduction was shown upside-down. The newspaper verified this fact, apologized, and published the same picture rightside-up and upside-down. Whereupon more people wrote letters to the Editor, declaring that it made no difference one way or the other. One sent in a picture of Trafalgar Square, London, to prove that if that were printed upside-down, everyone would notice the mistake. This is one of many paintings Mondrian didn't sign (one assumes that a signature is on the bottom, rightside-up), so it isn't easy to tell which side is the top, unless you ask the owner.

There are similar controversies about Kandinsky and other nonobjective artists. Many people believe the artists themselves would never notice it if someone added a line or a form to their work

Broadway Boogie Woogie is cut into four sections, without changing any part of the original design. I am not inclined to belittle Mondrian; I consider him one of the most important artists of this era. But at the risk of being denounced as sacrilegious, I state my belief that each of the four sections is equally interesting, and may be seen from any angle. In a photographic reproduction given by The Museum of Modern Art, the top of the full painting is carefully marked. Otherwise, it would be difficult to print it rightside-up.

or painted out something. Expressing the belief that at least some of Mondrian's paintings, *Broadway Boogie Woogie* (Museum of Modern Art) among them, might be turned upside-down or on either side, or cut into several smaller paintings, without damaging the total appearance of the whole picture or any of its parts, might bring the wrath and scorn of many people upon my head. Nevertheless, I did cut a photograph of *Broadway Boogie Woogie* into four sections and use them in different directions. My contention is that non-representational paintings are mostly well composed and skillfully executed, but that some, if not all, might be cut up, or turned any old way, and be equally as interesting. See for yourself in the illustrations.

After all, someone cut two columns off the sides of the *Mona Lisa*, without irreparably damaging a realistic painting; and perhaps, or even probably, making the work look better than it did before. So why not believe that a nonobjective work might be cut off, too? I also firmly believe that pure pattern, lines, and colors can make a most attractive picture, just as the colors and pattern of a sunset are beautiful and entrancing, although otherwise meaningless (except that a sunset signifies the end of another day). *N. R. F. Collage #2* (The Whitney Museum of American Art) by Robert Motherwell (1915–) looks best the way the artist intended it to be seen. At least I think so, but this may be due to the fact that some of the paint ran downward near the top.

Asymmetry and rhythm

Practically all nonobjective paintings seem to be asymmetrical. The comparison between colors and music, propagated by Kandinsky, isn't at all far-fetched. I've created crayon drawings while listening to radio music, merely under the inspiration of the musical composition. My nonrepresentational works have the same rhythm, the same flowing lines as the music to which I was listening. My drawing was finished when the music ended. Each note has its counterpart in form and color. Composers use what's called underpainting. Why couldn't painters use a sort of musical rhythm?

How to compose a nonobjective painting

It seems to me that an artist doing this kind of work has to be thinking of something; not necessarily of something tangible and visible, but of a mood, a poetic experience. He can start by applying a spot of color, but, from then on, his hand, the brush, the color, have to move and flow according to his mood and according to his experience as a painter. A professional painter shows his knowledge in every brushstroke. The nonobjective painter has to be conscious while he's working. He will apply forms and hues which go well with his mood, and equally well with his pictorial achievement.

Is nonobjective art self-expression?

Nonobjective art at its best is just as self-expressive as any other school of art. No more, and no less. Look at the finest realistic, or at least representational, artists of all periods and all countries. Compare the works of Botticelli, Leonardo da Vinci, Veronese, Tintoretto, Mantegna, the Van Eyck brothers, Rubens, Rembrandt, El Greco, Velásquez, Goya, Renoir, Cézanne, Degas, Daumier, Gauguin, to mention only a few. Everyone of these, and many other, artists had his own feelings and emotions, his own personal approach to life and art, even in identical subjects and in the same periods. All these artists painted recognizable subjects, and several of them were highly controversial in their art. Many had severe personal troubles: Leonardo was in jail for moral turpitude; Veronese had trouble with the Inquisition, Rembrandt died in utter poverty; El Greco was ridiculed by the bigshots in Madrid; Cézanne was called the crazy son of a rich banker; Gauguin's life was almost unbelievably fantastic.

All these artists had three things in common: serious composition, technical skill, and strong individuality. I might add that they all based their art on what they had learned from their teachers, but all of them contributed something remarkable of their own. None of them followed definite, rigid formulas, but all of them avoided, knowingly or instinctively, the common mistakes made by art students and many artists as well.

Epilog

We can now tell when and why a composition is bad. How can we tell when and why a composition is good, especially as there are so many possibilities for good composition? We can only judge the quality of works of art by one standard: do they grow on us? Or do we lose interest in them? There have been artists who succeeded in producing clever or pretty subjects in pleasing colors, and have become immensely popular. Everyone wanted paintings by them. We can trace this back to ancient Roman times, as we see mosaic pictures of the same type, in the same style, in very many places.

On the other hand, certain artists who weren't very popular during their lifetime became important afterward, in the course of time. But there are also many works and artists who have been accepted by their contemporaries as well as by later generations. There has never been a time when Leonardo da Vinci, Michelangelo, Titian or Rubens would have been belittled or neglected, although Anglo-Saxon women are known generally to shudder at the sight of the very plump women in the works of Rubens.

By analyzing the works which have always been admired, as well as the works which have grown on us gradually, we detect certain elements which appear to be present in all of them. By studying the works which never pleased the connoisseur, or those which ceased to please the discriminating viewer after a while, we discover elements which aren't pleasing, or which are genuinely disturbing. When I speak of connoisseurs or discriminating viewers, I merely distinguish between the trained and the untrained eye and taste; between understanding, and everyday convention.

A person who goes to the opera every week during the season, even if he isn't a music critic, is bound to know more about operatic music and performance than a person who goes to the opera for the first time in his life. A person dealing in diamonds and other precious gems knows more about them than the person who buys a diamond ring for the first, and probably the last, time. The same is true in art. A person who visits museums, attends exhibitions, studies the subject constantly, is bound to know more about art and its features than the layman who tells you that he's not an artist, he cannot draw a straight line, but he knows what he likes and he's sure that what he doesn't like cannot possibly be good. Such a person also knows much more than the beginner in art, who may have great talent, but no knowledge.

Thus, the expert, the true general practitioner of art, can tell you about certain basic facts with assurance, but there are many ways of creating outstanding or stunning pictures; and many future ways we can't even dream of. All I've done, therefore, was to warn you against the pitfalls, the elements we invariably find to be wrong in pictorial composition; and to explain to you certain forms and elements of composition we always consider good. The rest is up to you. You may very well turn out to be one of those few distinguished artists who add something new, something individual, to what they have learned from their predecessors. But, above all, be true to yourself. Don't try to be anyone else.

Index

Abbey, Edwin A., 146
Abstraction, asymmetry in, 165, 166; color in, 167; composition in, 165–167; decorative patterns in, 165; flat and three dimensional, 166, 167; geometric, 165; influence of African sculpture on, 165; influence of Japanese art on, 165; light and shadow in, 167; subject in, 165; symmetry in, 165, 166; top and bottom in, 167
Abstract-expressionism, 171
Academic art, 21
Aegean civilization, see Crete
African sculpture, influence of on abstraction, 165
Albers, Josef, 48
Alexander the Great, 15
Alice in Wonderland, 51
Altamira cave paintings, 12
Anglo-Boer War, 165
Animals, in art of ancient Egypt, 12; placement of in composition, 52
Angkor Wat, 38
Arp, Jean, 169
Asymmetry, advantages of, 27; and rhythm, 172; disadvantages of, 28; elements of, 27, 28; in abstraction, 165, 166; in Baroque art, 21; in Classic Revival period, 21; in Renaissance art, 142; in Sistine Chapel, 44; in floral arrangement for still life, 72; in Impressionist painting, 21; in Japanese painting, 23; in modern art, 23; in nonobjective art, 172; in Rococo art, 21, 28
Asymmetrical composition, 42, 44
Atrium, 15
Attic pottery, 14; influence of on Picasso, 158
Avery, Milton, illus. by, 167

Balance, in composition, 25–31; in nature, 25; in pictures, 25, 27, 28
Baroque art, 21; asymmetry in, 21; interiors in, 149; portraits in, 135; wash drawings in, 158
Bauhaus, the, 169
Beardsley, Aubrey Vincent, 141, 158
Beckman, Max, 139
Bellows, George W., illus. by, 120; *Stag at Sharkey's* of, 147
Bierstadt, Albert, illus. by, 96
Black-and-whites, see Graphic arts
Blake, William, 141; illus. by, 160
Boats, see Ships
Bosschaert, Abraham, *Omnia Varitas (All's Vanity)* of, 73
Botticelli, Sandro, 41, 172
Brancusi, Constantin, 165
Braque, Georges, 23, 71, 165
Bruegel, Pieter the Elder, illus. by, 46, 119; *The Wedding Dance* of, 44
Buffet, Bernard, 44; *Still Life with Artichokes* of, 68
Buonarroti, Michelangelo, see Michelangelo

Byzantine painting, 18; composition in, 18; effect of Christianity on, 18; symmetry in, 18
Byzantium, 17

Canaletto, 44
Caravaggio, Michelangelo Amerighi, 49
Cassatt, Mary, *At the Opera* of, 44; illus. by, 43, 131; *La Liseuse (The Reading Woman)* of, 129
Castor, 142
Cézanne, Paul, 35, 48, 68, 75, 172; illus. by, 118
Choosing your subject, 35, 37
Christian Era, the, art of, 17, 18; effect of religion on art of, 17, 18
Chagall, Marc, 18
Cityscape, choosing your subject in, 99; churches and public buildings in, 101; composition in, 99–107; cross streets and plazas in, 101; color in, 102; color of sky in, 105; figures in, 103, 105; houses in, 99; light and shadow in, 101; nature in, 105, 107; night lights in, 102; perspective in, 99; perspective in Oriental, 107; realism of Western and Oriental compared, 107; rhythm in, 101; roofs in, 101; shape of support in, 105; sky in, 105; streets in, 99; vehicles in, 103, 105; water in, 107
Claesz, Pieter, 68
Classic Revival period, 21; formulas in, 142
Cole, Thomas, illus. by, 62, 78; *Wolf in the Glen* of, 61
Color, appropriateness of, 53; drawing in, 158; in abstraction, 167; in cityscape, 102; in composition, 48; in interiors, 152, 153; in landscape, 80; in nonobjective art, 169, 171; of sky in cityscape, 105; in polychrome prints, 163; in portraits, 137; in seascape and landscape, 95, 97; in still life, 71; psychology of, 53; potential of, 48; values of, 48, 49
Constable, John, 92, 94; illus. by, 97
Constantine the Great, 17
Constantinople, 18
Conté, Nicolas Jacques, 158
Copley, John Singleton, illus. by, 111; *Portrait of Jacob Fowle* of, 129, 134
Counter-Reformation, the, 21
Cranach, Lucas the Elder, 129
Crayons, 157, 158
Crete, excavations on, 12, 14; painting of ancient, 12, 14
Cubism, 165

Dada, and nonobjective art, 169
Dali, Salvador, 68; illus. by, 77; *Persistence of Memory* of, 73
Daumier, Honoré, 141, 172
David, Jacques-Louis, 21; *Death of Socrates* of, 142; illus. by, 126

Da Vinci, Leonardo, 48, 141, 172; *Last Supper* of, 19, 27, 134; *Mona Lisa* of, 112, 134; *Virgin and Child with St. Anne* of, 142
De Chavannes, Pierre Cécile Puvis, 146
Degas, Hilaire Germain Edgar, 172; illus. by, 140; *Le Foyer* of, 142, 153
De Heem, Jan Davidz, illus. by, 122
Derain, André, 23
De Witte, Emanuel, illus. by, 113
Diorama, 33
Dix, Otto, *Flower Still Life with Cat* of, 68
Doré, Gustave, 141
Drawing, in art of ancient Egypt, 157; in art of ancient Greece, 15; in art of ancient Rome, 157; in graphic arts, 157, 158; in prehistoric cave paintings, 157; reversing original for prints, 163; monochrome, 158
Duccio di Buoninsegna, 19; *Majestà* of, 19
Duchamp, Marcel, 23; illus. by, 124; *Nude Descending a Staircase No. 2* of, 166
Dürer, Albrecht, 129
Duveneck, Frank, illus. by, 134

Eakins, Thomas, illus. by, 114
Early Christian art, interiors in, 149
Easel paintings, 149; in Rococo art, 21
Egypt, animals in art of ancient, 12; art of ancient, 12; composition in art of ancient, 12; drawing in art of ancient, 157; figures in art of ancient, 12; objects in art of ancient, 12; purpose of art of ancient, 12; religion in art of ancient, 12; symmetry in art of ancient, 12
Eight, The, 147
El Greco, 27, 141, 142, 167, 172; illus. by, 144; *The Adoration of the Shepherds* of, 142
Engraving, see Prints
Etching, see Prints
Evans, Sir Arthur, 14
Eye, binocular vision of the, 34; circle of vision of the, 34; how sees in pictures, 33, 34; how sees reality, 33, 34; panoramic view of the, 35; peripheral vision of the, 34
Eye level, in seascape, 83, 88
Erotic subjects, in art of ancient Rome, 15

Fabri, Ralph, illus. by, 58, 102
Figure, accessories in painting the, 137, 139; background in full-length, 139; comparative sizes in the, 51; composition in the, 109–112, 129–139; cutting off head in the, 134; cutting off part of the, 53; floor in painting full-length, 139; head in the, 137; in composition of ancient Rome, 42; in Ankor Wat friezes, 39; in art of ancient Egypt, 12; in art of ancient Greece, 15; in Byzan-

tine painting, 18; in cityscape, 102, 105; in High Renaissance, 19; in interiors, 150, 152; in Oriental art, 39; in seascape and landscape, 95; in Western art, 43; mistakes in painting, the, 137; optical illusions in, 63; placement of the, 52; shape of support in painting the, 137; symmetrically arranged, 27; where to cut the, 137

Flowers, accessories for in still life, 73; arrangement of in still life, 72, 73; asymmetry in arrangement of for still life, 72; containers for in still life, 72; exotic in still life, 72; in still life, 71-73; location of in still life, 73; selection of for still life, 71, 72; shape of support for still life with, 73

Foreshortening, in art of ancient Greece, 15; optical illusions in, 63

Freud, Dr. Sigmund, 11

Gainsborough, Thomas, *Blue Boy* of, 129
Gauguin, Paul, 172; illus. by, 143; *The Day in the Life of the God* of, 142
Genre painting, 141, 150; in art of ancient Rome, 15, 17; in Rococo art, 21
Giorgione da Castelfranco, 49
Giotto di Bondone, *Pietà* of, 19
Glackens, William James, illus. by, 75
Gothic art, altarpieces in, 18, 19; cathedrals in, 18; composition in, 19; portraits in, 134; stained-glass windows in, 18, 19; symmetry in, 19; tapestry in, 18
Goya. Fransisco José de Goya y Lucientes, 163, 172; *The Shooting of the Rebels (Los Tres de Mayo)* of, 45
Graphic arts, composition in the, 157-163; definition of, 157; drawing in the, 157, 158
Greece, civilization of ancient, 14; drawing in art of ancient, 157; figures in art of ancient, 15; foreshortening in art of ancient, 15; linear perspective in art of ancient, 15; religion in art of ancient, 14; vase painting of ancient, 14, 15
Greek proportions, in academic art, 21
Greco-Roman, history in David, 142; symmetry in Byzantine painting, 18; symmetry in Classic Revival period, 21
Grimshaw, Atkinson, *Near Burnt-island, Fife* of, 83
Gris, Juan, 23, 71, 165

Hamilton, Hamilton, illus. by, 155; *Lady in Black* of, 153
Hands, in portraits, 112
Harper, William St. John, illus. by, 154; *In the National Academy of Design* of, 154
Harrison, Thomas Alexander, illus. by, 90; *Marine* of, 88
Hartung, Hans, 23
Hassam, Childe, illus. by, 104; *Madison Square* of, 107
Head, cutting off of in figures, 134; in figures, 137; placement of, 51; placement of in portraits, 109; placement of on support, 134
Hellenistic art, 15
Herculaneum, destruction of, 15; excavations of, 15; murals of, 15

History of composition, 11-23; in academic art, 21; in ancient Crete, 12, 14; in ancient Egypt, 12; in ancient Greece, 14, 15; in ancient Rome, 15, 17; in Baroque art, 21; in Byzantine art, 18; in Classic Revival art, 21; in Early Christian art, 17; in early Renaissance art, 19; in Gothic art, 18; in High Renaissance art, 19; in Impressionistic art, 21; in modern art, 23; in Oriental art, 21; in prehistoric times, 23; in Rococo art, 21; in Romanesque art, 18
Hodler, Ferdinand, illus. by, 33; *Lake Geneva at Chexbres* of, 37; *Retreat from Marignano* of, 37; *Uprising of the Students of Jena* of, 37
Holbein, Hans the Younger, 129; illus. by, 132
Hopper, Edward, illus. by, 125
Hudson River school, the, 61
Huntington, Daniel, illus. by, 150

Icons, in art of Eastern Christian Church, 18
Iliad, The, 14
Illustrative art, definition of, 141
Illustrative subjects, composition in, 141-147; in modern art, 142, 146, 147
Impressionism, in art of ancient Rome, 17
Impressionist painting, 21; composition in, 21; interiors in, 153
India ink, 157
Inness, George, illus. by, 97
Interiors, color in, 152; composition in, 149-155; definition of, 149; figures in, 150, 153; how to draw, 150; in Baroque art, 149; in Early Christian art, 149; in Impressionist painting, 153; in Oriental art, 150; in Renaissance art, 149; influence of perspective in painting, 149, 150; light and shadow in, 151, 152; line in, 151; Netherlands, 153, 154; selecting view of, 150

Japanese art, influence of on abstraction, 165
Japanese woodcuts, influence of on Whistler, 129

Ka, 12, 14
Kandinsky, Vasily, 23, 165, 169, 171, 172; *Composition No. 35* of, 166; illus. by, 121, 164
Kirchner, Ernest Ludwig, 139
Knossos, Palace of, 14
Kokoschka, Oscar, 139

La Farge, John, 146
Landscape, buildings in, 83; color in, 80, 95; composition in, 79, 80; figures in 95; mountains in, 80; repetitious lines in, 80; rhythm of nature in, 80; roads in, 83; trees and bushes in, 80
La Tour, Maurice Quentin de, *Portrait of Madame de Pompadour* of, 45, 135
Lawrence, Thomas, *Elizabeth Farren, Countess of Derby* of, 129; illus. by, 108
Light and shadow, in abstraction, 67; in interiors, 151, 152
Line, in art of ancient Crete, 41; in art of ancient Greece, 41; in art of ancient

Egypt, 41; in Christian art, 41; in composition, 41-49; in reality, 41
Linoleumcut, *see* Prints
Lithography, *see* Prints
Louis XV, 135

Magic, in prehistoric cave painting, 11
Mannerism, 49; influence of High Renaissance ideals on, 19
Mantegna, Andrea, 172
Matisse, Henri, 23, 153, 165
Mead, Dr. Margaret, 11
Memory pictures, in art of ancient Egypt, 13; in Assyrian, Egyptian, and Babylonian art, 37, 39; in seascape, 88; in Oriental art, 39; of Ankor Wat, 38
Menzel, Adolph Friedrich Erdmann von, *Room with a Balcony* of, 153
Michelangelo Buonarroti, 12, 18, 141; asymmetrical composition of Sistine Chapel of, 44
Minoan civilization, *see* Crete
Minotaur, the, 14
Miró, Joan, 23
Modern art, asymmetry in, 23; composition in, 23; illustrative subjects in, 142, 146, 147; symmetry in, 23
Modigliani, Amedeo, 23, 165
Mondrian, Piet, 169; *Broadway Boogie Woogie* of, 172; illus. by, 170; *Trafalgar Square* of, 171; *Trees Along the Gein* of, 83
Monet, Claude, illus. by, 91; *Les Nymphées* of, 88
Monochrome drawing, 158; composition in, 158, 159
Motherwell, Robert, illus. by, 168; *N.R.F. Collage #2* of, 172
Mountains, in landscape, 80
Munch, Edvard, 139; *Portrait of Walter Rathenau* of, 135
Münter, Gabriele, *Still Life with Flowers* of, 73

New York school of art, 41
Nonobjective art, and Dada, 169; and music, 172; asymmetry in, 172; color in, 169, 171; compared to music, 169, 171; composition in, 169-172; definition of, 169; rhythm in, 172; self-expression in, 172; titles in, 169; top and bottom in, 171
Nonrepresentational art, *see* Nonobjective art

Objects, cutting off part of, 53; in art of ancient Egypt, 12; placement of, 52
Odyssey, The, 14
Op art, 45
Optical illusions, in composition, 59-65; in figures, 63; in foreshortened forms, 63; in photographs, 59; in pictures, 59, 61; usefulness of, 65
Oriental art, asymmetry in, 23; cityscape in, 107; composition in, 21, 23; figures in, 38; interiors in, 150; memory pictures in, 39; perspective of cityscape in, 107
Orozco, José Clemente, 146

Panthéon, the, 146
Pastel, 158
Pechstein, Max, 44